P9-CLJ-808

$12.95

"Rudhyar explains the rationale underlying houses, their use as a field of reference, their meaning as 'fields of experience', then covers each house in depth. One interesting chapter is devoted to a discussion of the polarity that is implied by any rising sign: Aries on the Ascendant, for instance, and its contrast with Libra on the Descendant...the thoughtful student should understand Rudhyar as part of a well-rounded astrological education."

---American Astrology Review

"If this necessary book is not a part of your astrological library, now is the time to add this work of a pioneer of modern, person-centered astrology."

---SSC Booknews

OTHER BOOKS BY DANE RUDHYAR

The Astrology of Personality
Triptych (Gifts of the Spirit, The Way
 Through, The Illuminated Road)
Fire Out of the Stone
Of Vibrancy and Peace (Poems)
New Mansions for New Men
An Astrological Study of Psychological Complexes
The Practice of Astrology
The Pulse of Life
The Lunation Cycle
Birth Patterns for a New Humanity
The Planetarization of Consciousness
Directives for New Life
A Seed

The Astrological Houses

THE SPECTRUM OF INDIVIDUAL EXPERIENCE

DANE RUDHYAR

CRCS PUBLICATIONS
Post Office Box 1460
Sebastopol, California 95472

Library of Congress Cataloging-in-Publication Data

Rudhyar, Dane, 1895-1985
 The astrological houses.

 Reprint. Originally published: Garden City,
N.Y. : Doubleday, 1972.
 Includes bibliographical references.
 1. Astrology. I. Title.
BF1708.1.R83 1986 133.5 86-17144
ISBN 0-916360-24-5

LIBRARY OF CONGRESS CATALOG CARD NUMBER 74-180105
COPYRIGHT © 1972 BY DANE RUDHYAR

All rights reserved under International and Pan-American Copyright
Conventions. Printed in the United States of America. No part of this book
may be used or reproduced in any manner whatsoever (including photo-
copying) without written permission from the publisher, except in the
case of brief quotations embodied in critical articles and reviews.

Published simultaneously in the United States
 and Canada by CRCS Publications.
Distributed in the United States &
Internationally by CRCS Publications.

CONTENTS

PART ONE

part one

Why Houses?

MOST ASTROLOGERS WOULD PROBABLY AGREE WITH THE general statement that astrology is the study of the correlations that can be established between the positions of celestial bodies around the Earth and physical events or psychological and social changes of consciousness in man. The motions of celestial bodies are, with very few exceptions, cyclic and predictable. As far as we can see, ours is a universe of order, even though this order is not too apparent from close up, since from our position on Earth in the midst of the happenings, involved in them, and emotionally reacting to them, we are unable to perceive the large picture of cosmic existence. When, however, we consider celestial events which occur at an immense distance from us, we can readily experience the majestic rhythms outlined on the background of the sky: the rising and setting of the Sun, the Moon, and the stars, the New and Full Moon, the conjunctions of planets and other periodic phenomena. Thus astrology, by referring man's seemingly unpredictable and aleatory experiences in his earthly environment to the rhythmic and predictable changes in the position and the interrelationship of the celestial bodies, gave to mankind a most valuable sense of order, which in turn produced a feeling of at least transcendental security.

There are many ways in which man can react to and interpret his realization that definite and at least relatively reliable correlations

can be established between what occurs in the universe around the Earth and outer or inner changes in human lives. Quite obviously such reactions and interpretations depend fundamentally on the stage of man's evolution in terms of the capacity of his senses to perceive what happens in the sky, and the state of development of his consciousness, his psychic faculties, and his intellectual as well as physical tools for measuring and interpreting what he experiences. All this finds expression in the social, religious, and cultural environment which provides the star-gazer with a certain kind of language, basic beliefs, and a socio-cultural way of life.

To disassociate astrology from the state of the culture and the society in which the astrologer lives and makes his calculations and interpretations is quite senseless. *Any* conceptual system has to be understood in terms of the conditions of life—social and personal, as well as geographical—of the men who act, feel, and think. The "truth," or rather the *validity*, of an action or a thought can be ascertained only by referring it to the larger social-cultural picture, and, deeper still, to a particular phase of the evolution of mankind, or at least of a section of mankind.

Because this often is not done, or done with a bias produced by projecting one's present state of consciousness upon the minds and feelings of men of archaic times and other races, much confusion arises. Astrology is a particularly fertile field for confusion and the proliferation of dogmatically stated opinions, whether or not these take the form of supposedly scientific analyses and erudite compilations of texts or of psychic hunches or "communications." Many complex theories and confusing interpretations have developed because astrology has been thought of as a thing in itself, a mysterious "science" using a puzzling terminology unchanged since ancient Chaldean times and supposedly still valid. Yet this terminology quite obviously has failed to fully take into account the radical changes in human consciousness and in man's awareness of the Earth's and of his own place in the universe which has occurred over these many centuries.

As a result the present wave of interest in astrology is encountering all kinds of obstacles and flowing confusingly into various channels. Much of the time this means losing sight of the basic function of astrology, which is to bring a sense of order and harmonious, rhythmic unfolding to human beings—not human beings as they

were in old Egypt or China, but *as they are today* with all their emotional, mental, and social problems.

LOCALITY-CENTERED ASTROLOGY
IN ARCHAIC TIMES

Until the end of the "archaic" age in the sixth century B.C., when Gautama the Buddha lived and taught in India and Pythagoras in the Hellenistic world, the consciousness of men—with perhaps rare exceptions—was fundamentally *locality-centered*. Relatively small groups of human beings lived, felt, and thought in terms of what one can best define as "tribal" values. Tribal groups, the basic elements of human society at the time, were as bound to the particular land from which they drew their subsistence as an embryo is bound to the mother's womb. The tribe constituted an organism; every member of it was totally integrated into this multicellular organism. Each member of the tribe was dominated psychically by the way of life, the culture, the beliefs, and the symbols of the group, whose taboos he or she could not disobey. There were no real "individuals" at this stage of human evolution; all the values upon which the culture and beliefs of the group were founded were expressions of particular geographical and climateric conditions, and of a particular racial type. The tribal community looked to the past for the symbol, if not the fact, of its unity; that is, to a common ancestor, or to some divine king who had brought it a revealed kind of knowledge and a special psychic cohesion.

The astrology which developed at this stage was also locality-centered far more than truly geocentric, that is, Earth-centered. Every tribal village had a central place which was considered to be either the center of the world, or the entrance to a secret path that led to such a center. What we today call the horizon defined the boundaries of life. Above it, the sky was the habitat of the great creative hierarchies of gods. The dark region below the horizon was the mysterious underworld to which the Sun retired every night to regain the strength needed to bring light again to man's horizontal world. It is of course possible that a few priest-initiates were aware that the Earth was a globe which revolved around the Sun; but if there was such a secret tradition communicated orally through rites of initiation, it apparently had no bearing on astrology.

For primitive, tribal man, astrology was an integral part of

religious symbolism as well as a means to foresee periodic natural occurrences affecting the life of the community and especially its agricultural activities or the mating of the cattle. In such a condition of life and with human consciousness focused upon the soil and the total welfare of the organic community, astrology was quite simple. It was essentially based on the rise, culmination, and setting of all celestial bodies—"stars" as well as the two "Lights," Sun and Moon. Two categories of "stars" were readily differentiated. Most of the stars as they rose and set kept their relationships to each other unchanging; that is, as they traveled around the sky, *the pattern* these dots of light made remained "fixed." Other celestial bodies, on the contrary, moved independently of each other and at times appeared to go backward; they were called "wanderers," which is what the word *planet* originally meant. Some of these planets appeared to the trained observer as small discs, rather than dots of light, and they were considered to form a category of celestial objects very different from the stars. Their periodic conjunctions were noticed, and their motions were plotted so that they could be measured and conjunctions foreseen.

Plotted against what? The obvious background or frame of reference was the permanent *pattern* of the distant stars. We must, however, realize that to the archaic mind the stars were not fixed. They were observed to rise and set. The only thing actually fixed was the horizon. Nevertheless the overall geometrical pattern which the stars made on the dark background of clear subtropical and desertic skies remained the same for centuries. It could therefore serve as a *frame of reference*, if it was subdivided for the convenience of measurement.

In order to understand how the concept of zodiacal constellations arose and the symbolic form it took, one need only realize that all tribal societies, as far as we know, used *totems*. These totems were associated with clans within the tribe; and these clans, in a sense, represented functional organs within the total organism of the tribe. Most often totems were animals with whom the men of a clan felt that they had some special relationship. They could, however, also be natural objects such as plants.

When men of past eras sought to give a more definite form and permanence to their society they sought to model it upon principles of functional organic order. The cosmos was felt to be an organic whole animated by a bipolar universal Life-force, sym-

bolized in astrology by the two Lights, in Chinese philosophy by the *Yang* and *Yin* principles active within all forms of existence. Indeed, Sky and Earth were seen ideally as two polarities, the former creative and divine, the latter receptive and fruitful, but filled with wild disharmonic energies which had to be integrated and domesticated—from *domus*, meaning "house." The wise man—the "Celestial" in China—stood as it were in the midst of these polarities, partaking of both Sky and Earth. His task was to impress creative Order upon earthly nature and to organize society according to cosmic rhythms and principles. In some cases the reverse process also operated, and totems were projected upon the Sky in order to emphasize the close connections which the clans felt they had with their celestial equivalents. Thus constellations were named after various tribal totems. Later on, the symbol of the Grand Man in the Sky, whose every organ corresponded to a constellation, was established.

This type of thinking prevailed in Greece, where heroes were transferred to the sky after their death and constellations were named after them. Later, in Medieval Europe, in alchemical and occult circles, the Sky was referred to as *Natura naturans* and Earth-Nature as *natura naturata*—the creative and receptive polarities of life.

In regions such as Egypt and Mesopotamia the seasonal factor is not as obvious as in more northern European regions; but the inundations of the Nile marked the most crucial moment of the yearly cycle. Astrologers here were first of all star-gazers and it is safe to assume that their zodiac referred to the constellations. Again let me stress that astrology at this point was locality-centered much more than Earth-centered. No Egyptian astrologer would have worried about what could be observed in the sky of the polar regions, or of the southern hemisphere. These worrisome problems began to appear *only* when it became known that the Earth was a globe revolving around the Sun, together with the other planets—when Western men began to travel and look at skies very different from those of Europe.

When this happened the old astrology became if not completely obsolescent, at least loaded with obsolete concepts and with an archaic terminology which in many instances no longer makes any real sense. A great number of long observed and tabulated correlations between occurrences in the sky and events in the Earth's biosphere have certainly remained valid. But this validity now

belongs to a new order of human reality. The consciousness of men who think in terms of the heliocentric system and travel all over the globe has lost at least a great deal of its binding attachment to a particular geographical locality, and society is no longer operating at a local or a tribal level. Men have been released from the tribe, "individualized" and uprooted, and even if some of them are still in fact locality-bound, in theory and in terms of the new universalistic religions, Buddhism, Christianity, Islam, they feel themselves to be, and are regarded as, "individuals."

If astrologers fail to take in consideration such historical, spiritual, intellectual, and social-cultural facts, remaining blind to the basic realities, the confusion arising from the use of obsolete terms and concepts will be perpetuated and the most basic issues will remain misunderstood.

The above paragraphs form an indispensable background for the student as he comes to familiarize himself with the concept of astrological houses. What are houses for? How did the concept arise, and what has become of it in modern astrology? How many houses should there be, and what are the complex problems one faces in determining the boundaries, or "cusps," of these houses?

To answer these questions in detail is beyond the scope of this book. But a few basic points should be stated as clearly and simply as possible before we come to the study of the four Angles in astrological charts, and of the different levels of meaning which should be attributed to the twelve houses as they are used at present.

ZODIACS AND HOUSES

From the point of view of archaic astrology, the concept of houses was very simple and posed few problems. As we saw a few paragraphs back, the astrologer needed a frame of reference or background on which to pinpoint exactly the positions of the Sun, the Moon, and the planets, and their angular distances from each other when seen from the particular area in which the tribal group lived. But the astrologer probably realized sooner or later that there were two possible frames of reference. One of them was the unchanging patterns made by those star groups—constellations—which are found close to the ecliptic; that is, close to the narrow band or belt in the sky along which the Sun, the Moon, and the planets move. Such a frame of reference is obviously *spatial*: celestial bodies

moving over the spatially extended shapes of the zodiacal constellations.

The other frame of reference was most specifically a *durational* one, for it defined the time it takes for celestial bodies to rise in the East, culminate overhead and set in the West. What is involved in such a type of measurement is, in modern terms, the daily rotation of the celestial sphere above and below the horizon. Such a rotation provided the ancient astrologer with the concept of "hours" and also of "watches," for especially during the night men had to be on watch for possible dangerous intrusions, whether of predatory animals or human enemies. The watchers worked in relays of two or three hours.

In the daytime it was the motion of the Sun around the visible sky which was the basic factor, for its changing elevation resulted in changes of temperature which in turn affected all or most human activities in agricultural societies. Changes in solar elevation could easily be reduced to the crossing by the Sun of various sections of his daily path around the visible sky; thus the time factor could be analyzed also as a space factor—actually the basis of the *sundial*, which measures time in terms of space. But this kind of space could be interpreted as strictly "terrestrial" space, while the space defined by constellations was "celestial" space; the differentiation was no doubt most significant at a time when the Sky-Earth polarity was the basis of a vast number of concepts with endless possible applications. This difference is still important to many astrologers, as we shall see presently.

When the modern astrologer speaks of these two frames of reference for the measuring of the motion of Sun, Moon, and planets he at once mentions that the first refers to the apparent yearly motion of the Sun around the zodiac—which today we understand to be in fact the revolution of the Earth around its orbit, the ecliptic—and the second to the daily rotation of our globe around its polar axis; but quite obviously this was not the way in which the ancients thought of the matter. And what is important are not the so-called "facts"—as we see them today—but the *meaning* man gives to his immediate and direct experiences. Astronomy deals with observable facts, while astrology is the study of the meaningful, rational or irrational, responses that man gives to these facts in terms of his concept of the nature and character of the universe.

But to return to the two frames of reference used for the meas-

ure of the positions, the angular relationships, and the cycles of
Sun, Moon, and planets: the first one is what we today call the
zodiac; the second, the circle of houses. But these terms and the
way they are defined and used are very ambiguous. You can con-
ceive any number of "zodiacs" depending on what you want to
measure; likewise our modern astrological houses and the "watches"
of archaic astrology are very different—different in number, in size,
and in meaning. We will try to throw some light on these am-
biguities and to clarify the position taken by astrology in the western
world.

First we should realize that the first zodiacs were most probably
lunar zodiacs divided into 27 or 28 sections, usually called "asterisms"
or lunar mansions. Obviously one cannot normally see the star groups
over which the Sun passes at any time of the year; one has to de-
duce this Sun's position from the stars that rise or set just after sun-
set. It is far simpler to ascertain the position of the Moon at night in
relation to the stars. Thus a stellar frame of reference for the Moon's
monthly cycle is indeed the more logical, especially for nomads
who raised cattle which had to be watched at night.*

Then one should consider the fact that the yearly cycle of the
Sun through the constellations could also be measured in another
manner. We speak today of the yearly motion of the Sun in
longitude along the zodiacal path; but it can be measured equally
well in terms of changes in *declination*. What this means is simply
that sunsets never occur at exactly the same place in the western
horizon. Only at the time of the spring and fall equinoxes does
the Sun set exactly West. At the solstice of summer it sets about
23½ degrees to the North-West; at the winter solstice, about the
same number of degrees to the South-West. Moreover, there are
also changes in the elevation of the Sun in the Sky throughout

* Lunar zodiacs seem to have been divided into 27 or 28 sections, evidently
because the Moon takes 27+ days to circle the celestial sphere of the "fixed
stars." The day is the basic measure of time because it refers to the alternation
of light and darkness, of waking consciousness and sleep—the most fundamental
fact in human experience. Lunar zodiacs refer to a type of human consciousness
in which all that the Moon symbolizes is basic—a consciousness which found ex-
pression in matriarchy and which is dependent on biological-psychic factors and
feeling responses. The solar zodiac presumably came into prominence as patri-
archal types of organization won over matriarchal systems. In ancient India there
were long wars between solar and lunar dynasties. The development of theism at
the time of the Bhagavad-Gita in India, then with Akhnaton in Egypt, and
finally with Moses was undoubtedly linked with the ascendancy of a "solar" type
of consciousness, and later with the growth of individualism.

the year, which determines the ever-varying angle at which the rays strike the Earth's surface, and as a result the seasonal changes in temperature and climate.

There were great cultures which erected huge stones at the western horizon in order to measure the position of the Sun in its yearly cycle of changes in declination—which in turn was related to seasonal changes. Whether these cultures also used a zodiac of constellations may not be too easy to determine, though both types of measurements may have been known—the zodiacal type referring mainly to the Moon, the declination or seasonal type to the Sun.

The concept of the zodiac became ambiguous and lent itself to much confusion when astrologers became fully aware of the motion called "precession of the equinoxes," which introduces a constantly increasing discrepancy between seasonal and stellar measurements. With the reappearance of the *sidereal* zodiac (constellations) in western astrological tradition, which for many centuries had exclusively used the *tropical* zodiac of signs referring to *the fixed pattern* of equinoxes and solstices, this confusion has become more pronounced.

I shall not discuss here in detail the values of these two solar zodiacs, which most unfortunately use the same terms—Aries, Taurus, Gemini, etc.—to refer to two different sets of factors. I shall only say that while the sidereal zodiac divides the band of twelve constellations whose boundaries are most uncertain and have been altered several times—the last time, some forty years ago—the tropical zodiac refers to a clearly known and precisely measured factor, the Earth's orbit. It depends also on equally clear factors, such as the equinox and solstices, with definite seasonal implications which are very significant in the lives of human beings living in the temperate regions of the northern hemisphere—it is our western civilization that today is dominating the whole world.*

There seems to be little doubt that the archaic civilization of which we have record used zodiacs—lunar and/or solar—which were "sidereal," that is, based on constellations; but these civilizations did *not* conceive or image the universe as we have since the Greek period and especially since the early European Renaissance. Moreover, these early civilizations were found in somewhat different

* For a discussion of the two zodiacs, the precessional ages, and the beginning of the so-called Aquarian Age, see my book *Birth Patterns for a New Humanity* (1969).

regions of the globe and under different climatic conditions. And I cannot stress too much the basic importance of these facts when we try to discuss and evaluate astrological data and techniques.

THE EIGHT "WATCHES"

Let us now consider the second frame of reference which can be and has been used for the measuring of the positions of Sun, Moon, and planets, namely, the circle of the astrological houses.

It is indeed most likely, as the late Cyril Fagan pointed out not long ago, that in archaic astrology what we now call houses were periods of time—"watches"—which were based on the rise, culmination, and setting of the Sun. These were divisions of the solar day into four basic periods, the fourth significant moment of the cycle being postulated as a counterpart to the culmination of the Sun at noon, that is, midnight.

One should understand the philosophical-psychological as well as the cosmological meaning of this fourfold pattern which dominates astrological thinking. The fourfold division of any cycle rests on the realization of the dualism inherent in all existence and in human consciousness. I have already mentioned the polarity of day and night, light and darkness, conscious activity and sleep, *Yang* and *Yin*. In the philosophies of India we find constant reference to the states of "manifestation" and "nonmanifestation." In the Bhagavad-Gita, Krishna as the embodiment of the universal Self (*Brahman*) states that he is the beginning, middle, and end of all cycles. But these existential cycles are only "half cycles," for every period of cosmic manifestation (*manvantara*) is balanced by a period of nonmanifestation (*pralaya*)—a cosmic day by a metacosmic night.

The periods of transition between these days and nights—whether in the cosmos or in human experience—are the most significant moments of existence. They are symbolized in human terms by the horizon, because this horizon divides the daily motion of the Sun into two basic periods, separated by sunrise and sunset. In near-tropical regions dawn and dusk are brief. The day bursts out quickly and night falls rapidly—a fact of great importance if one wishes, unwisely, I believe, to transfer certain ideas—for instance, the concept of "cusp"—belonging to a subtropical astrology to the astrology valid for temperate and high-latitude countries.

The awakening to conscious living—dawn, the *alpha* point of

the day cycle—and the conclusion of the day's activity at sunset—
the *omega* point—are and always have been basic in astrology,
as well as in religious and cultural symbolism. Noon is the point
of culmination of effort, leading—especially in hot climates—to a
phase of nourishment and rest. In polar opposition to it, midnight
is the time of deepest mystery, a very magical time.

A further division of this fourfold pattern in time was logical,
especially when linked with the need to define the length of night
watches. A three-hour period is quite fitting for such watches, and
the 45-degree angle is easily calculated when the advance of the
Sun in the sky is plotted on the horizontal plane of the sundial.
This 45-degree measure has had a great deal of meaning in occultism
and apparently is very significant when electrical and magnetic
force fields are studied today.

The eightfold division is probably also related to the at-
tribution of the number 8 to the Sun. In India the chariot of the
Sun god was driven by eight white horses, and the numerical symbol
which the Gnostics attributed to the Christ as a Solar Principle—
Rudolph Steiner spoke of Christ as a great "Solar Archangel"—was
888, or 8 operating at the three levels of consciousness, biological,
mental, and spiritual.*

Cyril Fagan recently claimed that the eightfold division of an
astrological chart was the earliest on record, and he pointed out that
these eight "watches" were given meaning in terms of the progress
of the Sun around the sky in a *clockwise* direction—and also in
terms of the types of activities most characteristic of the four watches
elapsing between sunrise and sunset. He is most likely correct in such
an assumption, but only as it applies to the type of agricultural
society of ancient times, even though evidently such a pattern of
activity still exists wherever men live close to the soil they cultivate
or to the animals they raise. It is a *vitalistic* pattern, and the Sun
is always to be considered in astrology the source of the Life-force.
But as man becomes more and more divorced from, indeed
alienated from, the soil and the instinctual, seasonal rhythms of life
—as man develops an individualistic mind and an ambitious ego—
the vitalistic patterns lose much of their meaning. A new set of prob-

* Cf. my book *The Lunation Cycle* for a further study of the eightfold
patterns in terms of the lunation and the eight types of soli-lunar personalities.
A series of articles I wrote long ago for *American Astrology*, "The Technique
of Phase Analysis," also uses in a special way charts divided into eight sectors.

lems develops, and today it is the solution of these new problems that is the main task for astrology. Why? Because it is at this level of psychomental individualization that modern man's most crucial needs exist. And everything has value in terms of its ability to answer to the *need* of mankind—whether it be astrology, or medicine, or science and knowledge in general.

Modern man's individualistic psychomental rhythm operates *in counterpoint* to that of soil-bound and locality-centered human beings. This is clearly demonstrated by the fact that in terms of contemporary consciousness, it is known that the planet Earth rotates on its axis, and not that the Sun moves daily around it. Thus the entire picture is changed, and we see the sequence of the modern astrological houses numbered and interpreted *counterclockwise.* Man's consciousness, mind, and sense of individual selfhood grow and unfold from potentiality at birth to a gradually more complete state of actualization *in opposition to* the rhythm of the Life-force. This inevitably produces individual problems, conflicts, and psychological complexes. But it is the human way to maturity, self-reliance, and creative fulfillment as a "person."

TWO BASIC APPROACHES TO THE SUN

From the archaic astrological point of view the determination of "watches" was simple enough, for they were nothing but divisions of the time it took the Sun to move around the dome of the Sky from sunrise to sunset. When astrologers were able to define the position of the Sun at any moment with reference to zodiacal stars and constellations, it was relatively easy to determine the approximate zodiacal positions of the beginnings of the eight watches at three-hour intervals. No special problem was involved, and the closer one lived to the equator the more harmonic the picture was.

When, however, one considers the Earth as a globe rotating on its axis and revolving around the Sun, and one seeks to build an astrological system which is no longer "locality-centered" but "globe-centered," and yet is relevant to individual persons who experience the universe from a particular point on *the surface* of this globe, all sorts of difficulties are met. Now three-dimensional facts are somehow to be projected upon a two-dimensional sheet of paper. At least three sets of coordinates can be used—local, equatorial, and ecliptical. To make matters much worse, the conservative and tradi-

tion-oriented attitude of most astrologers has impelled them to keep using many terms and figures of speech which fitted the archaic world-view but no longer make sense today in terms of our astronomical knowledge. Astronomers themselves have not done much better in some cases by using the same terms to refer to two sets of facts—for instance, longitude and latitude—and retaining old names.

There is not space here to go into technical details involving spherical geometry and the various systems of house division, that is, domification. Still, it is important for the modern student of astrology to realize that what he usually takes for granted in dealing with the houses of a birth chart is susceptible of several basically different interpretations. Cyril Fagan, who reintroduced the concept of the sidereal zodiac, also sought not only to promote the division of a chart into eight houses but to interpret their sequence in a clockwise direction. This probably was the ancient practice, at least in some regions, but Fagan's error was, I believe, to force archaic vitalistic beliefs upon modern individuals. We might as well accept Chaldean mythology as a basis for a renewal of religion! Every time and every culture has its own characteristic *needs*, and today we require an astrology which meets the needs of psychologically oriented, confused, and alienated egos—and particularly the needs of a large number of modern youths who, probably for the first time in history, have become fascinated by astrology, and this for very definite, even if often largely unconscious, reasons.

The meaning of the astrological houses, as they have been used in the Christian-European culture, is intimately related to the zodiac, and it is at least one of the reasons why western-style astrology has used a twelve-house system. Therefore I must again refer to the zodiac.

By analyzing recorded horoscopes in Greece, Alexandria, or Rome, one may present a good case for the claim that the shift from a sidereal to a tropical zodiac—that is, from constellations to signs representing equal 30-degree sections of the ecliptic—was due to an improper knowledge of astronomical facts, to a general confusion in the minds of men living during a disturbed period of history—which, in a sense, rather closely parallels, at a different level, our own time. But conclusions of this kind are usually superficial, and do not, I believe, give the deeper philosophical reasons for the adoption of this zodiac. Too much is left to

chance and to the mistakes of one or more individuals. Something much deeper is at stake, and it remains a fundamental issue today, though in a different way. The issue is metaphysical and cosmological, and it deals with the meaning to be given to the Sun.

A few pages back I stated that the constellations were originally devised in order to provide a convenient background on which to plot out the motions of the Sun, the Moon, and the planets. This may have been the way in which the relationship of the Sun to the constellations was thought of at a certain period of history, but there is abundant evidence that in archaic times this relationship was also given a different, almost dramatically opposite meaning—a meaning which is still very significant in terms of a type of metaphysical thinking which I have developed elsewhere. According to this approach, the Sun is to be considered only as a channel or lens *through which* the energies of cosmic Space are focused and directed upon the Earth and every living organism on it.

From the one point of view, the Sun is the dominant factor and the constellations merely form a background for measuring its motion and its cyclically altered relationship to the Earth. In the second case, the active factor is *space itself*—and we would say today galactic space. The Sun is only a focalizing instrument—some occultists have said "a window" through which pour day in and day out the immense energies of a space which is far more than three-dimensional and physical.

These two concepts of the fundamental nature of the Life-force can be called respectively *monotheistic* and *pantheistic*. Any student of religion knows how fiercely the Christian church has fought against anything related to pantheism. Witness the condemnation by the Roman Catholic Church a few years ago of Teilhard de Chardin's world view, in spite of his constant efforts to disclaim any pantheistic influence.

In archaic astrology, at least in some countries, the twelve constellations were understood to be the collective bodies of "creative hierarchies" belonging to a cosmic "World of Formation"—which in its totality might today be called the Divine Mind. From this point of view the Sun—and in a secondary way the Moon and the planets—were thought to be agencies that mobilized and released the creative energies of this Divine Mind. Other constellations might also be creative aspects of this Divine Mind but because they did not have in the Sun and the planets *direct channels to step down*

their energies to the level of human vibrations and consciousness they were only rarely effective in a human sense. The twelve zodiacal hierarchies were therefore the only ones truly in charge of life processes on Earth.

Such a cosmic picture was essentially "pantheistic," even if the metaphysical seer was able dimly to envision beyond this "sphere of the fixed stars" a still more transcendent realm, the realm of the Primum Mobile, or in more philosophical terms that of the forever unknowable Absolute, the *Ain Soph* of the Kabbalah. In contrast to it we have the "monotheistic" world picture in which the One God manifesting Himself vividly and personally to man is represented by the Sun, the solar I AM, the Egyptian *Aton*.

From this monotheistic point of view what is basic in human existence is the relationship between the creature man and his Creator, between the human and the divine. This relationship, in terms of astrological symbolism, becomes the relationship between the Earth and the Sun; and this relationship is expressed in *the orbit* of the Earth. Every month of the year—the high point of the month being the Full Moon, or for some people the New Moon—represents the development of one of *twelve basic responses* of human nature to its twelve essential types of Soul consciousness, twelve avenues through which the one divine Life can find means of expression.

From this point of view therefore the zodiac is logically and inevitably an "orbital" factor. It is the Earth's orbit, to which we keep giving the old and not very revealing name "ecliptic"—a name which has little to do with what it factually as well as symbolically represents. The stars then constitute a background on which the great "dialogue" between the basic types of men and the one God is carried on. They constitute a wondrous cosmic scenery on the universal stage. Nevertheless, some *individual stars* may become significantly involved in human affairs, but if they do, they refer to supernormal Visitations which more often than not intrude in, and tend to disturb the dialogue between earthly man and his Creator— that is, the Sun.

As the planets, from this orbital and heliocentric point of view, are also creations of the Sun, and as the light or rays they reflect upon the Earth have their source in the Sun, they simply differentiate or modulate the original solar Power, the God power of creation. It is therefore logical to interpret their positions and mutual relationships in terms of the Earth's orbit. Indeed the orbits of the

planets—some inside, others outside of the Earth's orbit—can be considered force fields which act upon the relationship between the Earth and the Sun. The Moon is especially significant in this way because as it revolves every month around the Earth, it distributes—symbolically at least—the energies released by the Sun at New Moon and reflected at all times by the planets.

Because of the paramount importance of the Earth-Sun relationship, it was almost inevitable that the basic twelvefold classification of the main aspects of the year-long cyclic pattern of changes in this relationship should be applied to the circle of houses. Twelve houses were believed to match and to be closely related to the twelve *signs*—not constellations—of the zodiac. But we should clearly understand how this was done.

The old locality-centered astrological outlook had become *globe-centered*—geocentric. The orbital-zodiacal relationship Earth-to-Sun was transferred to the entire Earth-globe, rather than to a particular locality bounded by its horizon. This can be seen clearly from the fact that what we call the "horizon" today in astrology—the "rational" horizon of astronomy—is a great circle which passes through the center of the globe. It is not the local horizon of the place for which a chart is made; it is only parallel to the local horizon.

This local horizon is to be understood as a "mean horizon" which does not take into consideration whether a person is born in a deep valley or on a mountaintop—a difference which is, after all, extremely small compared to the size of our globe, so that when the Earth's surface is seen from several thousands of miles above it, even the highest mountains appear almost insignificant in size. Besides, all astrology today deals with "mean positions" rather than with actual ones, which makes sense once we consider astrology to be a language made up of archetypal symbols and essentially "numerological" in the attribution of specific meanings to the separate factors constituting a cyclic series—that is, the series of zodiacal signs, of houses, and even of the planets in terms of their distance from the Sun.

But, to return to the relationship between the twelve zodiacal signs and the twelve houses. What is implied in the manner in which the traditional or classical type of European astrology interprets this relationship is the idea that the zodiacal signs refer to the energy substance of life processes, while the houses deal with the existential,

concrete, and circumstantial ways in which these processes operate during the life-span of an individual, or of a collective social entity. For at least some European astrologers today, the zodiac—of "signs" —is the positive force field from which flow all energies operating in the Earth's biosphere; the circle of houses, then, represents the receptive and sensitive terrestrial realm. This, in more modern terms, is the theistic differentiation of God the creator and man the creature.

The two polarities, divine and human, are in principle symmetrical. Man's "destiny" is written, *not in the stars but in the* tropical zodiac which refers to man's dynamic celestial nature, *natura naturans.* The actual "circumstances" according to which this celestial destiny works out in his daily life are indicated in the houses, and by the positions of planets, Sun, and Moon in these houses. The two cyclic series, signs and houses, are thus obviously progressing in the same direction, that is, counterclockwise.

This is and has been the basic attitude of the western astrology which we still find taught—with individual variations—in most textbooks. Unfortunately, the terminology used is often confusing, because many of the archaic and "pantheistic" concepts are still in evidence. The spread of "sidereal astrology" is making the confusion worse. *Historically speaking,* Mr. Fagan and his followers are probably right, as long as they speak of the archaic past—a past which is still affecting the many conflicting schools of astrology in India, land of spiritual traditions. But *psychologically speaking* they have failed to understand the deep change in human mentality that took place partly during the Greco-Latin period and even more during the European Renaissance. They do not understand, as I see it, the crucial need of human beings today; and their involvement in scientific techniques and their claim that astrology has value as an entity in itself—that is, *as a system* which must be recognized by the "scientific community"—seems irrelevant in terms of the present needs of our society in crisis—unless, of course, one believes that the future of mankind will be determined by an even more total reliance on technology and on the analytical intellect and its processes.

This does not mean that there is no validity in the siderealist's approach, or that the classical techniques of European astrology are in many ways confusing and obsolete. There is never a clear-cut question of "good" or "bad" in social-cultural, religious, or scientific matters, for the simple reason that all human minds do not operate at any time on only one wavelength. The world still contains a great

number of archaic, locality-centered, race-bound people, and of nationalistic individuals worshiping more or less dogmatically the "great heritage" of their particular country and/or culture. The demand for fortunetelling in terms of specific events is as great as it ever was, and probably greater; and the search for comfort, egocentric happiness, sensual enjoyment, and social prestige is still the drive of most human beings in our affluent and deeply polarized, neurotic society.

Astrology adjusts itself to the mentality and emotional expectations of the person who comes to it as a practitioner as well as a client—just as psychology does, and even medicine. You get what you give. As you ask, so will the answer be. What you want to know and, in most constructive situations, what you *need* to know condition, if not entirely determine, the kind of knowledge you will gain.

PERSON-CENTERED ASTROLOGY

We are living in an age of extreme individualism, and the "humanistic" approach to astrology which I have been formulating for many years seeks to bring to individual persons a more conscious realization of the deeper meaning of their experiences, so that they may be able to fulfill both their essential individuality and their destiny, that is, their place and function in the universe. In this type of astrology the human being is not understood to be *exterior* to his birth chart; he or she is not supposed to "rule" it by repressing its "bad" features and seeking to profit from the "good" ones. The birth chart is seen as the formula structurally defining a man's "fundamental nature." It is a complex cosmic symbol—a word or *logos* revealing what the person is potentially. It is the individual person's "celestial name," and also a *set of instructions* on how a person can best actualize what at his birth was only pure potential— "seed potentiality." The birth chart is a *mandala,* a means to achieve an all-inclusive integration of the personality.

I have developed these ideas at great length in many books and a large number of articles. Once they are well understood and emotionally as well as intellectually assimilated, it should be obvious that the entire approach to the interpretation of the basic factors in astrology has inevitably to change—otherwise the psychological results for the client, and for the astrologer as his own client, could be unfortunate, if not at times disastrous. Essentially the approach

should not be "ethical," that is, based on a dualistic attitude—good-bad, fortunate-unfortunate. No birth chart should be considered "better" than any other, even if obviously some charts indicate "easier" lives than others—but great and creative persons very rarely have an easy existence, inwardly if not outwardly.

Such a type of astrology, aiming at answering the needs of men, women, and adolescents in our individualistic society, must cast a new light upon most of the old concepts of astrology, especially where the nonconforming youth seeking to build a new way of life is concerned. A humanistic astrology must be person-centered because its basic concern is the development of the individual person—development in consciousness and feelings as well as development through external actions. And this person-centeredness has very definite implications and practical-technical consequences, for what such an astrology seeks to define and interpret is the direct relationship of the individual person to the whole universe, which, in practical terms, means his relationship to our galaxy considered as a cosmic "organism."

Archaic astrology was, as I stated, locality-centered. European astrology in its classical form was Earth-centered, the Earth being studied as a globe. What we need now, in a more definite and consistent sense than has been attempted during the past decades of this psychology-oriented century, is a person-centered approach to all the contents of our galactic universe. This approach is perhaps, in one respect, closer to the locality-centered archaic astrology than to the globe-centered astrology of the recent past; but the role of the *locality*—the character of which affected a tribal group of as yet non-individualized human beings swayed by vitalistic urges—should now be taken by an *individual person*, at least partially able to develop an independent, totally open, creative, and conscious approach to his total environment, cosmic as well as biospheric and social.

Such a change of emphasis will be particularly evident when we approach the topics of natal houses to which this book is devoted. I shall attempt to define the practical consequences of the new perspective; but I wish to stress from the outset that the change cannot yet be effected fully with the astronomical data at our disposal. Much more has to be known concerning the galaxy and its millions of stars. Still, we can begin to reorient our interpretations in the direction of what should develop fully in the centuries to come. In fact, insofar as natal houses are concerned, this reorientation does not greatly

alter the meaning traditionally given to them, or at least most of them, but it introduces new levels of meaning and it particularly shifts the main emphasis, insofar as planetary positions are concerned, from zodiacal signs to houses. The drawback of course is that such a shift requires that the precise moment of a person's first breath be known. But modern hospital techniques and parental interest are now lessening the difficulty of meeting such a requirement.

The Houses as the Basic Astrological Frame of Reference

WHEN A HUMAN BEING IS BORN AT A PARTICULAR TIME and in a particular place on the surface of the Earth he is surrounded on all sides by celestial bodies, visible in the sky or invisible below the horizon. Astrology states that the positions of these celestial bodies, *if related to the newborn* and if this relationship is significantly interpreted, define the basic *structural character* of this child's biological and psychic organism as well as the manner in which his potential at birth will or should be actualized through a series of *personal experiences*.

The word "person" can refer to collective persons, such as a business firm, a nation, or even a very definite sequence of organized social activities—the reign of a king or the taking office of a Presidential administration—but in this book I shall discuss only matters pertaining to individual persons. This is the field of "natal" astrology, and, as I see it, no system of natal astrology makes much sense today if it is not actually "person-centered."

A person-centered astrology deals with the relationship between a person and the universe which surrounds him—his cosmic environment. When we are dealing with a relationship, at least two

factors must be considered: in the case of person-centered astrology, the individual human organism which at its first breath came to be independently, directly, and organically related to the universe, and the celestial bodies *all of which* move around him in cyclic patterns.

Nothing in the universe is "fixed"; everything moves. Such movement, however, is meaningless if it is not observed by and interpreted in relation to a conscious person. We live in a world of relativity, but this relativity can be given a consciously defined meaning only in terms of a particular frame of reference and according to an at least *relatively stable* focus of perception. An individual person is a relatively stable entity, for although his body is obviously in a state of constant electrical and chemical transformation, and his consciousness likewise is never quite the same, nevertheless the genetic pattern in his cells—or whatever these genes biologically represent—remains the same from birth to death. He normally retains his original name and speaks his native language whose words and syntax play a most fundamental part in forming his mentality; he is a relatively permanent social unit belonging to a culture which but rarely experiences radical change even in spite of revolutionary crises.

Modern science has its "universal constants." They probably are only relatively constant and universal, but they serve as a frame of reference, without which hardly any "law of nature" could be considered reliable. Philosophers with a religious bent—cf. Aldous Huxley —speak of a "perennial philosophy" and occultists refer to a "universal tradition" or an "original revelation," both of which represent a stable, solid, secure foundation for beliefs considered essential to the mental, spiritual, and emotional welfare of mankind. Eastern, and even some types of western, mysticism may appear to surrender all sense of security and solidity, but mystics aim at total identification with God or complete absorption into a "unitive state," and to speak of God, Brahman, Nirvana, or Tao is to refer to a changeless, absolute condition which constitutes in itself a supreme state of stability, even if it implies constant change insofar as partial points of view and individual existential formations are concerned.

Astrology, in its traditional western sense, likewise has its "relatively stable" frame of reference: the zodiac. This zodiac may be conceived of in terms of constellations—*fixed patterns* of stars which appear fixed because in relation to us they are extremely slow-moving—or in terms of twelve divisions of the Earth's orbit,

an orbit whose shape changes but slightly through long periods of time—tropical zodiac. Either of these systems meets the need for a relatively stable frame of reference. What I have been suggesting in various writings is the possibility of another kind of frame of reference—a person-centered one better adapted to the needs and the character of a modern individual. I shall speak of it, at first, as the cross of horizon and meridian.

The reader familiar with astrological textbooks or even astrological magazine articles will probably think that there is nothing new in such a frame of reference. Every modern birth chart, he will say, contains a line which is called "horizon" and a vertical line, the "meridian." But names are ambiguous and can be misleading. As already stated, the astrological—and astronomical—horizon is a circle that passes through the center of the globe. It does *not* refer to either the "sensible" horizon—which can be very limited if one is at the bottom of a canyon—or what I call the "mean" horizon—which refers to the circle of space that would be visible for an eye on the surface of a calm ocean. As to the meridian in a birth chart, it is the two-dimensional projection of a "great circle" perpendicular to the astronomical—"rational"—horizon and passing through the points North and South. At exact local noon the true Sun is found crossing the meridian, but what is called Midheaven in an astrological chart is *not* the point overhead—Zenith— but rather the degree of the zodiac at which the true Sun is found at noon. The meridian is a circle of longitude passing from the South point, through the Zenith, to the North point of the horizon.

Perpendicular to this circle, but still in the vertical dimension, we find what is called the "prime vertical." This too is a great circle; it passes from the East point, through the Zenith to the West point of the horizon, and of course it also passes through the Nadir.

These three great circles—horizon, meridian, and prime vertical—are perpendicular to each other in three-dimensional space. Their intersections determine *six* fundamental points: at the horizontal level, East, West, North, South—and at the vertical, Zenith and Nadir. Of course we could think of any number of points on the horizon through which great circles would pass which would also cross the Zenith and Nadir, and North-East, North-West, South-East, and South-West points are often referred to. Nevertheless the concept of six directions of space—East, West, North, South, Above, and Below—is basic.

In a two-dimensional birth chart only four basic directions are shown. South and Zenith are somehow integrated, and likewise North and Nadir. The reason for this, beside the two-dimensionality of the chart, is that what the chart still considers essential is the— apparent—daily motion of the Sun. The zodiac moves daily together with the Sun because, in our classical western astrology, the zodiac is the "creation" of the Sun's motion—which means, in modern astronomical terms, the Earth's orbit. And of course the Moon and the planets go with the Sun as well.

As I said before, in archaic, locality-centered astrology, the only truly "fixed" frame of reference was the horizon of the locality where the tribe lived, or later where the city stood. When we reach the stage of development at which, in theory at least, the individual becomes the basic unit—self-reliant, free, creative—then astrology, having become person-centered, should logically use as its frame of reference the three-dimensional geometrical structure pro- duced by the six directions of the space *at the center of which* the individual stands. The three great circles mentioned above— horizon, meridian, prime vertical—therefore constitute the basic struc- ture of an individual's space. Wherever this person goes, he remains the center of this space. *Everything* that moves in the Sky—stars, Sun, planets, comets, etc.—has its place within this space structure. The position of any celestial body could be pinpointed and measured with references to it.

Some celestial body, like the Sun, may be far more important than another. It is certainly more important, for example, than a faint star moving in a trajectory having no geometrical relation to the zodiacal belt, that is, the plane of the ecliptic. But in a person-centered astrology there is no reason to give a quasi-absolute value to the Sun or to the zodiac. As symbol of the source of life energies, the Sun is essential in the same way that the heart of a person—linked with the solar factor—is essential to the continuance of life. If the heart ceases to beat for more than a very few minutes, the brain becomes damaged beyond repair and the organism loses its individualized consciousness as well as its biological existence.

But while the Sun and all that refers to the zodiac may be very important and basic, it need not be *the one essential frame of reference* in a person-centered astrology. It is the three-dimensional space structure which every individual person carries around him-

self wherever he goes—at least where he stands on a solid surface—that should be considered his *fixed* frame of reference.

To put it perhaps more simply: when a person travels from the Atlantic to the Pacific coasts what he sees *passing* at the horizon at every step he takes changes constantly. But *the fact* that he is the center of a horizon remains unaltered. The traveler always carries his horizon with him, and a Zenith always exists directly above his head. Stars come and go at this Zenith point; no celestial body is "fixed," but the Zenith is always in the same overhead direction. Whether this or that zodiacal sign rises at 9 P.M. and another at 2 A.M. does not alter the fact that the individual at both times fixes his gaze at the same eastern horizon—astrologically speaking, at the Ascendant.

If some people find it difficult to follow such a line of thought it is because they tend to confuse a structure with what happens at certain points within the structure. This is an almost universal tendency, because man reacts to an event rather than recognizing the place where the event occurs. By "place" I mean the role this event is meant to play in the total "structure" of the person's individual being and in the process of actualization of his birth potential, that is, his destiny.

In simple astrological terms, if a particular celestial phenomenon—say, a conjunction of Jupiter and Saturn—has occurred in the tenth house of a birth chart, this indicates that the conjunction of these two planets characterizes the *quality* of the person's social consciousness which will animate—and indeed which *should* inspire—his participation in the life and work of his community. I say "should" because I think of a birth chart as a "set of instructions" for the performance of the role which the individual has to play if he is to fulfill his destiny. Call it "karma" if you wish.

To sum up: In a person-centered astrology we are dealing with two essential factors: (1) the basic geometrical structure of the space of which the individual person is the center, and (2) *all* celestial bodies which *pass through* this structure in ever-varying interrelationships, or "aspects." Each of these bodies has different characteristics because each moves in different ways and with different speeds and also because each appears to us with different characteristics of size, color, and, in terms of modern astronomy, of place in ordered series—especially the series of the planets within the solar system.

It should be clear that the second factor includes not only the two Lights and the planets, but also all the stars around us, for, I repeat, the stars do move in our human experience—only they move while keeping a, practically speaking, permanent pattern of relationship, and this is what in the past has given them the character of being "fixed." As to the first factor, it refers to the houses as divisions of person-centered space. In our traditional western astrology, however, these person-centered sections of space are not only reduced to two dimensions, they are also considered to exist *in* the zodiac, and this is where the ambiguity and confusion lie, for there are at least two solar zodiacs, plus lunar zodiacs, and new kinds of "zodiacs" could be invented. On the other hand there is nothing ambiguous about East, West, North, South, Zenith, Nadir. These points and the space structure they define are *universal facts of human experience* and provide us with a universally valid structural foundation for the interpretation of our individual relationships to the universe.

At present, of course, a three-dimensional astrology using "birth spheres" rather than birth charts is not practical, even through I believe it will be the astrology of a more or less distant future. We have to deal with what is available *now*, that is, with two-dimensional charts. Nevertheless we can, and we should reorient our understanding of what these charts mean, and particularly our interpretation of the houses. We should consider these houses as strictly two-dimensional projections of the three-dimensional space of which the individual is precisely the center.

WHY TWELVE HOUSES?

As, in two-dimensional charts, the basic six directions of three-dimensional space must be reduced to four, that is, to the cross made by horizontal and vertical, four sections of space are established; and as a person-centered astrology deals essentially with problems rooted in personal experience and in changes in consciousness, each of these four sections should be subdivided into three subsections, for the reason that consciousness develops in a trinitarian dialectical mode. The concept of twelve houses should, therefore, be retained. In a broad sense, we can speak of the sequence of thesis, antithesis, and synthesis, but as these terms are rather ambiguous and susceptible of various interpretations, it

might be more accurate to speak of subject, object, and the relation between subject and object, or, metaphysically, of spirit, substance and form or of action, means for action, and the evaluation of the results of action.

All these trinities are experienced by the conscious individual in terms of the four basic realities of human existence which correspond to the four "angles" of the chart—Ascendant and Descendant, Zenith and Nadir. But, I must stress again that in the traditional way western astrologers interpret and define these angles, they do *not* correspond to the actual framework of the space of which an individual person is the center. The horizon of these modern astrological charts passes through the center of the Earth, while man lives at a point on its surface. The Mid-heaven is not the actual Zenith, but only a point in the zodiac. Thus if a star is located on the degree of the Mid-heaven it need not be the star just overhead at the true Zenith—and this applies as well, of course, to the *Imum Coeli*, or cusp of the fourth house, which is not the true Nadir.

This is so, I repeat, because our astrology is Earth-centered, but not person-centered. In practically all cases it considers only the relationship of the Earth as a globe to the Sun, and secondarily to the planets which move along the apparent path of the Sun. Stars and constellations have no astrologically significant place in classical European astrology, except as a vague remnant of an archaic tradition. Nevertheless, relatively inadequate as our astrological charts are today in terms of a truly person-centered approach, they have to be used; they can be used effectively if we keep in mind the basic realities which they symbolize. Any consistent and significantly structured set of symbols can be used if one is aware of what it represents and the level at which it is meant to operate.

Astrology is a symbolical language—in the same way that the I Ching, when related to its deepest metaphysical concepts, and the Tarot cards, with their Kabbalistic background, constitute such a language. All these sets "work" if used properly. They work in terms of the relationship between the interpreter and the inquirer, for it is only the character of this relationship, and the levels at which the minds of both persons operate, that adequately define the manner in which the whole set of symbols is to be interpreted.

Religion and science should be understood humanistically in the same way. Does Christianity as a set of great images and

potentially ego-transforming symbols "work"? Certainly, but it works destructively as well as constructively. Science has its destructive side as well—witness the pollution and destruction of natural elements, and the depersonalization and monstrous proliferation of human beings in blighted cities. Of course one can explain away the negative results, and place the blame on human nature. The value of any symbol is derived from the way it is used, which often means from the way it *inevitably will be used* by human beings, considering the particular stage of their present evolution. But even an obviously destructive use can eventually have constructive results. In the hands of a holy man the most specious and normally unwarranted means can produce spiritual changes, while in the hands of the criminal or the fool, they may lead to destruction or elemental bondage.

This is true of the methods used today in astrology. Nevertheless, we are at a turning point in the history of civilization. Friedrich Nietzsche, the tragic nineteenth-century poet and philosopher, proclaimed the need for a "revaluation of all values." Such a need is today far more universally imperative than it was a hundred years ago. It is imperative in *all* fields of human thinking, in all the codified and traditional feeling-responses which come under the name of morality—especially social morality—and in all interpersonal as well as intergroup behavior. I have spoken elsewhere of the need for a change at all levels from an "atomistic" to a "holistic" approach to reality.* The change which I am now outlining in terms of the concept of astrological houses is part of this great "revaluation of all values."

Such a change may seem relatively insignificant, as in most cases it does not change too radically the meaning attributed to each house of a birth chart. Yet it can and should be considered symbolic of what is taking place in all fields of human endeavor, because it refers to the relationship between the individual person and the universe as a whole; that is to say, it implies a fundamental revaluation of the meaning of this relationship. In this sense, it constitutes a most deeply "religious" transformation. It parallels the difference between the attitude of devotees of any organized religion—with its hierarchy of priestly intermediaries between crea-

* Cf. the series of booklets on Humanistic Astrology (1969–70–71) soon to be reprinted in book form.

ture and Creator—and the attitude of the practical mystic relating himself without intermediaries to the wholeness of existence.

In simpler astrological terms, the factor of "position in the zodiac" as understood today is an intermediary factor between the planet and the individual. Jupiter, as symbol of a basic function in the human personality—expansion and assimilation, social fellowship and prestige or wealth, etc.—*always remains Jupiter in any zodiacal sign.* What it is essential to know is the field of experience in which that function operates most significantly in terms of the fulfillment of the individuality and the destiny of a particular person. It is essential if we consider the birth chart—or any other chart at different levels—as a celestial "set of instructions." If, for instance, I have Jupiter in my natal seventh house I should seek expansion, and any other Jupiterian result, in terms of my relationship with associates and partners, at whatever level it may be. The seventh house refers to relationships and partnerships of all types, and partners include not only one's "mate" but also one's enemies, for both *constitute or lead to* an often necessary polarization of values.

The modern astrologer may agree with this up to a point; yet the first thing he usually seeks to know is the so-called "strength" of the planet in terms of its zodiacal position. He still believes, consciously or semiconsciously, that a planet focuses the energies that flow from a zodiacal sign or constellation and that these "energies" are what really make astrology work. That there are solar, planetary, and cosmic energies through space and that *the Earth as a whole* is affected by them is evident. But this really has nothing to do with astrology as it is practiced today with reference to the life and personality of an individual. Someday, no doubt, a science will emerge based on the study of these energies—it may possibly be named "cosmecology"—but it will not deal with the individual person. It will no more be astrology than Medieval or Asiatic alchemy is modern chemistry.

I believe that Cyril Fagan did a valuable job in defining astrological concepts in terms of an archaic, locality-centered astrology. But we are living neither in archaic times, nor in the European Renaissance. We are living in a psychological century in a time of total revolution and, hopefully, at the threshold of a new age in which individuals will be able to encounter openly the universe and all experience *without intermediaries* forcing social,

religious, or ethical categories upon them. Utopia? Perhaps, but all
new steps man takes are based on a vision which seems utopian
to the old and the settled. All new ages begin in confusion and
uncertainty. A few individuals may be the pure mountain source
of the new stream. Their minds and feelings may shine with clear,
limpid, unadulterated liquidity; but they are but the very few.
The ideals they live by or only envision in great moments of
illumination act upon the masses as a powerful ferment, and where
they act there is chaos. Today almost everything is indeed in a
chaotic state—and astrology is no exception.

SYSTEMS OF HOUSE DIVISION

The method used in modern astrology to determine the cusps
of the twelve houses is particularly chaotic. Literally speaking, the
term *cusp* refers to the *beginning* of an area of space or a period
of time. Yet some contemporary astrologers think that the term
should apply to the middle of a house. Cyril Fagan also came to such
a conclusion, but he was clear-minded enough to suggest in the sys-
tem he advocated the term should be replaced by "median."
What often causes an astrologer to think of the cusp as the middle
section of a house is the belief that the characteristics of a house
are found most explicitly and effectively after a planet has reached the
middle of this house.

Two concepts are involved here. The first, a very basic one,
refers to the very nature of astrology. Marc Edmund Jones long
ago defined astrology as "the science of all beginnings." In a
metaphysical sense, this means that an astrological chart can be
considered the archetypal or "seed" formula establishing the *set of
potentialities* released in the first act of manifestation—in the creative
Fiat, the Word-in-the-beginning—which is the origin of any exis-
tential cycle. What astrology studies is therefore the point of origin
and, revealed in it, the archetypal form of a particular beginning
of life or, in general, of any significant and originating event out
of which flows a particular series of developments. If this is the case,
then every astrological factor should likewise be related to the be-
ginning of some series of events or of a particular phase of develop-
ment. This applies to the first degree of a zodiacal sign, and of a
house, as well as to the conjunction of two planets marking the be-
ginning of their cyclic relationship. It is in the first moment of *any*

cycle that the archetypal character of this cycle is revealed to the astrologer.

The other concept, related to the first, is that if the most characteristic moment in a house is its middle point, this implies that the house is conceived in terms of time, rather than of space. The astrologer may feel that it takes some time for someone who starts a process to fully realize and be identified with the characteristics of that process. But again this would be true only in terms of *existential results* and not of archetypal *formative causes*. As I see it, astrology deals essentially with formative causes; or better still, with sets of potentialities being released, then only and secondarily with external occurrences. This is true at any rate of what I call person-centered and humanistic astrology. In this case the houses can be said to represent areas of person-centered space through which celestial bodies move. These celestial motions, of course, constitute a time factor; but what is archetypal and formative is the *spatial field* through which the motion takes place. In the same way, while the planets are in constant motion through days and years, what natal charts most importantly reveal is not the motion of each planet, but *the pattern* all these planets make at the beginning of an individual's life, that is, the moment of the first breath. The motions are "existential"; the overall planetary pattern is "archetypal." It establishes the structural form of individuality and destiny.

The most important cusps of the houses are the four angles— Ascendant, Descendant, Zenith, Nadir. These angles begin the four sectors of the modern two-dimensional chart. The essential formative factors operate at these four points. The horizon clearly defines the separation between above and below, the visible and the invisible; it cannot be the middle of something. It is only when the astrologer thinks of it first of all as the rising motion of the Sun, that he can broaden the concept of horizon to include the period of dawn. The spatial concept of horizon is that of a clean-cut line of demarcation; the Sun is crossing it, just as a runner in a race crosses the start and finish lines.

The ambiguity related to the mixture of concepts of time and space can be seen through the entire field of astrology. It is particularly evident when one approaches the problem of how to determine the longitude of the house cusps. Numerous systems have been devised and used, but the most frequently used systems all give the same degrees of the zodiac to the horizon and meridian.

Where they differ is in their calculations of the intermediary cusps
—that is, second, third, fifth, sixth house cusps and their polar op-
posites. The most widely used system today is the Placidus, which
finds the cusps of the intermediary houses by dividing into three
equal segments the semi-arcs of the Sun and all zodiacally ex-
pressed factors—that is, the *time* it takes for the Sun to go from
the sunrise point to the noon point. The Campanus and Regio-
montanus systems divide in two different ways the *space* between
the horizon and the meridian. The Porphiry system divides the
number of degrees separating the horizon from the meridian into
three.

There are other systems, particularly the so-called "equal
houses," which takes only the horizon into consideration and
divides the two hemispheres created by this horizon into six houses,
each of which contains the same number of zodiacal degrees. This
system is, in my opinion, totally indefensible because it does not
take into consideration the fact that both the vertical and the
horizontal axes are absolutely necessary to the interpretation of
human existence. Using only the horizon as a frame of reference
today is the equivalent of considering lying down the only significant
position for man.

The difficulty encountered by practically all these systems is
that on and above the arctic—and antarctic—circles natal charts take
on a very peculiar form, and in many cases cannot even be made,
because for several months the Sun does not rise or set. As the
zodiac in traditional western astrology is the path of the Sun, how
could one place degrees of the zodiac at the cusps of the houses
above the horizon when the Sun and the planets do not rise? If the
houses are equal sections of *space*—not of the zodiac—around the in-
dividual, there are always East, West, Zenith, and Nadir, and the
horizon always separates above from below; but at some times there
are only stars and no planets in the hemisphere above or below the
horizon.

The archaic locality-centered astrologer who lived in semitropical
or even temperate regions did not have to face such problems. For
him the Sun rose everyday and his astrology was based on that
primordial, taken-for-granted *fact of experience*. Today, however, the
situation is different. We have to build our astrology on a new basis,
and we must take into consideration that each hemisphere of the
Earth and the polar regions must have its own kind of astrology. At

the very least we must reinterpret some of the basic astrological factors in relation to the astronomical situations in each of these regions.

Person-centered astrology, however, is based on primary concepts which are valid everywhere; for at any place on the globe man is conscious of the horizon and of the Zenith. Every baby is born at the center of his space structure which he will carry with him wherever he goes. The only problem, astrologically speaking, is to ascertain all that he can observe and experience, as stars and planets pass through the twelve sections of this space structure.

The Houses as Fields of Experience

ASTROLOGY IS THE STUDY OF THE CYCLIC MOTIONS OF celestial bodies, but such a study would be no more than a branch of astronomy if it did not also imply a frame of reference *in relation to which these cyclic motions can be given meaning.* This frame of reference is not the same today as it was when man lived a purely tribal, agricultural life within narrow geographical boundaries. Today in natal astrology, or what I call person-centered astrology, the most important frame of reference is the individual person. Such an astrology is concerned with the special orientation of an individual human being who is conscious of his own individuality—or at least seeking to be conscious of this individuality and of all that it implies in terms of relationship to the total environment. This environment, astrologically speaking, is the entire galaxy and especially the solar system. What astrology claims is that the orientation of an individual to this solar and galactic environment—that is, to the "planets," Sun and Moon included, and to the stars—can define his orientation to his *biospheric and social* environment.

A man lives both within the Earth's biosphere and within a society—that is, a group of people, a community, and a nation which

have definite racial, cultural, and political-economic characteristics. He is primarily a biological organism, but he is also a person whose consciousness, mind, emotions, and behavior have been conditioned, and often rigidly determined, by the collective values that prevail within his family and his society.

Living, in individualized human terms, means *experiencing*. It is to be aware, to reflect upon what one is aware of, and to relate experience to past experiences—whether these be personal experiences, or experiences which society has reflected upon, recorded, and generalized into a tradition—social, scientific, religious, ethical, cultural, etc. Strictly speaking, one can speak of "experiences" only in terms of changes in the relationship between an individual and his environment—outer events—or changes in the ever-shifting relationship between the different organic and psychic components of the total person—body, mind, feelings, "soul." Where there is no awareness, there is no experience. An experience requires an experiencer.

The experiencer is changed by the experience, even if, having been aware of what occurred, he refuses to accept it within the *field of consciousness* over which, in most cases, his ego has dominion. This refusal changes the experiencer in a negative manner; and if the process of refusal is repeated, it gives form to a complex, and perhaps eventually neurotic or psychotic disturbance. In any case, if there is awareness of outer or inner changes there is an experience; but this experience is most often conditioned partly by external biological factors, partly by the intellectual and emotional pressures of family, culture, and society. When this occurs, the experience is not "pure" in terms of the essential individuality of the person. What our present-day "sensitivity training"—as well as many ancient techniques of meditation and interpersonal relation—seeks to produce is a purification of individual experiences. Man should learn to see, feel, hear, touch as if all his sensations were reaching consciousness for the first time, and as if all his responses were spontaneous, fresh, and "innocent" because purely *natural*.

This quality of naturalness could refer to the *biological* nature of man's instincts and emotional drives, or, equally, to the *individual* nature of the person. What is "natural" for a particular person may not be at all natural for another. In between these two levels of nature, social and moral patterns, traditional ways of seeing, touching, meeting, responding, are in most cases operating,

confusing all existential situations and deflecting, disorienting or even perverting the experiences. All these distorting pressures may be related philosophically to "karma." But how do we handle this karma? How do we clarify, purge, and reorient, first, a person's perceptions and then his responses?

There are many ways to approach this difficult feat, and many spiritual, occult, and mystical disciplines have been devised to such an end. Astrology, as I think of it, presents us with another method. This method has very little to do with the current popular use of astrology, or a similar use in ancient Alexandria and Rome, but it was not unfamiliar to alchemists, Rosicrucians, and other groups. What is involved in such a use of astrology is the realization that the universe around any individual person presents him, in symbolic terms, with the image of what he *needs* to orient himself adequately in terms of *his own individual truth*—in Hindu philosophy, *dharma*—to every basic kind of experience he could have in a lifetime. I spoke of the birth chart as a "set of instructions" given by "God"—or the universal Principle of Harmony—to whatever is born at the moment and place for which the chart is cast.

According to this conception, every astrological house symbolizes a basic type of human experience. The zodiacal sign at the cusp of the house and whatever planet may be found in this house—and in the future the individual stars which actually fill its space—indicate the manner in which each of these twelve basic types of experience *should* be met, and indeed *would* be met if there were no interference, no karmic pressure to disorient, confuse, and alter the experiencing process. The birth chart as a whole represents the "dharma" of the individual, what he is meant to be—provided, of course, that the chart is interpreted in a holistic, nondualistic, and not ethical—that is, good-bad, fortunate-unfortunate—manner. Each house of the chart symbolizes a specialized aspect of this dharma, one of the letters of the original twelve-letter Word, *logos*, that is the "truth" of the individual, that is, his spiritual—and therefore, in an individualized sense his natural—identity as a person.

Such a dharma refers to some integral set of activities *needed by* the environment in which the individual is born. A man is born as an answer to this need. The universe—and, more specifically, the planet Earth and mankind-as-a-whole—is, in the broad sense of the word, an organism; and just as a white blood cell is produced and dispatched to an injured part of the human body to fight possible

infection—that is, to meet the need of that part of the organism—so a man is born at a certain time and place to meet *a particular need* of mankind. This is this man's dharma, his "truth of being," his essential identity. And his birth chart is the potent symbol, or *mandala*, of this identity. It is his celestial Name, the "Signature" of his destiny.

As nature is prolific and cautious, several human beings may be born in a large popular aggregation with exactly the same birth chart. They are formed to meet the same need. As this need of their society may be complex and may operate at several different levels, their lives may be—in terms of outer events and results—very different. They may differ, first, because their genetic and environmental-social backgrounds are different and, second, because some may succeed in fulfilling their "instructions" while others may achieve but very partial success, or even fail utterly. This success or failure has nothing essentially to do with the chart. What the chart represents is *a set of potentialities*. Every release of potentialities, anywhere and at any time, contains the bipolar possibility of success and failure, of fulfillment and frustration succeeded by disintegration. Such is the most fundamental law of existence—simply because existence implies duality and all energies are bipolar.*

What this means in terms of a thorough grasp of the meaning of houses is—I repeat—that every house represents a basic type of human experience. A human being as he goes on living meets these twelve types. What he does with them will make his life, relatively at least, a success or a failure—and in most cases, a mixture of both. He is, in the deepest sense, free to move along the positive or the negative path. The positions of the planets—always now including the Sun and the Moon—do not *determine* his choice. They simply indicate the *type of energy* he can best use in order successfully to meet the type of experience symbolized by each house.

Neither Mars nor Saturn indicates anything that is "bad" or "unfortunate" in terms of an individual's dharma. If Saturn is located in the house that refers to a man's attitude toward what he owns and to the use of his possessions, it simply means that this individual should manage what he has carefully, conservatively, and with a keen sense of responsibility. Whether the man could be called rich or poor according to the social standards of his society has really, or let us

* For the development of such a metaphysical concept, cf. *The Planetarization of Consciousness*, Chapters 5 and 6.

say, spiritually, nothing to do with this Saturn position, because what
a person-centered astrology should deal with is not external events
or any *quantitative* fact, but only, or at least essentially, with *qualities*
of being, feeling, thinking, and behavior. The essential fact not
only psychologically speaking, but in terms of the most fundamental
evaluation of any aspect of human experience, is not *what* a person
does, feels, or thinks, but the quality of his actions, feelings, and
thoughts; and this quality is, of course, related to the individual's
motivation, but not necessarily his *conscious* motivation.

TWELVE CATEGORIES OF EXPERIENCE

It may be asked, of course, why out of the immense variety of
human experiences we select only twelve basic categories. There are
no doubt metaphysical and "numerological" reasons for this number
twelve, and I have already mentioned some of them. The basic
number is four, and it refers to the cross of horizon and meridian
in our western-style two-dimensional astrological charts. The division
of the circle into four sectors and all the patterns that can be based
on the fourfold principle—itself an expression of the dualism inher-
ent in all experience—are typical of all mandalas.

Carl Jung has paid great attention to mandalas, because of their
worldwide use in all ancient cultures, and because they symbolize
what he calls "the process of individuation," or of whole-making.
The basic task of man is *consciously* to become a whole being at
all levels of his existence; and he can become whole only by referring
all his experiences to a common center, which is also projected
as the circumference of his total person. In other words, he must
consciously realize the place which each experience occupies within
the total person.

In this process of becoming whole, two factors stand out: con-
sciousness and power. All human experiences and values can be
evaluated in terms of consciousness and power. Without conscious-
ness, power is subhuman in its manifestations; without power con-
sciousness is an abstraction, an insubstantial essence or breath, with
no existential referent. In astrology, consciousness is seen as operat-
ing in terms of the horizontal axis of existence; power and the
capacity for integral existence is referred to the vertical axis.

In any existential whole consciousness operates inevitably in a
dualistic mode: consciousness of self, consciousness of being related

to others. Selfhood and relatedness are the two fundamental terms in all existential realities, but there are several levels of selfhood, and relationships also operate at various levels, exteriorizing different qualities of being.

Power also operates in a dualistic mode: the power to stand as a self, to fully manifest the inherent potentialities of one's individual being, to become whole in concreteness of existence; and the power to answer the need of one's environment, group, or society, that is, to fulfill one's dharma, one's place and function within the sphere determined by one's individual capacities.

Selfhood refers to the East point of the birth chart, the dawning point of Light—and Light is a cosmic expression as well as the substratum of consciousness in its existential aspect. Relatedness belongs to the West point of the horizon—the symbolic coming-together of human beings for the purpose of reflecting upon shared experience.

Power in terms of *personal* integration is represented by the Nadir of the chart, which in modern astrological charts is approximated by the cusp of the fourth house—*Imum Coeli*. Power in terms of *social and communal* integration is represented by the Zenith, which in modern astrology is approximated by the Noon-point or Mid-heaven.

According to Carl Jung, man has four basic functions: intuition, sensation, feeling, and thinking. *Intuition* is related to the astrological Ascendant—the symbolical sunrise—because intuition is consciousness, aware of itself operating. In the opposite direction, *sensation* establishes a person's relationship to other entities surrounding him; we therefore refer it to the Descendant or cusp of the seventh house. *Feeling* is obviously symbolized by the Nadir point, because feeling is the most immediate manifestation of the response of an integrated organism to whatever he experiences as a change of state. At first, it is a change of internal biopsychic condition; later on it refers to variations in the attitude, or mood, one presents to experiences which alter one's basic sense of selfhood, of security, and of power as a person. *Thinking* is a process based on words and syntax, which in turn are symbolical expressions of a particular culture and social form of human togetherness. It is thus represented by the Zenith—or in modern charts Mid-heaven—because at this point man becomes conscious of experiencing within a communal setup.

The chart as a whole is divided by the horizon into two halves —or hemispheres in two-dimensional projection. The below-the-hori-

zon half can be said to be characterized by the key words TO BE; the above-the-horizon half, by TO FUNCTION.

To be a conscious self implies discovering oneself as the "subject" of existence and, gradually, to realize one's powers, to express them and eventually to increase, reform, or transform them. In the below-the-horizon realm a person essentially thinks, acts, and feels subjectively; he exists in a world centered around himself, and his approach to experiences is oriented toward self-realization and self-expression—and also of course toward dealing with the results of these *subjectively valued* activities.

In the above-the-horizon realm relationship is the keynote; thus partnership and the results of cooperation and/or sharing are stressed. The keynote is participation—participation in a process in which at least two and eventually many more people are involved. "Functioning" exists when there is an awareness of being part of a whole —of having a particular place in an organized and structured process, whether it be organic in the biological sense, or social-political-cultural.

In every hemisphere two basic points are to be considered: the horizon-created and the meridian-created "angles." The Ascendant refers to the original creative impulse which exteriorizes an archetypal form, a creative Word. This impulse has to be "incarnated" in a concrete substantial organism. A *stable and integral* condition of being has to be reached through which the individual being can use "power"—that is, biological and psychic energies—not only consciously but effectively. And this refers to the Nadir and the fourth house.

Thus we might say that what was a release of potentiality at the Ascendant becomes actualized *in a subjective and strictly person-centered sense* in the fourth house. This process of concretization occurs in three stages. Each of the first three houses represents a type of experience which, if successfully met, will bring the process to a point of culmination. These three phases repeat themselves in terms of each angle, and thus manifest the astrological sequence of *angular, succeedent, and cadent* houses. The first, fourth, seventh, and tenth houses are angular, because they represent the creation or exteriorization of the meaning of each of the four angles. The second, fifth, eighth, and eleventh houses are succeedent, and the others, cadent.

One can define the basic character of these three categories of houses by using the following key words:

Angular houses: *to be*
Succeedent houses: *to use*
Cadent houses: *to understand* or *transform*

Thus the first house refers to the subjective discovery of being, or individual selfhood. The second house refers to the use of what the individual being finds available in order to exteriorize itself, in the broadest sense, one's possessions at birth, including all innate capacities of body and psyche. The third house is the field of experience that brings to us an understanding of the relationship between being and using, between the subjective sense of self and the objective reality of the means for action, that is, the possessions of the self.

When we start from the Nadir, we start with "to be"—a stable, more or less well-integrated personality, operating from some kind of "home" or root foundation of organic existence. This refers to the type of experience represented by the fourth house—angular. The fifth house—succeedent—symbolizes those experiences which allow a person to use the biopsychic energies generated by any stabilized organized whole. The sixth house—cadent—is the field of experience which enables him to understand the results to this self-exteriorizing use of energy, to cope with negative results, to improve his technique of action and transform his motives.

We shall see in a moment how the key words for the three categories of houses work out in the above-the-horizon realm dealing with functioning in terms of human relationships and with participation in the activities of a greater whole—a group, a society, a nation. But as we survey the first six houses—below-the-horizon realm—we can see a broader pattern emerging, which will also repeat itself in the sequence of houses above the horizon. Six basic operations can be defined which, below the horizon, refer to the subjective consciousness of self. Above the horizon, these same basic operations refer to the development of the kind of consciousness which results from relationship, cooperation, and finding one's place in society. These six operations can be defined as: *being, having, informing, maintaining, expressing,* and *transforming.*

The experience of "being" in the first house leads to and becomes substantiated by that of "having"—having a body, having possessions, having talent, or, negatively, lacking these in any satisfying sense. In the third house, a process of giving form through selection, classification, organization goes on. This means adjusting

to one's environment, relating sensation to sensation, developing cunning and intellect, and formulating and communicating one's responses to one's environment.

The fourth house refers to everything that maintains the individual characteristics of the self in a stable form; the fifth house to any experience through which the personal self seeks to exteriorize its power; the sixth, to experiences which impel one to transform, reform, or broaden the consciousness of self—or in most cases, only of "ego"—thus to personal crises at all levels and dealing with possible solutions to personal problems.

The same kind of sequence can be seen operating in the above-the-horizon realm of experience, of which the Descendant—seventh house cusp—is the archetypal point of origin. The seventh house refers to the "being" of relationships, that is, to the quality of our approach to relationships—how we meet the world, and particularly "the Other," whether it be partner or companion—and above all, how we *should* learn to meet and work with others regardless of how our society, religion, and culture have been trying to condition us by collectively held images, ideals, and taboos. The eighth house refers to the use to which we put the energies born of togetherness —that is, of possessions held in common—which obviously must take into consideration the collective rules of business, investment, transfer of possessions, etc. Such a use, under certain circumstances, can imply a regeneration of self-centered activities, a transformation of "self-image"—especially whenever a conflict occurs between this self-image and the "image of relationship"—what Carl Jung describes as the *anima* in a man's life, and the *animus* for a woman.

The ninth house is very specifically the field of experiences which induces in us a deeper understanding and a greater expansion of consciousness. These experiences give form to our appreciation and evaluation of social and cosmic processes. They deal with our attempts to generalize and communicate, no longer personal and environmental issues and concerns, but what affects all men and the universe as a whole. And as the Mid-heaven is reached, we are shown the most fruitful way to "achieve," to bring matters of communal importance to a head, to fulfill our individual selves through participation in the work of the world.

The eleventh house suggests the best way to put to use, and enjoy, what we have achieved, to express ourselves as members of a community rather than as individuals—and also to imagine better

modes of togetherness, new forms of business or social organization. Then the twelfth house ends the cyclic process of experience essentially in one of two ways: it can mean a fulfillment in understanding and wisdom of the inner life, which reaches toward the emptying of life contents, that is, "death" in the symbolic sense, which in turn leads to the beginning of a new and higher phase—or on the other hand, it may lead to a disruption of all relationships and a tragic sense of failure which prolongs itself beyond the cycle's end into ghostly unresolved memories.

And then the cycle begins again.

HOW TO USE THE HOUSES

Every new experience is a challenge to the individual's ability to be himself, to stabilize his personality, to assimilate what will make him grow and mature so he can best participate in his community and more generally still, in the evolution of mankind. He is challenged and tested by the experience. He has to discover his individual truth of being and to develop all his innate capacities *through* the experience, accepting it fully and being ready to assume the responsibility for its fruits, while at the same time being as much as possible "free from attachment to these fruits"—as Krishna enjoins his disciples to be in the Bhagavad-Gita.

The first great experience is, of course, birth, but every experience can be approached and met as a new birth. Really to live is an act of unceasing rebirth. The problem for every person who seeks really to live as an individual, and not merely as a replica of some social, moral, or religious prototype, is *how best to approach* these ever-renewed rebirths—how to meet every type of experience in what the existentialist philosopher calls an "authentic" manner or, in Hindu terms, how to fulfill his dharma. As a man fulfills his dharma he neutralizes an ancient karma and he answers the human need that called him into being.

To the humanistic astrologer who accepts the fundamental attitude I have outlined here and in all my writings, astrology is a means to this end of individual fulfillment. The birth chart, and other kinds of astrological charts that refer to the beginnings of cycles of existence, small or large, are to be used in terms of this end. They are "instructions" that formulate in a celestial code the

best means to reach the fulfillment of one's dharma through authentic responses to every basic individual experience.

Every person will try to decipher this code according to whatever knowledge or capacity for intuitive illumination he has acquired. He should do the deciphering by himself and for himself. But since we usually live in confused or oppressive social conditions, and our psyches are filled with conflicts and doubts, we often need or want to consult an interpreter adept at deciphering the celestial symbols. Still, it is our own life, our own past, and our own dharma —and we should strive to do the interpreting for ourselves, for every interpretation is itself, potentially at least, a rebirth in understanding which may open up a new phase in the total cycle of unfolding our consciousness.

An individual's birth chart tells him how he can best fulfill his destiny. Of course, the study of and meditating on one's birth chart is not the only way to achieve this understanding. There are many other possible approaches, but astrology has great universal validity when approached in the right spirit. Everything in a chart refers to the best way of meeting life's experiences in an authentic manner. And the houses constitute the basic frame of reference in terms of which we should interpret the celestial instructions.

As I stated above, there are many systems of house determination, especially where the cusps of the intermediate houses, that is, those between horizon and meridian, are concerned. This obviously generates a great deal of ambiguity and confusion, and there is no way at present to solve the problem in a completely satisfactory manner. Perhaps this is what should be in terms of our highly individualistic society, for it suggests to us that there are today *alternatives* for everything, that no truth is "absolute," and that we have to learn what we can and then forget it, allowing the intuition—or the God within or the Inner Guide—to show us the most significant alternative for us as individuals, here and now.

Some astrologers seek to escape the ambiguity by ignoring the houses completely and relying solely on the planets. But a similar ambiguity exists, as we have seen, concerning which of two or more zodiacs is the best, and if one relies only on the angular relationship between the planets and devises various systems in order to refine *ad infinitum* the analysis of such an over-all pattern of planetary relationships, it is possible to evade the most basic issue: *Who* am I?, which is not the same as: *What* am I?

The *what* refers to the pattern of the entire solar system as seen from the birth locality, because this *what* deals with the particular organization of the basic life functions and psychic drives within the person, that is, the way in which life energies operate in a particular person. On the other hand, the *who* refers to the cross of the horizontal and vertical lines in our modern charts, since it is this cross that defines the particular orientation of the individual to the universe around him. If we thought of stars instead of degrees of the zodiac, this *who* would be symbolized by a star rising exactly at the East point, and one culminating at the Zenith exactly at the moment the air hits the lungs of the newborn. The stars at the West point and at the Nadir would reveal the complementary polar aspect of this essential *who*.

Today astrology is still basically zodiac-centered, and the Sun factor still dominates its popular aspect. We have to deal with what is available, just as a pianist has to deal with the equal-temperament twelvefold western scale system if he is to play, compose or improvise on a piano. A new sense of tone is slowly developing within music, however, and is giving birth to new instruments and a new approach to combinations of sounds. The same thing is happening in astrology. There are astrological "classicists" who worship seventeenth-century models, just as there are musicians who swear by baroque music. Some astrologers, as well as some musicians, however, are looking toward the future rather than the past—toward the individual person rather than the tradition-bound "silent majority." One must always decide *where one belongs.*

In other words, if we want to use the astrological material available today—because we really have to!—we have to determine the character of the houses by the zodiacal sign and degree at their cusps. We can also consider the "planetary ruler" of the zodiacal sign at the cusp and, of course, whatever planet may be located in the house.

The sign at the cusp refers to the kinds of experiences that can best enable the individual to actualize his birth potential within the realm structurally defined by the house being considered. If we see that Sagittarius is at the cusp of the first house, that is, the Ascendant, we can deduce that the individual's search for "being" will be most successful in terms of experiences involving Sagittarian characteristics —expansiveness, broad understanding, social consciousness, the study of general principles, teaching, perhaps traveling, perhaps religious

pursuits, etc. If Sagittarius were at the cusp of the second house, the Sagittarian characteristics would apply to "having"—that is, to possessions and their use.

In the case of a Sagittarian cusp, Jupiter is the "ruler" of a house. The ruling planet of the house refers to *the type of energies most needed* to meet successfully the type of experience related to the house.

When a planet is located in a house, this indicates that the function represented by the planet finds *its best area* of manifestation in the field of experiences referring to this house. Conversely, if this type of experience is to be met successfully, the kind of functional activity represented by the planets will be *most effective*.

Again let me stress that, according to this new person-centered approach, there are no "bad" or "good" planets. Every planet represents valuable and necessary types of life-energy and functional activity. Mars and Saturn are just as good and fortunate as Venus and Jupiter. And the same applies to interplanetary aspects, which are no longer to be thought of as "fortunate" and "unfortunate," but rather—to use a now current terminology—"soft" and "hard," or, as I would say, *form-building* and *energy-releasing*.

This, then, is how a humanistic astrologer approaches the interpretation of the houses. In the next part of this volume, I will discuss the meaning of each of the twelve houses more specifically. In concluding this section, I should perhaps emphasize even more strongly a point stated above.

Astrology is a language. It uses symbols, and these symbols have to be decoded and interpreted. No system of interpretation is absolutely "true"—no more than any theory of science, or any system of social morality is absolutely "true." Everything depends for its *validity* on the time, the place, and the person, or the integrated and stable group personality. In fulfilling his destiny to the best of his possibilities a person has to use what his environment and his culture, including the language he speaks, offer him at the time. He may change his environment, but essentially he cannot change the time and place of his birth—that is, his archetypal structure of being. This structure is his own "truth," everything should be referred to it, not self-centeredly, but in terms of conscious and effectual participation in some greater whole.

We can effectively participate in a whole only if we are willing

to accept at least *some* of its means of expression and forms of thinking and knowing. Thus, if we are to operate in the western world today in terms of astrology, there are things we must accept. They are there to be used. We must use them as they seem to us, at any time, *to best meet the special requirements of our life philosophy and the needs of people with whom we want to communicate.*

Thus, if we believe in the validity of a house system and a particular zodiac, it is these we should use—and use them as consistently as possible. We are familiar with them. We identify our mind processes and feeling responses with them. And, if we do this honestly and logically in terms of whatever situation we meet, or of whatever people demand of us, we will be successful. It will "work."

Science and technology "work" because mankind, under the ruthless and aggressive leadership of western races, has needed the kind of results they provide in terms of expansion, comfort, environmental mastery, ego pride, etc. These results are dear to us, and we have achieved great things with them. We are now coming to realize, however, that such results may have very negative aspects, and may actually destroy us all. Many of us, young people especially, have recognized these negative aspects and are reacting strongly against this civilization into which we have been born. Yet, even as we try to envision a new world, we still have to use the means available to us in working toward its conception and birth.

This is always the case. No man is born alone and without a past. All he can do is to repolarize this past, first within his own nature, then in his environment. No man can *transform* a culture without being *informed* of its contents; he cannot affect something within which he does not, in some manner, participate.

part two

The First House

IN TERMS OF A PERSON-CENTERED APPROACH TO ASTROL-
ogy, the act of breathing defines the first moment of individualized
existence. At the moment of the first breath a valve in the heart
closes, blood rushes into the lungs, and the two essential living
rhythms of the human organism, the rhythm of the blood and that
of the breathing, are established in a particular way. A third rhythm,
of which we know hardly anything, may also be initiated, which refers
to pulsations of the cerebrospinal fluid, itself related to electromag-
netic—"etheric"—currents.

The identification of "life" with the breath is as old as human
thinking. The Sanskrit terms *prana* and *atman* refer, at two dif-
ferent levels, to the breath. So do the Greek word *pneuma*, which
signifies both breath and spirit, and the Latin word *anima*, meaning
soul. In a still broader sense, existence itself implies motion, dy-
namism, rhythmic change.

In the biblical book of Genesis all existence is said to begin
with God's command "Let there be Light." But this Light is not the
Sun's light, as can be seen from succeeding biblical statements. It is
motion, vibration, and therefore rhythm. The unborn foetus ex-
periences rhythms, but this experience takes place within a *closed*
environment dominated by the rhythms of the mother. It is only
as the human organism emerges into the *open environment* of the

universe that he can begin to operate actively and positively as an "individual person." To be born as a potential individual person is to breathe. It is for this reason that the yogi who aspires to merge his individuality with the universal Whole practices *pranayama*— literally, death of the breath. He willfully disindividualizes and depersonalizes his total being, or at least his consciousness.

Breathing is therefore the first act of independent existence within the open environment of the universe. It is the first assertion of *being*. The first house of a birth chart begins with the Ascendant, the symbol of sunrise, of the beginning of activity on our planet, and in general of all beginnings. Every experience can be a new beginning. Every individual can be reborn at any moment. He can relate himself to *his* universe in a new way, a unique way—his own way. This way constitutes, or at least manifests existentially, his identity—which also means the manner in which he is oriented to the universe.

What I mean here by *universe* is simply existence as this individual person is able to see, feel, know, experience it. We can speak of this universe on three main levels. Man is born within the Earth's biosphere—first level. He is also born within the solar system —second level. He can relate himself consciously to and participate in the activity of the galaxy, of which the solar system is only a small part—third level. Beyond the galaxy one can picture either a finite Einsteinian universe or infinite Space, and there is probably some truth to both concepts. For any realistic and experiential purpose, however, one should stop with the galaxy—and indeed it is always valid to know where and when to stop in one's intellectual speculations, lest one loses one's consciousness in an ocean of pure nondifferentiation and existentially empty abstractions.

These three levels—the Earth's biosphere, the solar system and the galaxy—are very real, at least potentially. They are capable of being experienced by us and, therefore, they can be used as symbols of a three-level process of development of the individual self. This development takes place theoretically in three phases, when it takes place at all, in terms of human experience and of the growth of the type of consciousness which can be formulated and translated into action. This three-level process can also be referred, at least in an archetypal sense, to the three basic periods of a human life individually and consciously fulfilled: from birth to age 28; from 28

to 56; from 56 to 84. The 84-year cycle is that of Uranus' revolution around the Sun and, as Uranus is essentially the symbol of transformation and metamorphosis, this cycle refers to man operating at the level at which constant transformations are possible. On the other hand, the traditional 70-year cycle of existence—three score and ten—refers to a human life dominated by biological and socio-cultural traditions, and by the 20-year cycles of the Jupiter-Saturn relationship, and it should be obvious that the majority of human beings are still operating at that level of existence and consciousness.

The number 28 has been considered "the number of man." It relates 4 and 7, and thus represents the full *concrete* workings of the 7-year cycle, 4 being the symbol of concreteness. Three 84-year cycles contain twelve 7-year periods, and bring this 7-year cycle to potentially full cosmic manifestation. In a more occult sense this 84-year cycle refers to the building of the immortal Christ Body, or in Buddhistic terminology the Diamond Body, the product of the "Marriage of Heaven and Earth."*

I shall return in a later chapter to these cycles, for what concerns us here is the fact that the experiences to which each of the twelve houses refer can be met, at least potentially, and given meaning at three fundamental levels. An individual can be born and reborn at each of these levels. Likewise, he can experience and deal with what he owns in terms of several sets of values—second house—and he can correlate and think out his experiences, as well as develop his particular approach to his environment—third house—at three different levels as well. Then, as he seeks to find a base upon which to build a solid and secure sense of personal activity, he can find such a base either in the superficial relationships and traditional ways of his family, or in the deeper levels of his collective, national culture —symbolized by the taproots of great trees. He can also reach the symbolic core of the Earth, which means the very center of his "global" being—fourth house.

Returning now to the first house: A human being is born physically out of his mother's womb. He can—yet he need not—experience psychologically a "second birth" as an individualized person gradually becoming more conscious of his place and function

* Cf. my books *The Astrology of Personality* and *Triptych* (*The Illumined Road*) for references to such a process—and works such as *The Secret of the Golden Flower*, translated by Richard Wilhelm from the Chinese.

in his community. This is his birth in individuality, while the first birth was a birth in "organicity." Some individuals reach the level of a third birth—a birth in Light or in spiritual reality.

If one considers this three-level birth process as a time sequence of developments, one can then refer these to *the beginnings* of the three 28-year cycles of conscious individualized existence—theoretically to actual birth, to the period between ages 27½ and 29, and to that between 56 and 59. But one can also think of these three levels of birth as without time referents for, potentially at least, the three levels are there all the time; man can function at each level and all levels *if* his consciousness somehow can attune itself to the vibratory rates of these levels and become aware of their specific horizons. Every man is living at the same time in the biosphere, in the solar field, and in the galactic universe, but few men are really conscious of all that this implies.

The first house of a person's birth chart indicates essentially the type of experience through which he will best discover who he is as a unique individual. He can make such a discovery at three basic *levels of awareness*, which may be called instinctual, mental-cultural, and spiritual-cosmic. These levels can be reached in an active, dynamic state of consciousness or reflectively and passively. Indeed, every astrological indication can always be interpreted positively or negatively, which here means reflectively. The first house and its origin or cusp, the Ascendant, indicates how the reaching can be done more effectively and significantly, in order best to release an individual's set of potentialities characterizing a particular person. Later on we shall see how one can interpret the presence of every zodiacal sign and every planet in the first house.

I spoke in the preceding paragraph of levels of awareness. Every experience can be seen as a test in self-awareness as well as a test in one's readiness and willingness to be born again. Most human beings, however—implicitly if not explicitly—refuse to be born again. A person may close his mental-spiritual eyes to the potential meaning of an experience—that is, to what it may bring that would impel him to perform an act of self-delivery. Hindu philosophy speaks constantly of liberation or deliverance from the *maya* of desires rooted in the basic "ignorance" of the human condition. But what is essential is not liberation so much as the bringing-to-birth of a new form of consciousness, a new mode of existence at a new level.

Every deeply and totally lived experience can arouse in the individual a will to rebirth and transformation or transcendence, yet certain types of experiences are more adequate, significant, and effectual means than others in bringing this about. We must look to the first house and especially the Ascendant to find what these may be. Natural processes of growth cannot or rather should not be forced, but awareness does not imply willful action. One can "watch and wait"—and, some will say, pray—without demanding from life that the magical experience come, without impatiently yearning for it.

The unexpected is usually the most revelatory, but one can polarize one's consciousness to the unexpected. One can create *and maintain*—which is harder!—a quality of ready expectancy— again one may speak of it, in a broad sense, as "prayer"—which avoids the pitfall of demanding *a particular event*, outer or inner, from life. What is first and foremost to be realized, however, is that one cannot breathe a truly deep and vitalizing breath without *first* emptying one's lungs and, at other levels of existence, one's psychic being and one's consciousness.

To be empty, to become filled, to respond to the influx of whatever is being experienced—these are three essential phases of an almost dialectical process. But in terms of human existence we should realize that what comes first is being full—full of unauthentic, unindividualized contents, full of the karma of *homo sapiens*, of a particular race, culture, and family and, one could add, of the unconscious vestigial remains of previous incarnations. The newborn is filled with mother stuff; the child who comes of age is filled with socio-cultural stuff. If he is to experience the second birth, he has to emerge from this collective social-cultural matrix. He has to discover the individual tone of his being, his own *mantram*, his celestial Name. And now that there usually is no Initiator to give him his secret Name he has to discover it in some deep surge of consciousness. Yet actually this celestial Name is his birth chart.

The power of that Name, while it individualizes, also *isolates*. The greater the intensity, the sharpness, the precision of the characteristics of that Name—revealer of individual destiny—the stronger the inevitable sense of isolation which follows the revelation. Jesus asked of his disciples, "Be ye separate!" The Patanjali yoga aphorisms stress what has been translated as "isolation." In olden days the Hindu chelas were forbidden to touch any other human being; they

slept on mattresses filled with their own breath so they would be insulated even from the soil's magnetism.

Today we are operating at a different level. In old India what had to be overcome was the deep unconscious attachment to tribe and soil, while in this century, particularly in the United States, it is a poignant feeling of not belonging anywhere, of nonrootedness and psychic alienation. The focus of the new way of life is therefore *total relatedness*, and the ideal is life in a commune in totally open forms of relationship. In this situation the symbol of the Descendant—seventh house cusp—may be more validly stressed than that of the Ascendant. Yet the real "commune" of the days to come should be one in which *individuals* consciously and deliberately come together to reach beyond their socio-cultural egos and to experience the harmony of holistic interdependence, each being ready and willing to perform his destiny within the whole.

The word isolation is related etymologically not only to *solus*, "alone," but to *sol*, "Sun." Every Sun is isolated in space, the center of a group of planets upon which it radiates its vitalizing energy; yet a Sun is also a star, and as a star is one companion among many in a Brotherhood of stars in the galaxy. This is indeed a most revealing symbol. As suns, individual persons are, or appear to be and feel, isolated. This is the price one has to pay for individualization— an often heavy price required for an inherently tragic process. But to be isolated need not mean *to feel lonely*, and even less, alienated.

No Sun radiates life to its planets in empty space; no individual is born on an alien Earth. Every Sun is essentially a star in the galaxy, and every individual is born to fulfill a function, to answer a need of mankind and of the Earth, the one home of mankind. But in times such as ours, in order for a man significantly to live his *dharma* he needs to become, at least for a while, separate from that section of mankind that mothered him. An old occult saying is: "When the son leaves the mother, he becomes a father." The seed must leave the plant that gave it form and substance before it can become the source of a new plant, perhaps on a distant soil upon which it was blown by winds of destiny.

The man who has thus experienced a second birth as an individual gradually more aware of his destiny must be, in some sense, *different* from other men still huddled within the matrix of their society. Yet difference can easily be a negative word, for many an

individual tends to emphasize and to glorify his difference from the collectivity. The injunction "Be ye separate!" is valid only as a necessary means to an end; but once achieved, this end, as is so often the case, dismisses the means as valueless. The consciousness can no longer validly focus its attention upon these means.

A feeling of difference breeds a sense of separativeness, of distance, of incompatibility and perhaps fanaticism for what one has discovered. The positive counterpart of "difference" is *distinctness*. To be distinct is to stand out in the midst of a group—not because one wants to or one is proud of the fact, but simply because while the other members of the group may operate confusedly and in an unauthentic, unformed, uncharacteristic manner, the distinct individual lives an authentic and formed life which reveals the unique character of his being and his place of destiny. His life is a series of "Signatures" with which he marks all he touches with his own genius, in whatever area of activity he may perform his distinctive deeds.

Such a man is an origin, while the man whose great desire is to be "original" is mainly concerned with emphasizing, perhaps beyond the limits of taste and validity, the difference of which he is so ego-proud. The craving for originality embalms and mummifies differences, but underneath all differences stands the one ground of man's common humanity.*

The secret of rebirth—rebirth at the core of every experience— is to be empty of self, yet to maintain silently and in faith a formed receptacle into which the downpour of spirit may flow, then flow through. A source is a place through which water, hidden in the vast expanse of the soil, flows. Every experience can be the source of new and transforming—thus, creative—life developments. Every experience finds itself revealed at the Ascendant of the moment at which it happens.

To speak of the Ascendant and the first house as representing the "personality" conceived as an evanescent and mostly illusory fact of existence, as many theosophically inclined astrologers have done, and to glorify the Sun in the birth chart as symbol of the "spiritual Self," or Individuality, is to miss the central fact of the spiritual life as it can be lived today by individualized persons. The Ascendant is indeed the most elusive and hard-to-know factor in a

* Cf. D. Rudhyar, *The Planetarization of Consciousness* (Part Two) for the metaphysical and cosmological basis of these statements.

birth chart, but *just because* it is the most fleeting and most individual, it is the point of manifestation of the universal spirit—or God. God acts only through particulars. Generalities and mere life power belong to the intermediary realms, to the level of cosmic building and formative agencies. The Divine *incarnates* only in the individual —He or It *overshadows* the group. The supreme responsibility always lies with the individual. At the exact moment, in the most definite manner Destiny speaks and acts *through* the individual.

The first house of a birth chart refers to the area of experience within which Destiny may speak at definite moments to impel the performance of specific acts. What is needed in the individual person who could be such a focusing agent for the Divine is total readiness, total openness to any and all circumstances and demands of existence. It is perfect availability, but availability *oriented to* that aspect of the world's life which, for this particular individual, has the character of authenticity.

One can often discover what zodiacal sign was rising at birth by studying a person's features, particularly the structure of his face and his facial expression. The head symbolizes the essential character of the individuality of the person as a conscious being. Everything "comes to a head" in the face, at least in normal circumstances, for the face exteriorizes the form of the individuality. It has been said that the eyes are the windows of the soul, but the head is the home that the individuality has built. It reflects the creative Word in the beginning.

The zodiacal sign on the Ascendant normally tells us much concerning the *dharma* of the individual—that is, the central potentiality which the person should seek consciously to actualize as a vessel or lens through which the Divine may act. If there are planets in the first house they indicate the kind or kinds of functions which will be most valuable in the process of discovery of one's authentic being.

To be, to breathe, to begin and always and forever to begin again, to meet and reveal the presence of God and the power of creative selfhood in every experience, to speak with authority in terms of one's dharma: these are words. Meditating upon these words may lead the perceptive individual to the very source of his or her own being.

The Second House

TRADITIONALLY, THE SECOND HOUSE REFERS TO POSSES-sions and, in our society, to money—symbol of the capacity to own whatever a person needs or desires. The concept of possession is, however, very complex; it has several levels of meaning and most astrologers, unfortunately, tend to interpret this concept and "second house matters" in a superficial, mainly social, way. What is really at stake in the type of individual experiences that can be related to the second house of a birth chart is the problem of *ownership*, what is meant whenever an individual uses the words "mine" and "my own."

After most babies have learned to speak a few words, they dis-cover the use of the word "mine." It may happen suddenly, and for a while the very young child, as he or she touches various ob-jects, proclaims excitedly "mine!" Actually, conscious existence im-plies a basic kind of ownership and a rudimentary sense of possession —that is, the conception of some material substances as being "mine." The person who says *I am* has to have a larynx and tongue to say it with. The *I* is but an abstraction without the *am*, which im-plies the existence of a physical body. This body is the first and fundamental possession of the self. It provides the means for the gradual actualization of the potentialities inherent in the field of selfhood. It contains within its cells and atoms an immense reservoir

of potential energy. How is this energy being *used?* How *should* it be used so that the newborn may fulfill *its function in the Earth's biosphere and in mankind?* These are questions to which the second house of a birth chart ought to be able to give some valid answers.

As I have already said, the second house is a "succeedent" house, and the motto of this type of house is *to use.* The birth process impels a new human organism into the open environment of the biosphere; whatever is back of this impulsion has to consider how to use the powers inherent in that organism. At the strictly biological level, life is the causal factor in the birth—life operating according to the particular mode of operation of the species *homo sapiens* and being focused through the parents. These parents act merely as carriers of the sperm and ovum. As individual persons their role is minimal, though it is traditionally believed that it is possible to affect, before and during pregnancy, the type of spiritual entity which will embody itself in the womb.

Life operates through what we call the instincts. The new organism is "programed" to meet existential needs and emergencies in definite ways. The instincts tell it how to use its many component parts. In animals the programing is effective and admits of no deviation, and the more advanced a species is along the evolutionary scale, the greater the possibility of adjusting to radical changes in the environment, provided they are not too radical or too sudden. In human beings this possibility is remarkably developed. The more advanced the process of individualization is—a process which depends on the stimulation and complexification of the mental faculties—the greater the potential to transcend instinctual reactions. As the mind begins to reflect upon itself—that is, to be conscious of being conscious—the "I am" sense begins to operate in the consciousness of the organism, polarizing or actualizing what we may think of as a transcendent factor—a monad or Soul—or as an immanent rhythm of existence—self.*

The moment the child becomes consciously aware of being an entity distinct from the other entities around him, he inevitably realizes that there are some things which he can call "mine." His consciousness soon detaches itself sufficiently from the various organs and functions of the body to be able to speak of "my" hands, "my"

* For a more complete definition of the terms "self," "soul," etc., see my book *The Planetarization of Consciousness.*

head or tummy, etc., especially when pain is localized there. That Peter *has* a strong body, and Jane *has* a beautiful face might be stated by parents and relatives. The child *has* a name, a body, a particular temperament, special abilities. These characterize him; they are his possessions at the most personal and intimate level of existence.

According to some thinking, these possessions are what they are because of the genetic conditioning and ancestral past of the child. They are his first and most basic inherited possessions. If one accepts the concept of reincarnation of a transcendent entity, the soul, the body and all that is latent in it—faculties, character, tendencies, innate powers of the mind, psychological predispositions, etc.—constitute what this incarnating soul has to deal with, what it possesses and can call "its own." The problem for this soul is how to use, to manage, to actualize fully, and even to enjoy these basic possessions.

This constitutes the first level of ownership. A second level deals with objects of possession, eventually with money, with the capacity to increase one's possessions in order to satisfy wants, fancies, and moods, and later on the ability to give a positive value to one's relationship with other persons and with society as a whole. This is the social level of ownership, using the term social in its broadest sense, which includes a child's relationship to his family and his friends or associates. At this level acquisitiveness becomes a driving force, in exaggerated form becoming the billionaire's greed for the power which enormous wealth can bestow.

Everything that one comes to possess is in one way or another the result of the activity of living organisms and social groups in the past. Every person, in a very real sense, inherits the past of nature and of human society. His inheritance may be small and inadequate for true self-actualization, or it may be overwhelming in its potential scope, but it always represents the past. The belief in reincarnation adds another dimension to this past, that is, tendencies, faculties, and karma produced from past lives and carried over into the present. What to do with all this past *now* constitutes the basic second house question. The answer rests with the concept of *management*; that is, of intelligent, effective, and successful use resulting in the best possible actualization of one's birth potential, and therefore of one's individuality.

The proper use of possessions leads to the revelation, exterioriza-
tion, and fulfillment, in relation to other human beings and to one's
society, of one's individuality, that is, of *who* one is. A person realizes
what he is by using what he owns; he demonstrates what he is to
himself and to all men, by the use of what he was given at birth
along with what he comes to acquire later on. Ideally, he should
transform these possessions in terms of his individual purpose and
destiny. This, however, can hardly be achieved if a person does not
advance beyond the traditional use of possessions, for then he acts
merely as a servant of the past, as the agent of ghosts, of karma—
whether individual or social. His life, then, is lived by his ancestors,
either in terms of perpetuating the social-cultural privileges inherited
from them, or of being driven by ancient social-religious hatreds
and fears.

Animal instincts are conditioned by the past experiences of the
species, and so are the responses of primitive human beings. Even
more individualized persons are programed by traditional patterns of
behavior impressed upon them by parents and state or religion.
Patterns of possessiveness and demands for exclusive ownership are
still basic in our society. "It is mine; no one else can have it" is the
great cry of our modern individualistic and capitalist society. The
great drive is the drive for profit and wealth, and for the more
intangible possessions related to prestige, social influence, fame, and
even "love." Nearly everyone clings to some kind of privilege—the
negative aspect of ownership. It is negative because it is based on
the past, and usually on insecurity, fear, and pride. The positive as-
pect of ownership, on the other hand, is the capacity to bring the
energies of Nature and the values of the past to a new level of
efficacy and fruitfulness—efficacy and fruitfulness *not* in terms of
special privileged individuals, groups, or social classes, but in terms
of the whole of mankind.

Possessions should be used. Unused capacities or wealth—for
instance, land—are impediments to human growth, whether it be
individual or communal growth. But the individual must not
identify himself with what he owns, for then he is used by his pos-
sessions—which automatically demand expansion—instead of his
using them. The individual should impress the rhythm of his in-
dividuality upon what he owns; he should give an individual and
not merely a collective social *meaning* to his possessions. He should

make his ownership significant in terms of his individual character and destiny. He should dedicate what he *has* to what he *is*, for it is *being* which alone gives meaning to *having*. Nothing is more futile and spiritually empty than having without being, and this is true of all kinds of possessing. A sound and wholesome society should establish as a basic principle: *No ownership without individually significant use.* What is or is not significant must remain a personal issue, yet the community can demand of the individual that he consciously and deliberately dedicate what he owns to a purpose which *to him* is significant. The purpose to which possessions are put alone gives them value and gives meaning to ownership.

There is nothing sacred in the mere fact of ownership. Only an essential unspiritual society, like our western society today and even more perhaps in the last centuries, can glorify the fact of ownership regardless of the way possessions are used, or of whether or not they are used. At the third level of human existence, where spiritual and all-human values are accepted as standards of living, all possessions are naturally and spontaneously consecrated to the process of human evolution—which means in a narrower sense to the welfare of the community to which these possessions are related, for wealth arises from human cooperation, implicit or explicit as the case may be.

To amass a fortune from some new invention, or from the discovery of natural resources on one's land, is actually and spiritually a crime against social harmony and communal health. A man's possessions are the direct result of centuries of human efforts and interplay; all possessions are the outcome of natural and social processes in the past. The owner inherits all he owns from the history of the biosphere and of human society. What alone can give meaning and value to his possessions is the use he makes of them. What is demanded of him is that this use add new value and new creative meaning to the vast tide of Earth life and human society.

In the final analysis, the individual who lives according to spiritual values realizes that he himself, as a living person, is the one ultimate possession to surrender to mankind on the altar of human evolution. In this gift, he fulfills himself by freeing himself from the possessiveness of possessions. By owning nothing he may at last blend his being with the great rhythms of the universe.

He lets himself be carried on by the universe, and his consciousness can become a magic mirror on which every event acquires significance and value. He is possessed by the universe to serve the ultimate purpose of all existence—the revelation of Meaning.

God is the all-encompassing Meaning of all possibilities of existence.

The Third House

WHEN AN ASTROLOGICAL TEXTBOOK SPEAKS OF THE THIRD house as that of "brothers and sisters, and near relatives," it actually means the earliest environment of the newborn and of the growing child's relationship to it. Everything in this environment affects the baby and it is in contact with it that he comes to discover the extent of his powers and to differentiate what he is, as a living organism endowed with a special kind of consciousness, from an outer world. This world contains objects and perhaps animals and growing things, as well as members of his close family. Indeed, astrological references to members of his family—parents, siblings, relatives—belong to a type of life which is still closely involved in tribal relationships or kinship. In a society in which old-time family patterns lose most of their importance, more fundamental values have to be considered, values which refer to whatever the environment-as-a-whole presents to the growing consciousness of the child.

The relationship of the child to his environment is basic in the formation of his character and of his responses to life. Such a relationship exists simply because no living organism is born in a void. It is born under the influence of everything that fills the space around the boundaries of its inner world, that is, around its "skin" or, we might say, around the field of forces pervading all its organs and its cellular activities. Any organism must first conquer its

"living space." In many cases this conquest implies a fight, even if it is only the fight for attracting and holding the attention of the maternal provider of necessary food—and the mother's love providing a sense of security and well-being.

Brothers and sisters may be or may appear to present obstacles to getting this attention, and therefore they may come to be regarded as competitors. But other people, objects, and the, to the child, incomprehensible activity of the food-and-love provider, when away from him, compete as well to deprive him of exclusive attention. It may not even be the actual mother whose attention the child requires and instinctively demands. Actual physical kinship may be much less important than is traditionally believed, and in cases where the baby received his milk from a wet nurse who also took complete charge of him, this kinship bond did play a secondary role. Still, there may be a deeply unconscious instinct at work linking the organism of a child to his close family, though undoubtedly the importance of this instinct, if it exists, is assuredly magnified and glamorized by all traditional cultures that give to blood relationship and to all ideals rooted in a tribal kind of consciousness and social organization a hallowed significance.

This instinct finds its primary field of manifestation in the fourth house, but *before* it can affect the consciousness of the child, he must learn to deal with his environment, and its impact upon him exists as a challenge. It is on this challenge that the development of the nervous system is based, for the nervous system of any living organism is the concrete organic manifestation of the capacity to come to terms with the environment.

In the child this "coming to terms" is at first entirely unconscious, or at least it is instinctual and does not demand what we call in a human sense, consciousness. It operates originally as "sensations" and as spontaneous muscular responses to them. The first cry of the newborn is a muscular response to the sensation of air entering the respiratory membranes. Gradually a definite system of connections between nerve cells is stabilized which is the foundation for human intelligence. By intelligence I mean the capacity to come to terms with any environment—first, physical, then also psychic—and therefore to adjust to its ineluctable demands and eventually to transform it as far as is possible. At its lowest level, intelligence is the cunning of animals as well as of primitive men and children. Cunning is the ability to play one factor in the

environment against another—for instance, when the child plays one of his parents against the other.

In a sense this constitutes a "game," and the game of life becomes increasingly more complex and subtle as the social environment increases in complexity—and also as man seeks to survive in environments that are very different from his native habitat, such as on the moon's surface. Any game implies rules, and Nature sets the rules in the normal biological game of life. Man makes his own rules, however, in sophisticated social games, and even in national or international politics. In order to get along, one has to know and to understand the rules, meaning—in the biospheric environment and the solar system—the "laws" of the universe. From the traditional Hindu point of view the universe is the *lila* (play or sport) of the Creator. Man therefore must discover the rules of the universal game set by God. He asks God for clues by means of invocation and prayer, or by seeking to attune his intelligence to the mind of God. God in turn kindly rewards the seeker, and humanity at large, with various kinds of "revelations."

The third house, then, refers not only to the nature of the environment and to the persons who act within it—close relatives, etc.—but to the development of intelligence and eventually of analytical intellect and empirical science. What differentiates this house from its opposite, the ninth house, is that the third house refers to experiences involving direct personal contact with the close environment of the individual, while the ninth house deals with experiences which can only take place in terms of cooperation between human beings. Ninth house experiences imply language, a cultural background, and what Korzybski* called the time-binding faculty in man. Such experiences postulate a transfer of knowledge from generation to generation. They are based on a complex and socially stabilized type of understanding. In the third house "understanding" is still very rudimentary; it is characteristically empirical; it pieces together personal observations, classifies them, and fits them into a practical set of rules. These are, however, simply rules and not universal laws. The third house type of mind generalizes as little as possible. It is behaviorist, pragmatic, technique-oriented. It simply wants to know the "how to" of doing things for practical reasons. It can be most inquisitive and inventive, but

* Alfred Korzybski (1879–1950), Polish-born founder of the Institute of General Semantics.

also subtle and cunning in developing experiments—witness the incredibly complex experiments devised by laboratory scientists, whether physicists or psychologists. Yet it is not philosophical and even less metaphysical or religious. It is the mind of the specialist, not of the generalist.

Still, in order to control or transform his environment, a man has to formulate his findings, at least in a primitive and pragmatic-technical manner. He learns to communicate with other men, yet this communication refers essentially to practical goals, to how to survive, and eventually to how to feel happy and personally fulfilled in one's environment.

We should look at the third house as an inevitable follower of the first and second. In the first house the basic issue *to be*— that is, to discover what we are and who we are, and to assert our individuality. In the second house we discover and experience the kind of material substance—first, biopsychic, the social-cultural and financial substance—which we own and therefore is ours *to use*. In the third house we come to know how *best* to use it in the environment in which it has to be used; and this knowledge can only come to us, at this stage at least, by trying to act out what we are and using our possessions—meaning first of all, our bodies— *up to the point where we are blocked by the resistance of surrounding objects and people.*

Every child from the moment of birth instinctively tries to find out how far he can go in any direction, physical as well as psychological, before his gesture or action is stopped by something or someone. He learns that he is not born in a void. He is surrounded by obstacles and opposing forces and wills; he has to define his own "living space" and to know what is available to satisfy his needs and what is permissible within the boundaries of his activity.

The need for such a knowledge repeats itself at a higher level and the adult also must learn how far he can safely go in social and intellectual fields. Often the individual refuses to admit personal limitations or dangers in the use of what he has come to possess; and neurosis, psychosis, or social tragedy may be the result. Mankind today is facing such a kind of potential tragedy because western man refuses to accept the limitations of what he can do in and to his planetary environment. We have to learn the real extent of our power as physical and mental human beings, and

the real value of what we possess—our technology and our affluence—and the only way to learn may be, alas, to find out objectively what the end results of the use we make of these possessions will be. A megalomanic self-image seeking to project itself by means of enormous powers wrenched from nature inevitably will most likely elicit a very forceful reaction from our planetary or cosmic environment.

We should learn fast if we want to avoid a catastrophe. Knowledge at the level of the ninth house tends to be theoretical and very general, but third house experiences have a character of immediacy. Survival may be at stake. The search for knowledge in the third house field of experience is, or should be, conditioned by the need to know in practical terms how everything works so that the individual may more effectively demonstrate what he essentially is. When, however, the person is driven in this search for knowledge by socially determined goals and pressures, the knowledge he acquires ceases to have real significance for himself as an individual. His intellect may become bloated, filled with meaningless data which he cannot assimilate. If he does not retrace his steps or "drop out" from the environment which substitutes a false ideal for his true individual selfhood, then some kind of tragedy may be unavoidable.

The third house is called, quite significantly, a cadent house because it implies the possibility of a fall away from what is indicated in the angular house that has come before. A cadent house can mean integration and synthesis, or it may end in disintegration and collapse, or perversion. A process of transformation can operate, and the experiences related to all four cadent houses may be—and should be—preludes to reorganization in a new realm of existence. But the process can backfire when the experiences related to the angular houses—first, fourth, seventh, tenth—have not been sound and wholesome, and/or the powers used in the succeedent houses—second, fifth, eighth, eleventh—have been abused or misused. This is particularly obvious where the sixth and twelfth houses are concerned, but it is no less so in terms of the mental processes related to the third and ninth houses. Our present society glamorizes knowledge, especially technology and all "how to" types of information. With computers it has acquired the capacity to store, correlate, and make available enormous amounts of information. This capacity is a third house matter. It can be a blessing or a curse, depending on the strength and validity of the image man

has of himself and the universe. Alas, the image that western man has made at the official level of his thinking is essentially crude and megalomanic. Unless it is fundamentally altered, a fall seems inevitable. It may not be too late to alter it, but the time is short, extremely short.

The Fourth House

WITH THE FOURTH HOUSE WE REACH ONE OF THE MOST significant, yet generally one of the least truly understood sections of the modern astrological charts. The reason for considering the fourth house only in its most superficial sense—as referring to the home and to all real estate values—is that most of us are still living on an Earth which, in our basic feeling experience, remains *flat* in spite of all that our intellects profess to know to the contrary. Astrology is still drawing a great deal of its symbolism and meanings from a Ptolemaic conception of the world; thus it still associates the fourth house with the idea that below the surface of the Earth there is nothing but solid substance extending forever in depth and with no other meaning *except that it is solid and that it is a foundation upon which to build houses and from which to raise crops and extract subsoil wealth.*

The fourth house does indeed have such a meaning, but as we come not only to know with our brains, but to feel with the whole of our personality—body *and* psyche—that the Earth is a sphere and that we are living on its curved surface, the fourth house takes on a new, much deeper meaning. It takes on a global significance, for it not only comes to represent the productive soil, the foundation for the home, and the Earth into which to dig graves—the "end" of all things—but it carries the meaning, above all,

of the *center of the globe*. In the fourth house the person can and should reach the experience of center—the center of his own global, total personality as well as the center of global humanity, of a firmly established and concretely real brotherhood of man. Without such an experience of *center*, an individual can never demonstrate in its fullness his *human* stature. He remains a creature of the flat layer of productive soil which constitutes the surface of the Earth, whether he roams upon it like a superior animal or settles in rigid vegetable rootedness to a particular spot called "my home" or "my country."

The fourth house, then, can be said to have two basic meanings according to the level at which a man's consciousness operates. In a primary and biological-psychic sense, it refers to the soil in which the "man-plant" (a term used in ancient esoteric traditions) is *rooted*. The cusp of the fourth house is the point of deepest sustainment and most secure foundation for the building of anything that is to rise above the ground. Thus it refers to the ancestral tradition and the great images and symbols on which a culture is built—Spengler's "prime symbols" and Jung's "archetypes of the collective unconscious"—indeed, to all that a person takes for granted as evident truths, including the postulates of science and its constants.

In order to emerge successfully from the matrix of his particular culture and religious-ethical tradition a human being needs a deeper and more individualized type of sustainment. Symbolically speaking, his taproot reaches to the center of the globe. Individuality can only be experienced as centeredness in self, and by self I do not mean a transcendent, all-inclusive principle, but rather a rhythmic power that resides at the very center of concrete existence. That power has been represented as residing in the "heart," because the heartbeats constitute the most fundamental rhythm of the living organism. In Rosicrucian symbolism this center is pictured as the Rose that blooms at the center of the Cross—a cross formed in the human body by the vertical line of the spine and the horizontal line of the extended arms.

In such a center, wherever it is exactly located, the Hindu mystic and yogi felt and saw the presence of *atman*, the center of all reality. In the Bhagavad-Gita, Krishna, the incarnate Deity, says: "There dwelleth in the heart of every creature, the Master, Ishvara, who by his magic power causeth all things and creatures

to revolve mounted upon the universal wheel of time. Take sanctuary with him alone, with all thy soul; by his grace thou shall obtain supreme happiness, the eternal place . . ." (William Q. Judge's translation).

It is indeed in the symbolic Nadir—which is also the Midnight point of the consciousness—that the "God-experience" can be had. There dwells the immanent God, the God-in-the-depths who polarizes the splendor of God-in-the-heights, the flamboyant noon-God whose face cannot be seen without blinding the onlooker. Every truly individualized person "knows" by an intimate existential and irreducible knowing that there can be no secure foundation except when he has reached a state of unshakable centeredness. Until this state is experienced a human being remains bound to some kind of matrix. It may no longer be the actual mother or substitute Mother-image; but the cultural tradition, the organized Church, or even the Party for old-time Communists, can remain an enveloping psychic or ideological womb. All "solid" foundations may crumble, the tree firmly rooted may be felled, but the globe forever retains its center. "Global man" is secure in the centeredness of his individualized selfhood.

One can carry one step further the symbolism of the taproot able to reach the center of the earth. The vertical line of the birth chart (Zenith-to-Nadir) points to the Sky as seen at the antipodes. If all men stood erect on the surface of the Earth, the downward prolonged line of their spinal columns would meet at the center of the globe and, going farther, reach the antipodes. By looking exactly above to the Sky every man contacts a different star. The heads of men are directed to different points of the Sky; their feet are oriented to the center where all earthly things are one. Unity is at the center of the Earth, not in the Sky. Man's common humanity is experienced in the depths; it is the head functions which differentiate and divide.

This is why what is called depth psychology is so significant today, in our era of individualization based on the superficial pseudo-center of consciousness and desire that we call the ego. Depth psychology uses the concept and the experience of depth to reach the center. When a human being reaches his own center he also discovers that he is one with all other human beings, for all things converge at the center. In Masonic tradition this is referred to symbolically as meditating on the Midnight Sun, for at midnight

the Sun is at the cusp of the fourth house, illumining the antipodes. The individual realizes what he is by uniting with his opposite, and philosophers have often spoken, in an abstract sense, of the reconciliation of opposites. Every value and quality can be defined by reference to what it is not. The concept of good rests on that of evil. The famous Shakespearean phrase "To be, or not to be: that is the question" is a typical expression of the tragic duality inherent in western society. However, being and nonbeing, life and death, *yang* and *yin* are inseparable. A global, holistic consciousness—symbolized by *Tao*—includes these opposites but in varying proportions.

Astrological textbooks, inspired by statements made in Theosophical books, often claim that the first house is the house of "personality." This, as I see it, can be most misleading, if by the ambiguous term personality one means the total person and what it radiates. What the Ascendant and the first house actually represent is *the original impulse of individual being* or, we might say, the self as a particular vibration and rhythm, and the unique destiny of the individual ever so little different from all other individuals. This impulse has to acquire substantial material around it in order to exist as a truly functioning human being. The newborn, with his rudimentary consciousness, has to learn what he is able to use as body, faculties, and possessions—second house—then what the limitations are that may be imposed upon this use by his environment, and the opportunities it also affords him—third house. Only then can the consciousness, the *I*, become fully organized and stable as a "person."

The fourth house experiences deal with this process of integration and stabilization. At the primary level of the biological and psychic-cultural consciousness, integration is theoretically or ideally achieved within a home and in terms of a definite, stable tradition. The normal successfully integrated person is a sound specimen of a family type as well as of a collective ideal of culture and social behavior. As a truly individualized person he becomes centered in the unique rhythm and power of his individual selfhood and destiny. At a still higher level this individuality becomes consciously and totally attuned to the needs of mankind, and the person becomes a "personage" with some kind of mission as an agent of Man or God. The astrological character of the fourth house and the planets which

may be located in this section of the chart should help to discover the best way to reach a state of integration and to acquire a solid, effectual basis for the personality.

Personality, as the term is used here, is more than merely a bio-psychic organism able to function effectively among other organisms; it can be considered *an engine* able to release power for work. Indeed, every organism is actually an engine through which life energy operates. The functional integration of parts within a living whole generates power. This power has to be used is some manner, and the experiences related to this use belong to the field of the fifth house, which therefore is called the area of personal self-expression.

The vertical axis of an astrological chart refers to power; the horizontal, to consciousness. The kind of power related to the fourth house is private, in the sense that it is produced by the biopsychic whole that we call an individual person. It is the power of a particularized manifestation of the type of life generally characterized by the human species, *homo sapiens*. It is the power implied in "being a person." This person in most cases is basically conditioned, if not entirely determined, by ancestral family and socio-cultural patterns. It is an engine mainly mass-produced on the assembly lines we call tradition, family, school, and environment. Yet, in some cases, and in vastly increasing numbers today, these culturally mass-produced persons leave the factory for special treatment, not only acquiring individual characteristics—even mass-produced engines do not operate in exactly the same way—but becoming independent and self-actualizing. A person then is no longer a mere biosocial specimen, but is truly individualized, which means that a power operating at another level than life takes hold, at first perhaps most hesitantly and incompletely, of the engine of personality. This power can be called Spirit, Soul, Self, or even God according to the kind of metaphysics one accepts. It operates *through* the mind, which in turn affects the biological organism, but it is not mind in the usual sense of the word. Some philosophers and psychologists speak of will, but here again one must differentiate between what is most often called will, and belongs merely to the realm of biological drives and emotional desires, and the spiritual Will which alone can truly individualize.

Will is power ready for concrete expression. It is that which actualizes what has been only a potentiality. The Ascendant refers

to the potential of being. It is symbolically "the Word that was in the beginning," the *logos*. But a word is only *an image potentially able to mobilize force*; of itself it can do nothing until it arouses a feeling in a concrete, actual organism. Then the power inherent in that organism is moved by the feeling and an action results. The Ascendant gives the word: the Nadir and the fourth house refer to the organism and its capacity to be moved by an image, a word, and in general by the kind of feeling which spontaneously mobilizes and directs the energies of the human organism, whether at the purely physiological or the psychological-intellectual level.

The fourth house can be said, therefore, to refer to the basic psychic function which Carl Jung called *feeling*. The first house refers to Jung's *intuition*, which really means a definite sensitivity to superpersonal directives or to image-symbols revealing at once the character and meaning of a whole complex situation. Both intuition and feeling as defined in astrology are essentially personal, in the sense that they produce intimate and incontrovertible experiences that concern the individual and reflect his or her stage of development.

This stage of development is expressed in the second house by the individual's possessions—possessions at all levels, of course—and in the third house by the way in which the individual goes about meeting his environment, reacting to it, and accumulating, then formulating to himself information. A computer can be fed a multitude of data; in the same way the family environment, the society, T.V. programs, newspapers, and a few years at college can feed the growing brain of the child and adolescent a mass of information—all third house experiences. These experiences are useless, and indeed often may become psychologically toxic, unless they are coordinated, integrated, assimilated, and therefore related to the self and its unique capacity for *centralizing consciousness*—the Ascendant, symbolically. Thus there is a time at the end of the period dominated by the third house—theoretically late adolescence in a normal life—when one should know to stop ingesting more and more data, and to work instead at the process of stabilization and self-imposed limitations. In olden days this was the time for marriage and home-building, that is, for defining precisely where one elected —or was led—to stand, and for "taking root" in one's own place of destiny. The concept of home and of building a family has evidently lost a great deal of its meaning in our technological society of

rootless wanderers and of intellects avid for more and more information and excitement, but regardless of the association of third and fourth house experiences with a particular period of life, the fact remains that the passion for new experiences and the accumulation of information are meaningless unless we, as individual persons, carefully assimilate these things and make them the building blocks of our own "house of personality." The Ascendant may tell us *who* we are; but the Nadir indicates *what* we are, at least potentially, and where we stand.

Third house knowledge should be transformed into fourth house power. It is possible to stop looking for more knowledge too soon so that personal integration and power to perform individual acts may be too narrow and ordinary. It is also possible to keep on acquiring data which cannot be constructively and significantly integrated into one's system of living and world view, and this can lead to various types of catastrophes. Our whole western society is following this latter course and may reach a stage at which it will suffocate in a mass of unassimilable data and the neurotic compulsion to have and to know more and more of what it can no longer integrate within a wholesome and harmonious philosophy of being.

In the sector of the astrological chart which begins with the fourth house—usually referred to as the North-West sector, because of the two-dimensional character of the chart—everything depends upon the indications related to the fourth house and particularly to its cusp—the *Imum Coeli*, or Nadir. Fourth house experiences tell basically what the human being is as a concrete, actual person. These personal foundations condition what the individual will be able to express, love or hate, procreate or create. All these activities will have either a solid character or an uncertain one, a harmonious or a congested quality of creativity—or no creativity at all. And this in turn will lead to the reaping of the harvest—or to no harvest—in the type of experiences to which the sixth house refers.

The Fifth House

IN THE FOURTH HOUSE, WHAT HAS BEEN ASSIMILATED, stabilized, integrated, or built in the fourth house produces potential energy. Power becomes available for use. At the biological level this is not only the energy needed for intercellular exchanges and for adjusting the body to changes of heat, humidity, or magnetism occurring in the physical environment, but the nervous and muscular energy required to get food, meet obstacles and enmity, and satisfy basic physiological needs, for instance, the need of the species to reproduce itself through mating. In a mentally and emotionally developed individual, personal power is available to a lesser or greater extent for self-expression in terms of social or cultural values.

Creativity is referred to the fifth house because to create, in a human sense, is to impress upon one's community some characteristics of one's own personality. It is to make one's own mark upon one's society, or upon mankind in general. This obviously can be done in various ways. Giving birth to a child and raising him to become a person of social-cultural importance is the biological way. Producing a work of art or of literature, founding a cultural institution, imagining and developing a great invention which affects men's way of life, leading one's nation to a notable achievement— all these activities exteriorize and put to use the power of the creator, inventor, or leader.

In some cases, however, the exteriorized power and the projected vision originate in a realm that is actually superpersonal. The person becomes the *agent* for some great collective or planetary and evolutionary purpose; he is like a translucent and perfectly shaped lens *through* which light is condensed and brought into focus. At this focal point power can operate and work can be performed. This work—the creative act and its products—is undoubtedly *conditioned* by the nature and temperament of the person, yet even more basically it is *determined* by factors which transcend personal idiosyncrasies and even perhaps personal desires or attempts to control the creative process or direct it toward a consciously defined end.

We should realize, however, that when a person performs a work of social significance in terms of his profession and under the pressure of a collective need, and when this work has, as it were, the conscious or unconscious backing of a social institution, a business firm, or of the whole community, such a performance—creative though it may appear—refers just as much or more to the eleventh house as to the fifth. In the fifth house theoretically the person acts as strictly as possible as an individual. He is not concerned with collective social results or, if he is, then it is mainly to the extent that these results will bring him fame, prestige, and ego-satisfaction. In the fifth house a person seeks to enhance his own nature. He is more concerned with being "original" than with orginating. Whether or not it is consciously acknowledged, the question "What can I get out of it? How can this act make me feel better, more fulfilled, happier, greater?" always lies behind his acts. This applies to nations as well as to individual persons, as exemplified by our American approach to international affairs.

If the fifth house traditionally is considered to be the section of a birth chart referring to love affairs, while the seventh house refers to marriage, it is because, at least in the old-time society, a love affair was supposed to be merely a release of emotional-sexual tensions and/or personal frustrations and unhappiness, or often a mere play or pastime, or a contact determined by personal ambition. On the other hand a marriage or a steady business partnership implied the permanent union of persons who conceived this association as a means to produce biological, social, or cultural results—results that were considered *functional* in terms of the whole community. Marriage until quite recently did *not* mean the freely sought union of two independent persons seeking in this union a way of greater

personal fulfillment in love, for a marriage was most often arranged according to class and financial status for the purpose of preserving the human race and the values of a particular culture and religion through the procreation of children properly educated to perform this role—a point which today is very often misunderstood or conveniently forgotten.

The fifth house is the area of experiences which are essentially the outcome of emotions, and we should be careful to distinguish *emotions* from *feelings*. Feelings are experienced in the fourth house because they constitute the spontaneous reactions of a whole organism to a life situation, whether at the purely biological and instinctual, or at the psychological and individualized level. It may be an *inner* situation—as when a person feels pain in some part of his body because an organ has been injured—or an *outer* situation caused by an encounter with another person. Feeling is a holistic process involving an organic state of consciousness, or at least semi-consciousness. This state then seeks exteriorization, and the exteriorizing process is *both* an e-motion—a "moving out"—at the psychological level, and at the physical level some kind of muscular or chemical reaction. The lie detector and related instruments have shown conclusively that all emotions—whether fear, love, depression, happiness, or anger—are synchronized with organic changes and muscular movements, however slight and unconscious these may be. It is such responses to confrontation or to inner happenings—making definite mental images in meditation can be one of these—which should be considered fifth house experiences.

The fifth house has been associated with "gambling" in any form, from gambling for love to taking risks in promoting artistic or financial enterprises. Such an association is valid whenever the gambler strictly follows his hunches or imagination, or succumbs to the pressure of an inner frustration or complex. But when the risk-taking is discussed with a partner and based on an intellectual evaluation of social and business processes, then it should be referred to the eighth, or in some cases to the eleventh, house.

It is also traditional to speak of the fifth house as referring to childbearing and education, at least in its earlier stage. The reason for this is that most parents tend to consider their children projections and extensions of their own personalities; they often expect their children to be what they have failed to be. They may seek to give them opportunities they did not have in their own youth, or

project upon them their own longings and ambitions, perhaps so they can vicariously enjoy their achievements and even their loves. Parents may also feel that it is their duty more or less forcibly to impart to their children the culture and the manners which they themselves received from their own parents.

Education thus becomes a process of impressing upon the supposedly virgin mind and feeling-nature of a child a collective set of socio-cultural rules and patterns of response. If understood in this way the educational process takes only minimal cognizance of the child's individuality and uniqueness of being and destiny. This, more than anything else, is what has produced today's youth rebellion. This rebellion is partly the result of the fact that many parents are no longer convinced that their cultural and religious-ethical tradition is worth being passed on, or that changing circumstances of life in our technological age makes this impossible. It is also the result of the great increase in the many kinds of external stimulations— T.V. dramas and news, parental scenes at home, constant change of environment, etc.—which generate premature sensorial and intellectual development, while leaving the feeling nature without root-sustainment and examples of integrated and solid group living.

At the biological level the fifth house can still refer to one's progeny even in our chaotic society. Today, however, it has come to deal increasingly with the attempts at emotional self-expression and creativity of men and women who need to "let off steam" while engaged in dull and automatic activities, and who must find some kind of outlet for their frustrations and neurotic compulsions. This house nevertheless is also the field of experiences which refer to the truly creative activities of great artists and the glamorous performances of musicians, actors, and movie stars.

Every house of the birth chart refers to some great test, because every class of basic experience compels the developing individual to face himself in a new way and to deal with a particular category of problems.* The sign on the cusp of a house and the character of the planets which may be found in this house should give the student of astrology clues as to *the best way* in which he or she can solve these problems. No planet can be considered to give indications which are in themselves negative, for they all refer to a type of energy which is essentially valuable, even if man at his

* These twelve basic tests of existence are described in Part Two of my book *Triptych*, entitled "The Way Through."

present stage of evolution tends in many instances to use it imperfectly or so as to produce cathartic and perhaps disintegrative effects.

We may define the test involved in first house experiences as that of *isolation*, that is, emergence from the mass as a unique individual. In the second house the test is of *ownership*. In the third house the test is of *thought*, that is, how to take a conscious and intelligent approach to the challenges of one's environment. In the fourth house the test is of *stability*. In the fifth house the great test involves the ability to act out one's innermost nature in terms of *purity* of motive and using in a "pure" manner the means available for the release of one's energies.

The words pure and purity have been sadly abused. To be pure is to be exclusively what one is as a unique individual in terms of one's own destiny. Pure water is water that contains no sediment or foreign chemical substance; it is purely H_2O. A pure action is one which exteriorizes the essential character or nature of the actor. To be pure is to perfectly and exclusively perform one's dharma—the Bhagavad-Gita adds "with no personal concern for the fruits of the action," for such a concern indicates ego-involvement in what the act will do to the actor.

Every action implies a release and a conscious or unconscious use of power. Energy flows out of the actor. A pure act is one which uses energy according to the intrinsic character and rhythm of that energy. For instance, at the strictly biological level, the nature and function of sexual energy is essentially the procreation of children which will perpetuate the human race. The result of procreation—the child and his needs—eventually demands a vast expenditure of energy and work on the part of his parents. The male and female organisms in copulation act as carriers of the sperm and the ovum—this is their natural sexual function. They act then as *servants of life*, and life responds to their dedication, unconscious though it may be, by *exalting in them their vital rhythms*, which is the meaning of the orgasm. The moment of exaltation "feels" wonderful, and human beings therefore want to repeat it. But to repeat it under conditions which preclude the procreative purpose is, *at the biological level*, cheating life; therefore religious institutions, like the Roman Catholic Church, which consider biological factors essential foundations for basic rites and, in general, human values—whether or not they would admit this fact—oppose contraceptive practices.

Man, however, does not function only at the biological level
where he serves the human species; neither does he operate only at
the social-cultural level at which he is a carrier of values and tradi-
tions. Man can become truly individualized, at which time his im-
mediate goal becomes fulfillment as a whole person. Sex at this level
acquires an entirely different meaning, for it refers mainly to the pos-
sibility for two persons to find in each other what they need—
that is, what they individually lack—for personal fulfillment and
creative happiness. The interpenetration of their biopsychic en-
ergies can powerfully help to bring about in each partner a more
wholesome approach to existence and to social contacts or problems.
This then is the psychological and, secondarily, social value of sex.
Such a value is denied if the sexual act comes to mean no more
than self-gratification, a mere release of glandular energies, or the
fulfillment of some egocentric personal or social purpose. The
act then loses its purity. It becomes adulterated.

For the person to whom occult energies or subtle biopsychic
forces are real and significant factors in his potential development,
purity in relation to sexual acts may have a still different meaning.
He may see in the sexual act a process of attunement, and perhaps
identification with the great polarities of cosmic existence—the *Yin*
and *Yang* of Chinese philosophy, the *Shiva* and *Shakti* of the Hindu
Tantras. If this occult or mystical approach is earnestly followed,
then any personal or ego-conditioned feeling and thought during
the ritualistic act would constitute an impurity. In this approach, the
personal characteristics of the partners lose all significance: what
counts is the ability of the partners to avoid bringing personal
cravings or unconscious compulsions into the act. It is very rare for
a western man or woman to be able to conceive of and experience
sex in this manner, but it may be that some young persons today
awkwardly and intuitively are trying to reach such a level of sexual
experience.

Everything I have said in the above paragraphs about the sexual
experience can be applied equally well to the performance of any
action. The Medieval Christian ideal of doing every act, even the
most routine, as if in the presence of God, is another way of stating
the same thing. Any action can be performed out of mere biological
or social necessity, or it can be performed in terms of the demands,
the passions, the frustrations, or the moods of the personal ego.
At a higher level, the performance can be totally dedicated to God,

or—what is essentially the same thing—it can be so open and attuned to the great rhythms of the universe that the performer truly experiences himself as an agent of cosmic powers, a single thread in the sublime tapestry of the universe.

The Sixth House

THE SIXTH HOUSE IS A "CADENT" HOUSE. IT IS THE LAST of the three houses which have their symbolic origin in the Nadir, that is, in the lowest end of the vertical axis of a birth chart, the meridian line. The cadent houses are the third, sixth, ninth, and twelfth, but there is a basic difference between the sixth and twelfth houses which end respectively in the Descendant and the Ascendant —the western and eastern points of the natal horizon—and the third and ninth houses which end respectively with the Nadir and Zenith.

The horizon is an unmistakable fact of experience. It separates what is above from what is below the Earth's surface. No division can be more concrete. The vertical line of the meridian, however, is not so easily perceptible. The eastern and western halves of the sky and of the whole chart are not separated by any obvious partition. One moves easily from the third house to the fourth, but the transition from the sixth to the seventh, and from the twelfth to the first houses is sharp. It indeed implies *a crisis of perception,* a "revolution in consciousness." The sixth house refers to a period of personal readjustment; the twelfth to a period of social and existential repolarization. Yet the sixth house type of experience leads naturally to the seventh, and as a man experiences in the twelfth house the closing phase of a cycle of experience he is also sowing,

whether he knows it or not, the seeds which will produce and condition the beginning of a new cycle in the first house.

Why should there be experiences of sixth house readjustment and what does such a readjustment imply? This question can be answered by considering the fact that the sixth house follows the fifth house of self-expression and emotional or creative activity. A time comes in every man's life when he is forced to realize that what he does, feels, or thinks does not come up to the ideal of behavior, personal achievement, and success which he has set for himself. Even the most self-satisfied individual is aware of some lack; his self-satisfaction is very often a screen behind which he hides an unacknowledged sense of inferiority, uncertainty, or dread of failure. If there were such a thing as a completely self-satisfied person, life would someday prove to him that his body or his mind, his emotions or his nerves were not able to meet some emergency or challenge. Illness, pain, inner doubts, and conflicts are characteristic proofs of at least relative defeat or inadequacy.

But who can succeed completely in the exteriorization and actualization of the potentialities inherent in his personality? Once the creative work is completed, the composer, writer, or artist is often painfully aware that he could have produced a greater work. The lover comes to the point when love ebbs away or brusquely terminates, and the poignant feeling may arise: "Why was I not able to keep this love relationship radiant, fulfilling? What did I do or say that disturbed or killed the feeling of communion?" And the parent or educator who encounters the rebelliousness and perhaps scorn or enmity of the child he had wanted to educate, cannot help but wonder what he did wrong, or if the ideal he projected upon the child was really of any value. Thus, an experience of failure arises as self-expression and creative efforts meet reversals and the mind and soul feel empty and defeated by life—indeed, to some degree at least, self-defeated.

The real problem in such circumstances is what the individual does with his experience of failure and the results of at least relative defeat. How does he respond to the realization that he lacks strength, endurance, adaptability, technical skill or wisdom, refinement, and the ability genuinely to love? How does he meet the realization of the necessity for self-improvement? How *should* he meet it so as to ensure the best possible results?

A man's true inner worth is often revealed when he has to face

experiences of inadequacy, lack, frustration, or defeat. When he is
equal to the ordinary needs of the day and able to meet with fair
poise what life and society—or his family—demand of him, we see
only *his abilities* at work. When these fail or are not equal to their
task, when his body falls ill or his mind loses its normal stability,
then we see *the person himself*. But we actually come to know this
person's real self not so much by what he achieves as by the way he
approaches the emergency, by the *quality of his response* to lack
and defeat.

If a person with great reserves of vitality falls ill and makes a
spectacular recovery, if a nation confronted with war or disaster
throws itself successfully into a program of enormous production,
this does not necessarily reveal the greatness of the individual's inner
self or of the soul of the people. What counts spiritually is the
quality of the effort and what this effort creates in the person or the
nation. It is the aftermath of victory that tests the spiritual quality of
the victory. It is what victory does to the mind and soul of the
victorious.

Crises are opportunities for growth as well as challenges, but
there is growth and growth! A man can grow bigger and fatter,
more wealthy and more self-important. Does that make him better
able to meet the next crisis? Does it make him come closer to fulfill-
ment of his true and essential purpose in life? If it does not, then it
is only a false kind of growth. To grow is to become, actually and
effectively, what you are potentially, as a spiritual being, at the
threshold of your birth. It is to achieve the essential purpose of your
life as a whole—God's purpose for you, as the religiously inclined
person would say.

The essential question, then, is: How can I best orient myself
to an oncoming crisis? If it comes unannounced (such as sudden
illness, an accident or death), what is the most basic power, func-
tion, or drive that I should call into play to meet the emergency—
and, what is more, to meet it so that I grow spiritually from the
effort?

Most people, obviously, do not stop to ask these questions or to
find the answers; it is well that they do not, at least *at first*, because
it is good for a young person to test himself, to know his limita-
tions by actual failure. This builds character and a realization of
"self." But when they grow older and realize that there is something
quite wrong about the way they have approached their crises and

dealt with their illnesses or sense of inferiority, then the time has come for finding out more about themselves and their innate ability to meet these crises. Reorientation has proven to be necessary. New techniques, perhaps, must be learned and, what is more fundamental, a new approach to the use of the skills one already possesses.

This is where the idea of discipleship comes in. One may learn the tricks of the trade from written instructions or from an impersonal statement. One may memorize a set of responses to a critical situation—for instance, what to do in a traffic jam when driving a car. This is technical knowledge; today in America we worship this kind of knowledge. But a technically skillful driver may—through impatience, emotional recklessness, or overfatigue and nervous tension—still cause a serious accident. The technique may be there, adequate to meet the impending crisis, but the personal, emotional, or physiological approach to the possibility of crisis may defeat the ability to use that technique. In some cases, the presence of a subconscious wish for failure or death may make defeat almost compulsive.

Discipleship, when properly understood, does not mean simply learning a skill. It is being subjected to the contagion of example from an individual who not only has the skill, but is able to use it to the fullest in times of crisis. A student acquires knowledge from a teacher; a disciple receives from his master the power to transform his personal attitude to life, to himself, and to God, so that he can use whatever knowledge he has—or whatever inspiration comes to him—effectively and creatively.

This power that the disciple receives, however, does not come to him *unless he qualifies for it*. He must discover the manner in which he can best qualify, and this implies always some kind of preliminary reorientation. Before the disciple can actually receive the power to experience, with the help of the master, a true inner metamorphosis, he must *desire* to change and to grow. He must be ready to serve and to obey, for true and eagerly accepted service is the only cure for egocentricity or selfishness. The capacity to obey and to take directions is necessary if the disciple is to pass successfully through crises that imply a challenge to the very existence of his ego.

Because the sixth house represents fundamentally everything that deals with *personal crises* and the way to meet them, it shows, more than any other factor in the whole of the astrological field,

how an individual can grow and become transformed. It indicates, by its contents, the basic type or types of challenges to be expected whenever opportunities for growth are presented. These opportunities may be presented by life itself, or by the presence of the master and spiritual guide, *whose task it is to make the opportunities more definite and, thus, the crises more focalized and acute.*

In traditional astrology textbooks, the sixth house is said to refer to employment—either to servants one employs or to one's employer —to everyday work, to all forms of training, to matters concerning health and hygiene—and in specific cases to military service. As usual, such traditional meanings by themselves are superficial, limiting, and fail to reveal the basic significance of this most important house.

The basic significance is that of personal growth. Growth means transformation or change of condition. This change requires taking a new step forward, or, if the motion is negative, backward. In every new step a person takes, there is a moment during which he is off balance, having left a previous state of equilibrium (or stability) and not yet having reached the state ahead. This off-balance state indicates a crisis. All crises are transitions between two states or conditions of existence or consciousness. Most transitions are difficult or painful; hardly any man will pass through them deliberately and consciously unless he is made to desire the risk by a sharp or poignant realization that he lacks some skill, that he has, at least partly, failed or been defeated.

Illness may be the direct result of some defeat of the vital energies unable to cope with a challenge to grow stronger, or an attempt by the soul to impress upon the consciousness the need for a revision of attitude, or the normal sign of bodily disintegration in old age. It may also be imposed upon the body, or the mind, by the violent impact of some over-all social crisis, war, or revolution. In this case, however, the twelfth house is the main field of disturbance; the sixth house, its polar opposite, primarily shows the response of the individual to a social situation.

One should not forget, however, that for the individual to respond to a social or national need is the normal way to grow; this normal way does not inevitably require that he pass through acute crises or experience illness. What is demanded is that he contribute to the productivity and growth of his community, and this contribution usually takes the form of employment or service.

Such a contribution may include a multitude of small crises or determined efforts to adjust to social conditions—even if it is only daily commuting in crowded subways, or the effort to overcome fatigue every morning as the alarm clock—the modern slave driver!— whips one out of slumber.

If the relation of an individual to his community is negative, employment means slavery, crude or attenuated; if one's society is torn by war or revolution, the field of sixth house experiences means compulsory military service of some sort. Crises become sharper then, even if they are small and repeated. Yet these crises still can mean growth for the individual—the slave can demonstrate far greater spiritual growth than his ruthless master! What counts is the attitude taken and the degree to which the spirit within, the inner self, has been aroused and has been able to induce transformations in the total personality. This should include, at least to some extent, the transformation of the body's responses and instinctual urges and desires.

At the limit, the alternative to transformation is death. Death can be a very slow and gradual process to which the individual soul assents or even induces out of weariness or despair. Growth always means some type of transformation. The message of the sixth house is: *Be ye transformed!* No person with an emphasized natal sixth house should seek to escape or refuse to heed this call for transformation.

To conform is to accept a static condition; it is to accept the inevitability of crystallization, the degradation of the living into the inanimate, the stone. All dynamic living implies transformation— the transformation of one's personality and creative contribution to the transformation of society and civilization. To be creative is to be an agent of transformation; it is to use crises to the fullest so they come to mean effective and successful metamorphoses.

Birth, catharsis, and metamorphosis most often imply suffering. The great sixth house test is the test of *suffering*—and also of patience and endurance. The ability to endure with such vibrant and steady faith that the crisis will lead to a new type of experience and thus to a kind of rebirth or reintegration is the assurance of success. Still, faith does not make the pain or psychic pressures and anxiety any less real; it may, however, give them constructive meaning, and man can endure almost anything that he realizes to be meaningful, unless the vital powers of his body can no longer activate worn-out organs.

In a well-known Gnostic hymn of the early Christian centuries Jesus is made to say: "If you had known how to suffer, you would have had the power not to suffer." Suffering is the path to repolarization or rebirth. The Resurrection implies the preceding Crucifixion. One must learn to face failure with courage and clear thinking—whether it be your own failure or that of persons close to you or of your society as a whole. One must confront the causes of failure or frustration *objectively and dispassionately*, as if from a distance, yet with compassion and without guilt feeling. This is detachment and also what is really meant by severance. Severance does not deny empathy; it creates distance, and distance is essential in the evaluation of what has happened.

It is said that time heals all wounds, but this is only because the many subtle bonds of feelings and memories which linked the doer with the deed one by one break and vanish from the consciousness as other experiences come crowding upon the mind moment after moment, year after year. The doer disinvolves himself from the deed, and the suffering is forgotten—until the day, perhaps, when a new test of one's capacity to transform oneself and to reassess and reorient the release of the personality is met. It must be met at the very place within the field of consciousness at which a similar one once was experienced. All depends then on the quality of the healing process that had taken place. Complete healing strengthens the disturbed function; incomplete, it may leave the organism weakened and vulnerable.

The sixth house refers to all experiences of healing, and to the fear of illness or failure. If the roots of the personality are not deep or extensive, the individual seeking self-expression and emotional fulfillment in fifth house activities is more likely to fail in his attempts if he uses self-expression to mask his longing for help. Failure then leads to self-pity. The hurt consciousness cries out: "Why did this happen to me?" It happened because the individual had not yet realized his full power and his essential destiny.

Such a realization often comes through dedication to a work. It may come in service, for it is only by serving that one can gain mastery. The deepest worth of an individual is revealed in his capacity and readiness to serve—which may mean his ability to recognize greatness in others and to feel humble. The great person is humble because he knows, deep inside himself, how much greater he might have been. True greatness precludes self-satisfaction. Only

the great man can see beyond himself; and the vision of that beyond must pass through the "shadow" attached to any achievement. In the sixth house the individual may meet his shadow—not the final "Guardian of the Threshold" who belongs more to the twelfth house, but the shadow of one's desire to be great, noble, powerful. This may come through humiliation, illness, or uncontrollable fear when the challenge of destiny comes. It may be a strongly cathartic experience; it can also be an exalting and transforming Visitation. The quality of the response of *the total being* to this Visitation determines the quality of the truly productive relationships into which the individual can enter with others.

The presence of a planet in the sixth house of a birth chart does not imply that this planet is in a disadvantageous position. There is nothing intrinsically negative or "bad" about this natal house. When a planet is located in it this means that the basic function represented by this planet *should be used* in order most successfully to meet the experiences related to work, service, illness, self-transformation, retraining, and the repolarization of one's energies and of the ego that has used them to some extent ineffectually. These experiences are necessary to the total process of individual growth. They occur at two or three levels, from that of material work and health care to that of true discipleship to a "master of works." These experiences should not be shunned just because they usually involve strain and stress, pain and suffering. As I have written elsewhere: "Pain is the custodian of our undiscovered treasures . . . Men are not quite yet 'Man.' They are moving toward the Mastery, the right use of 'human' power . . . Suffering is the footstool of our divinity. We may stumble over it and fall back into the womb of time to renew once more our tragic attempt at metamorphosis. Or we may step upon it, raise our countenance by damming the very stream of our tears, and use suffering to reach the extended hands of Him Who is our resurrected Self. Suffering can only cease with the Resurrection, in any man who is truly human. For to be man is to be ceaselessly more what one is. Until humanity merges into divinity. Until the individual becomes Man. Until all victorious men, having learned to use rightly in its fullness the power that is theirs *in* God, no longer need suffering."*

* See *Triptych: The Test of Suffering,* page 167.

The Seventh House

As THE SEVENTH HOUSE IS REACHED WE ARE DEALING with experiences that result from a type of activity based no longer primarily upon the individual self but instead upon sustained modes of relationship to other selves, modes of relationship which imply a fundamental sense of cooperation and sharing with other persons. But mere cooperation does not tell the whole story, for of itself it may have but an impermanent and superficial value. The cooperators should feel that their "operation in common" serves a purpose within a larger unit of existence, normally within a particular social community, or at most within mankind considered as a planetary organism. It should be a *functional participation*. One should find implied in the relationship between two partners an at least dim realization of what the relationship is *for*, what is its purpose; and in this purpose each partner should then be able to discover his or her own individual purpose. A life without purpose—or, as the American Indian would say, without a "vision"—is hardly worth living; it is not greatly different from the life of an animal. But obviously human beings can live, act, and cooperate, consciously or instinctually, in terms of a variety of purposes.

This matter of purpose is very important astrologically—as well as psychologically and socially—for it alone can clarify the basic relationship between the first, the fourth, the seventh, and the tenth

houses. In the first house a man can realize intuitively—and at first
in an instinctual sense below the threshold of what we call con-
sciousness—that he is an individual "I." This realization, in terms
of actual and effectual existence, leads in the fourth house to a
conscious and more or less stabilized feeling of being a particular
person with a particular character and certain basic beliefs and values,
on the basis of which the person acts, expresses himself, succeeds
or fails, learns and suffers on the path of self-transformation. This
self-transformation implies a change of polarity. The individual
comes to realize that, willy-nilly, he or she is a component part of a
larger whole. This is often a confusing realization which leaves one
quite insecure, faced, as it were, with a great question mark on the
horizon of consciousness. What am I supposed to do? Will I be
able to do it well?

The child very likely does not ask himself these questions, at
least not in a basic sense, because he normally takes for granted his
belonging to a family and an environment. He tries to express him-
self in it, is hurt, learns, etc. It is normally at puberty, with the
rise of sexual energies, that the feeling that some power far greater
than his limited consciousness arises. The human species claims the
child—he or she has to perform a special function, he or she has a
biological, personality-transcending purpose. The adolescent is also
increasingly claimed by his society as he goes to high school and
college. He finds himself operating in a field of activity in which he
is not sure what is demanded of him, or whether he likes and can fit
in with these demands. He may be emotionally lost, he may rebel
blindly, he might escape into intense religious fervor and dedicate
himself to the God of devotees—the sublime Thou, Who is con-
veniently always there to listen and comfort, provided He is ex-
clusively worshipped.

In horary astrology it is said that the seventh house of a chart
cast at a certain time to answer an inquirer's question shows "the
result of the matter" inquired into. The *function* of an organism is
the result of his *identity*—first house. Everything is born to fulfill
a particular function. That function can be known only, however,
if the new entity is related to the other entities with which it has to
cooperate. "Life" produces males and females, but they are of no
value to the human species unless they function together. Each
person learns what he or she is, not only biologically but in terms
of the socio-cultural community, *only* as he functions together with

other human beings. This functional cooperation eventually produces something of value to the human race, to the particular society, or to both.

If a primitive man in New Guinea found an old airplane propeller lying in a field, he could describe its shape in detail and even build some kind of sculptural decoration around it; it has "form" and is made of substances which can be determined. It is an entity; but the New Guinea tribesman does not know what it is *for*. He could only know this, if he could be taught how it operates *in relation to* other objects, all of which are functional parts of an organized system with a definite purpose: that is, flying. If a man who never left city slums is sent to a forest and becomes attracted to the shape of an acorn lying on the ground, he may play with it, even dissect it, but he will not be able to see in it the potentiality of a great oak. He cannot know its function, its place in the cycle of vegetation, unless he can somehow relate it to the tree. It is only in relation to other entities that any single entity has significance in terms of living processes or of the organized activities of a communal or national whole.

The same is true, with some important yet perhaps not so essential differences, of a human being. We may know what he is made of structurally and biologically, but such a knowledge is necessarily incomplete until we see him function in relation to other individuals and within a collective social-cultural field of activity.

Function suggests purpose, and both are inherent and potential in what a man *is*, but they are revealed only as he *operates* within the larger whole within which he is a participating unit. Theoretically, the purpose of an individual existence is fulfilled in the tenth house, but this fulfillment—positive or negative, partial or complete—results from what was established or realized consciously at the level of the seventh house. The quality of a person's relationship to others at the functional level is the foundation upon which he will achieve or fail to achieve whatever has been the inherent purpose of his existence since he was born, whether or not he has been at all aware of that purpose.

Individual experiences related to the seventh house should all refer to activities which, at least potentially, have a functional character. The ultimate keynote of these experiences is *participation*; yet the experiencer may not be aware at first that he is participating in a greater whole—a community, or the human species. He may be

enthralled by his partner and the excitement of the partnership, or he may be confused by it. The glamorous feeling of coming to know and experience fully another human being in and through whom one may reach self-fulfillment powerfully affects the honeymoon period of the relationship. It is, however, often as the partners settle down to the everyday work involved in the relationship that its functional meaning becomes clear. The value of a public and ritualistic marriage ceremony is that, at the very beginning of the conjugal relationship, its social significance—how it is to be a part of family and group processes—is definitely asserted and solemnized. The expected presence of some result to come from the conjugal relationship—children, or at least some form of cooperative achievement—is made to overshadow the purely emotional tension and the ecstasy inherent in the relationship. It is for the same reason that a man entering an important public office is made to go through a public ceremony of inauguration or coronation. He is entering into a relationship which has a definite public function—relationship with new associates with whom he is to cooperate in the fulfillment of his task. He is wedded to a social purpose.

This act of being wedded to a purpose is inherent in all seventh house types of relationship, even—I repeat—if the individuals being related are barely aware of the basis of their association. But it is only in the eighth house that the responsibility which such an association entails becomes apparent to the partners, perhaps vividly and emotionally. As it may mean the "death" of some illusions, and the regeneration of the partners' egos, the eighth house has been called the house of death and regeneration.

Today the concept of marriage has changed so much that it seems as if the relationship of a man and a woman has no function other than that of bringing personal happiness, security, and emotional fulfillment to the partners, with no significant reference to either progeny—service to the race—or social-cultural achievement— service to the community. This, in a sense, is the result of the over-individualistic and analytical character of our civilization and its piecemeal consciousness which considers parts as if there were no whole in which they were meant to operate. These parts nevertheless are also wholes, which themselves are constituted by many interrelated and interdependent parts.

Today the answer to this, often taken for granted, is that a human being is a very special kind of whole which does not belong

functionally to any larger unit. From the point of view of the philosopher believing in "Personalism," every person is an end in himself, a kind of absolute. He relates to other persons, but this relationship is *essentially* personalistic; that is, it is not a part of any cosmic operation, it is not "functional." Society, mankind, the planet Earth do not constitute "organisms" of which human individuals can symbolically be called component cells. Essentially, each individual stands alone and self-sufficient, as a *monad*. Contacts made with other individuals have a purely existential character; they have value and meaning only in terms of what they bring to each individual *separately*.

All this may seem quite metaphysical and of little consequence to the astrologer, but actually the preceding paragraphs present the basic opposition between the two most important approaches to the relationship between two or more individual persons, and between these persons and both the organized social community in which they live and the human race as a whole. Whether one takes one approach or the other will fundamentally affect what human relationship, marriage, and partnership will actually mean in everyday life. The sad thing is that people today more or less unconsciously try to live partly in terms of one of these approaches, and partly in terms of the other. Thus a basic confusion reigns in all matters of human relationship—all seventh house matters.

The old-time religious approach to conjugal relationship and to any at least relatively permanent partnership in work having a social or cultural character was basically functional. Today this functional foundation is lacking in a great many instances. Individual meets individual just for the sake of development of their respective personalities. This, of course, can be very valid and constructive, but the relationship becomes an end in itself, or rather a means to assist the fourth house development of the essentially separate personalities, or the release of fifth house energies. When this is the case, then it is almost inevitable that sooner or later some eighth house type of experiences will spell death—or if all goes well, transforming rebirth—to the relationship.

To sum up: experiences related to the seventh house—that is, to marriage and all forms of more or less stable partnerships—can merely mean the *cooperation* of individuals, or they can mean *participation in a larger whole* to which the related persons are deeply conscious of belonging in terms of a common destiny or a

definite social-cultural purpose. The main issue in these relationships is not whether there is great love, or the deeply felt common interest of business partners, but what is the *quality* of this love or this common interest. The marriage may mean what the French call *l'égoïsme à deux*—a difficult phrase to translate, but meaning the union of two persons solely for their own mutual satisfaction and personal growth*; the business partnership may be entered into solely for the profit of the two partners with no concern for social consequences. On the other hand, the relationship may be consecrated to a more-than-personal purpose at whatever level it may be.

No astrologer can positively tell which of the two approaches a person will follow in his or her close and stable relationships, but the zodiacal sign on the cusp of the house, the place and aspects to the ruler of that sign, and the nature of the planets which may be located in the seventh house can tell a great deal that can help a sincere person eager to participate in a greater field of existence to determine what are the best conditions for such a participation, and perhaps also alert him to some of the dangers or tests involved in it. This may not make the relationship easier; it could make it more significant and more fruitful.

The most important point, astrologically speaking, implied in all the above discussion is that one should never consider the seventh house—or indeed any house—*alone* when interpreting a matter referring to experiences or problems dealing with this area of human existence and activity. The principle of relatedness, Descendant, and the principle of selfhood, Ascendant, constitute two independent polarities. What one is as an individual self will be demonstrated in the way one relates to other persons and to the world in general; likewise the results of relationships provide feedback which affects what psychologists today call one's "self image."

The pattern of individual selfhood—which at the biological level manifests itself in the genetic code within all the cells' nuclei—is a

* Years ago a Russian film, concerning a young man and young woman who were both fighting on two war fronts, was reviewed in the *Soviet Russia* magazine, January 1943. A letter from the boy to his beloved comrade was read saying: "In our time the fate of the world is being decided and that fate must be decided by us. We are facing a stern and militant life and I want to share this life with you." How important it was that the boy did not say "share *my* life," but instead "share this life with you." A shared participation in a new life: how different from *l'égoïsme à deux*!

permanent factor in the cycle of an individual's existence. Change in the personality comes through all types of relationships. Relationship is the creative—and in some cases, destructive—answer to the existential fact of relatedness. The seventh house is thus potentially the most dynamic of all houses. It is in this field of human experience that the person can be most basically transformed. It is also here that man experiences his greatest freedom—unless certain planets are very close to the descendant, planets which symbolize compelling pressures of destiny which alone can build through the magic of relationship the type of foundations required for the fulfillment of a powerful purpose inherent in the individual self. In such a case, the individual may find himself driven by this purpose to enter into a certain type of relationship, or into a relationship with a certain type of person, which might provide experiences that can serve best to dynamize the purpose of destiny, even if it be through stress and strain, or even tragedy.

Marriage, and other kinds of partnership as well, can be a field of unresolvable tensions. The experiences derived from these tensions can also serve the purpose of personal growth and lead to the fulfillment of the individual's destiny. The planet near the Descendant is normally a strong indication of how best to meet such experiences. They will be met at different levels according to an individual's stage of development and, one might add, according to the phase in the evolution of the "Soul" which this particular life embodies. A dialectical process can be seen at work here, as indeed everywhere, revealing three basic levels of relatedness.

At the basic biological and tribal level all relationships are subservient to the compulsive dictates of life and to the welfare of the communal group. Relationships are definitely purposeful and regulated socially by strong taboos, essentially formulated in view of what is naturally valuable and constructive for the tribal whole, though in time other preoccupations may pervert the original purpose.

When man reaches the stage where the individualization process begins to operate strongly, relationships take on a more personal character, but the basic relationship of marriage is still subject to the biological imperative and to the need to preserve and transmit cultural and religious values. It is only since the Industrial Revolution began to break down traditional patterns of relationship— actually not before the beginning of this century—that an intensified

kind of individualism and the revolt of women against patriarchal rules have utterly transformed the institution of marriage. Marriage has lost most of its social and institutional-religious character. It has ceased to be in most cases an affair determined by parents, social class, and financial values. It is now mainly a matter of two individuals coming together of their free will in order to enjoy a richer life in common. Thus the factors of selfhood and relatedness have received nearly all the attention and those referring to the tenth and even the fourth houses have lost their main importance—this, because the majority of marriages, at least in the United States, are without a sense of destiny and social or transcendent purpose (tenth house) and practically without very vital and solid roots, social as well as geographical.

A third level should now be reached, at which perhaps whatever is left of the marriage pattern will be even more transformed. At that level the relationship once more will be dominated by a common purpose—social and supersocial, spiritual or planetary. Truly autonomous and authentic individuals will be joining their energies, perhaps in a ritualistic manner, so as to work for a truly common and deliberately shared purpose—a functional purpose envisioned in terms of participation in the total evolution of mankind and of the Earth.

It seems evident that this third level of close and creative relationship—which can be, yet need not be, also procreative—is still inacceptable and perhaps unthinkable for the immense majority of humanity. But great changes may be imminent, and the emerging nonwhite countries may find in their ancient cultures features which will make it easier for *all* people to accept a new type of fruitful and superpersonal togetherness.

The Eighth House

THE LIFE OF AN INDIVIDUAL IS LIKE AN ELLIPSE WHICH has two foci, as opposed to the circle which has but one center. These two focal points, principles or tendencies around which gravitate the life and the consciousness of a human being, are, as we saw, *selfhood* and *relatedness*, represented respectively by the Ascendant and the Descendant. Because astrology refers all of its symbols and interpretations to the beginning of cycles—the first point of individualized existence, the first breath which relates the newborn organism to an open environment—the houses of the birth chart are numbered starting from the Ascendant, one through twelve. Cycles of existence, however, are not closed circles; the two forces derived from the principles of selfhood and relatedness dominate one half of the cycle each. The below-the-horizon hemicycle is dominated by the drive to actualize as fully as possible the potentialities inherent in the individual at birth; the above-the-horizon hemicycle, while still deeply affected by this process of self-actualization and the drive toward self-fulfillment, is powerfully conditioned by the character and the results of the relationships the individual must enter into if there is to be complete personal fulfillment.

For these reasons, while it is perfectly logical to number the houses from one to twelve, one should also take into consideration the fact that at the Descendant a new set of factors begins to

occupy the person's attention—factors related to change-producing and, at least at some level, purposeful relationships. Thus the Descendant is also, in this sense, the starting point of a series of experiences which require productive relationships—relationships which also inevitably transform the individual's outlook and consciousness in a basic way. The house numbered eight, if one begins with the Ascendant, should also be interpreted as a second house when one starts from the Descendant. Every one of the six houses above the horizon can therefore be said to have two fundamental meanings, one related to the Ascendant—principle of selfhood—and the other to the Descendant—principle of relatedness. The individual unfolds and actualizes his powers through the first six houses, and the relationships encountered in these six areas of existence are experienced and valued primarily in terms of the individual self.

In the same way, what becomes actualized and productive in the six houses which begin with the Descendant is primarily whatever the individual encounters in terms of relationships which have an increasingly dominant momentum and power—and this is so whether one considers conjugal or strictly social relationships. The individual henceforth focuses his attention less on his own self than on what relationships bring to his life. Eventually, of course, what these relationships bring will be fed back to his sense of self, and a new cycle will begin at a more conscious and mature—or, negatively, at a deteriorating—level of personal existence.

This does *not* mean that at any moment of his life a person has experiences only in the area of a single house. All houses are potentially involved in every moment of life—just as summer is implied in winter, and the icy polar wastes in tropical jungles. What the astrologer does when he gives definite meanings to a house field in terms of a cyclic process of personality-unfolding is to establish basic categories of experiences, and above all *the relationship* between these different categories, that is, the way in which they fit in with each other and one type depends upon and conditions the others. Every type of experience is potentially implied in every other, and each important experience can be related to a basic archetype. It is the relationship of the experience to this archetype which gives it its essential meaning in terms of the *whole* life of the individual.

Such is at least what a holistic approach to existence asserts. A truly full experience may be lived in the Now, but if there is a

character of true plenitude in the experience, every field of activity —every house—will be involved to some extent. Nevertheless, one field will be accentuated, and it is this accentuation, this focus of conscious attention, which will deeply influence the meaning of the experience and condition its results.

When the traditional astrologer speaks of the eighth house as the house of death and regeneration, his interpretation is based mainly on the correspondence so often—and in my opinion, unduly —stressed between zodiacal signs and houses; that is, the first house corresponds to Aries, the second to Taurus, and the eighth to Scorpio. There is some validity in making such correspondences, but usually it is just confusing. Zodiacal signs and houses represent two fundamentally different sets of values. They refer to different factors, even if the two sets of values are related in various ways— particularly from the numerological point of view. In the case of the eighth house nothing is to be gained from such a correspondence because Scorpio is one of the less understood signs of the zodiac and the most unintelligently maligned.

In the seasonal cycle of the solar year, Scorpio refers to midautumn. In temperate climates at that time the yearly vegetation is indeed normally experiencing "death." But within the process of disintegration and in the midst of the decaying leaves there are also seeds which do not die. To identify one's consciousness with the seed process is for the individual to rise above cyclic death, and perhaps to experience if not a transforming *mutation* or fundamental repolarization, at least to participate in the eventual rebirth of vegetation in springtime. Numerologically, and according to the Gnostic-Christian tradition, eight repeated at three levels is the symbolic number of the Christ (thus 888). The Christ *mythos* being centered around the Crucifixion and the Resurrection, this number 8 fits well the house of death and regeneration.

But the cyclic sequence of houses has another important meaning. It refers to twelve basic phases in the unfolding of the consciousness of an individual. Consciousness, in the western sense of the word, implies two opposite poles: selfhood and relationship. As no individual is born alone or without a past, the results of past relationships—karma—condition the new self, which in turn proves himself to himself and to the world by the way he meets and experiences new relationships. These relationships later on condition a new self.

Thus, astrologically speaking, the Descendant should be seen to begin a new process of which the seventh house is the first phase and the eighth house the second. The eighth house also refers to possessions, but—except perhaps in horary astrology in which every symbolic concept is personalized and interpreted in terms of separate events—the traditional interpretation of this eighth house type of possessions as "the partner's possessions" is inaccurate. What is indicated are the possessions *of the relationship*; that is to say, the eighth house refers to the whole existential situation which *the relationship* has to face in order to actualize *its* potentialities. It also reveals what is available to the relationship in order to become an operative factor in society.

Obviously what the relationship "owns" is what the partners bring to it. But it is not *only* the sum of the two contributions, for the moment there is a seventh house type of partnership the stabilized and goal-oriented interactions between the two partners adds a *plus value* to these contributions considered separately. The quality of the partners' relationship becomes an active and productive—or inhibiting and perhaps destructive—factor. This is a very important point. For instance, if there is a planet in a person's seventh house it will affect not only this person's capacity for relationship, but also the fruitfulness or the problems affecting the eighth house.

Moreover, just as no person is born in a void, so no relationship occurs in empty space. The space is *both* the biosphere as a whole, and the particular society to which the partners belong or in which their relationship starts and will develop. The biosphere provides the partners—according to climate, land, and season—with their basic physical needs; the society has established ways in which any partnership is to be conducted. The conjugal relationship has to meet social and religious-ethical taboos just as a business partnership has to be incorporated, to follow a set of regulations, to pay taxes, etc. The relationship has to *conform to precedents valid in its environment*. Society provides it with a great many opportunities, but with many restrictions as well. All of this refers to the eighth house.

The house, its cusp, and the planets located in it indicate how a person can best and most realistically approach both the opportunities and the restrictions involved in bringing the relationships he enters to a fruitful state. Fruitfulness may mean money, growth, influence, or it may signify that, through this relationship,

the individual will experience a valuable self-transformation and be able to reach depths of awareness and experience which he could never have attained alone.

Relationship should not be thought of only as involving two partners in an exclusivistic kind of conjugal or business association. Several partners, and indeed a group, can come together on a relatively stable and solid basis—certainly as solid as most marriages are today. Such a group can have a business meaning, but its purpose may be religious, political, or "occult." The group relationship usually operates through some kind of ritual: modern business is a long series of rituals, from the office and factory to Wall Street and its stock exchange; Army life is almost nothing but a painful sequence of rituals, ending on the battlefield. A whole city, if it were observed from above during a whole day, would present a motion picture of traffic rituals, congestion and decongestion, light and darkness. Religious organizations have their rituals. The purpose of all these rituals, and of all collective festivals, including concerts, operas, and baseball games, is to strengthen collective psychic bonds between the members of a particular society or group. In other words, the ritual is meant to generate the special *plus* factor that is produced when the group is psychically and emotionally integrated. There is even a physical or electromagnetic integration which takes place when human bodies touch and move together according to shared rhythms.

The rituals that various occult or mystical groups follow in their meetings, especially in the dangerous form of "ceremonial magic," have the same purpose as any social or religious rituals, except that they have, or should have if they are effectual, a still more conscious, deliberate, and often powerful purpose. *Mantras*, incantations, traditional gestures, and the use of symbolical objects may bring to a sharp focus their will-force as well as the emotions of the participants in the group. The rituals of the American Indians are quite typical of a certain level of this group operation, those of Free Masonry another. Indeed, society as a whole is founded on rituals.

It is only when individualism is intensely emphasized that the ritualistic patterns of social institutions may break down. But soon enough the rebellious individuals establish a new kind of rituals. The business of living alters its group formations, its standardized procedures, and its fashions, but the eighth house type of experiences

are always there to be faced. Sexual rituals, too, remain although fashions and moralities may change.

The basic problem is whether these daily rituals are to be given a positive, exalting, or emotionally enhancing meaning, or if they are to be experienced as a boring routine and drudgery. It is when facing such a problem that the ideal of the Practice of the Presence of God at every moment of the day acquires its beautiful and healing significance. Every ritual *could* evoke the Divine in its participants. It can achieve this realization only when the *quality* of the relationship between the participants makes the evocation possible—and thus their rebirth at a higher level of inclusiveness and egoless love.

In a society in which almost everything is affected by "business" it is indeed strange that this word is not mentioned in the traditional list of matters to which the houses refer. To think of the second house of a birth chart as the house of business is to miss what the word business, essentially implies. The second house refers to what an individual privately owns and what he can use to actualize his birth potential—whether the possessions are tanglible assets or psychological and spiritual capacities. The eighth house deals with business proper because any type of business implies some kind of contract or agreement involving at least two persons and being more or less legally guaranteed by society as a whole. Marriage is or was a contract theoretically valid "until death do us part," and guaranteed by legal and religious sanctions. Installment buying, mortgages, and all the varieties of exchange, whether or not they involve money, are based on interpersonal and social relationships, and this basically means *on trust*.

Three basic factors are implied in all matters which really deal with the eighth house field of experience: trust—which itself implies honesty—management, and responsibility. And back of them stands the broad seventh house activity of love—love as the capacity to give a constructive and integrating meaning to interpersonal, and thus social, relationships; thus, as the substantiation of the experienceable and concretized meaning and value of *togetherness*.

To participate in a ritual activity when one does not trust the participants can be very dangerous, even though this is what one does constantly when living in our modern society, particularly in modern cities; and this is why our society gives to the eighth house a mainly negative meaning. Politics is the negation of trust; and

until the very concept of politics no longer finds place in social and interpersonal relationships, social togetherness must have its bitter fruits in the eighth house, as well as some instances of bountiful harvest. Politics must be superseded by management in the social and business sense of the term. That is to say, the outcome of a relationship or a business contract—and the *plus value* generated by human cooperation—should be managed, not only for the sake of the participants, but for the sake of the relationship itself and of what it brings to society and to mankind *and the Earth*, the vast planetary organism in which mankind should perform a definite function, just as the vegetable and the animal kingdoms, the winds and the sea, do perform.

If a seventh house relationship is truly functional and purposeful, it is in the field of experiences related to the eighth house that this functional purpose finds itself *substantiated*. As it is substantiated and takes on a very concrete character, the partners must face up to the responsibility of whatever it is that the relationship brings to other persons, and especially to the whole community and to the Earth.

The cooperative activity of a couple or of a group produces various results, releases new energies, or creates new wealth. How are the fruits of this activity to be used? This is the basic eighth house question because this house is a succeedent house and all such houses—second, fifth, eighth, and eleventh—deal with the use of the power made available by what occurred in the angular houses —first, fourth, seventh, and tenth. In the second house an individual uses what he owns, and a certain kind of *personal* management is implied. But in the field of business, proper management takes on a *superpersonal* meaning, that is, the manager uses the fruits of group activity not for himself, but for the relationship between the group participants—thus for the firm, the government, the nation as a whole.

Responsibility means the ability to respond. Respond to what? To the conjugal or social situation created by the concrete results of a cooperative relationship. This means the ability to control, handle, and put to constructive social purposes the fruits of this relationship.

This responsibility applies to all levels of seventh house activity —to sexual activity as well as to business profits, or losses! Power is released. It may be substantiated as the conception of a baby, or as

both monetary gains and the pollution of air and water by an industrial enterprise. Every release of power can be both positive and negative—most often it is a little of both. Is the business profitable? What legacy does it leave for the future? And this means, above all, the future of the participants, for any relationship entered into and any signed contractual agreement will bring a legacy to the participants. It could mean death to the past followed by rebirth, or the kind of dying which surrounds the future with karmic ghosts and unresolved frustrations.

The eighth house is a very important house, but one that is hard to interpret in an individual's chart. It is in terms of eighth house types of experience that a person has to make perhaps his or her deepest and most vital choices. These choices will affect not only the individual, but society as a whole. In that sense, the Existentialist philosophers are right in saying that every man is responsible for the whole of mankind.

The Ninth House

EXPERIENCES RELATED TO THE NINTH HOUSE ARE ESSEN-
tially those encountered by an individual in the course of his search
for the meaning of things. This House, being a "cadent" House, also
refers specifically to matters which enable partnerships and all kinds
of group activity to operate most successfully and to expand within
the framework of a particular society and culture. This requires a
knowledge of the over-all conditions, procedures, and laws which
structure a particular society's way of life and the possibilities this
way of life presents for success and expansion. The ninth house
is traditionally the house of philosophy and religion, but it also
deals with all legal matters. It refers in general to whatever expands
a person's field of activity or the scope of his mind—long journeys,
close contacts with other cultures and with foreigners in general,
and those "great dreams" which reveal to the open consciousness
facing life-changes the meaning of past, present, and expectable
events as well as the trends of individual and collective destiny.
Experiences with seers, prophets, fortunetellers, future-oriented stat-
isticians, extrapolators, etc., also come within this ninth house field.

The ninth house opposes and complements the third house.
While the third house refers to the need of an individual to come to
terms with, and thus to know and understand, his close and personal
environment, the ninth house is an area in which he seeks to dis-

cover the significance of larger fields of social existence which he may not experience directly but which his mind may explore through the use of analogy, generalization, and abstraction. These two houses symbolize the two polarities of the human mind, the concrete and the abstract. Any fully developed mind operates in terms of a combination of both types of thinking, but nearly everyone will tend to favor one over the other. In our analytical and empirical age, the man with a scientific bent will naturally focus his attention on third house experiences; Louis Pasteur typifies this trend, as his birth chart reveals a complex aggregation of planets in the third house.

On the other hand, the metaphysician or the philosopher whose function is to synthesize data and to discover general principles could be expected to have a full natal ninth house. Such an expectation, however, is not too often justified, because planets in a house do not *necessarily* indicate that the individual will have outstanding experiences or produce great things in terms of what the house represents. A planet in a house indicates that the function signified by this planet *should be used* to its best advantage in dealing with the experiences to which the house refers; it should be used because problems will arise in that field of experience which can best be solved in this way. Where, however, there is no great problem in that field because the person is spontaneously able to handle what he finds there, the house may well be empty. One must look for another kind of indication in the zodiacal sign at the cusp of the house or in its ruler. The presence of the Moon's nodes may be significant and, as always, the whole chart has to be considered, for sometimes what seems to be an outstanding feature in a person is actually the secondary result of some more basic trait or faculty. An apparently great thinker may actually be a medium or channel through whom the collective mind, or even the mind of a partner whose influence may or may not be consciously acknowledged, operates.

In Albert Einstein's birth chart, Jupiter at Aquarius 27° is in the ninth house in opposition to Uranus in the third, and Pluto squares Jupiter. This can be considered remarkably symbolic as well as prophetic. Einstein's famous formula made possible the atomic bomb, a bomb which uses uranium and plutonium, the latter element unknown when Einstein was born and even when he established his Theory of Relativity. But while Jupiter in the ninth house obviously expanded his capacity for abstract thinking, and

Uranus in the third house made his analytical intellect sharp and impatient with old concepts, these planets refer just as much to the type of problems he had to face and how he solved them. These problems, of course, had a great deal to do with social factors—Jupiter—and with his natal environment, which he had to leave. Jupiter being the ruler of a very full Piscean tenth house dynamized by the Sun's presence would normally suggest that he would gain maximum professional and public influence in a foreign country.

In matters concerning the mind of an individual, one should always differentiate between "knowledge" and "understanding." The act of knowing belongs to the third house because it implies merely the direct contact of a person with something in his environment. Knowledge can be derived directly from sensations or, in a psychological and mystical sense, from an equally direct and as incontrovertible inner perception or realization. Understanding is a far more complex process because it involves the synthesis of many factors and known data. It is the result of a holistic process which actually implies as a background the experience of a people and their culture. One does not, strictly speaking, "know" the *meaning* of anything; the experience of meaning comes from understanding.

A synonym for understanding is comprehension. To comprehend something is to apprehend a togetherness of factors on which that thing depends for its existence and its behavior. In the deepest sense, to understand something or someone is to take into consideration the relationship of this thing or this person to the whole universe. You may "know" that a person committed a crime, but you can "understand" this action only by seeing it in its personal, social, and even cosmic—thus astrological—frame of reference. Newton "knew" that ripe apples fell down from the apple tree, but he "understood" this only when he could relate it to a universal law, gravitation. The most difficult form of understanding, of course, is one which refers to an action or a person in which the knower is personally involved.

The complex nature of the process of understanding and of the search for meaning leads in most cases to the use of symbols. The ninth house is the house of symbols. All words are symbols. Most gestures are symbols being consciously or unconsciously enacted. The mating dances of birds are symbols, and so are the human acts and body attitudes in courtship. All arts are symbolic, even if the artist refuses to admit this in his preoccupation with what he calls "ob-

jectivity" or random elements. This preoccupation in some modern artists and musicians is in itself a symbolic expression of a particular phase in a culture, and the artistic results symbolize such a phase. The clairvoyant who is asked to solve a client's problem usually visualizes a symbolic object or scene, or hears within his or her brain words which are also symbols.

Symbols have to be interpreted. Each individual interprets them in terms of what he *is*, what he *knows*, or what he *feels*— and/or has personally felt in the past—against the background of his culture and family tradition. A birth chart is a symbol as well. It symbolizes the complex relationship existing between a newborn organism and the universe. Likewise all religious concepts and mystical visions are symbolic of such a man-to-universe relationship. To speak of a "God experience"—a typical ninth house experience—is an awkward way of symbolizing in a word, God, the "feel" of the so-called "unitive" experience in which the whole universe is reduced to a unity upon which the person projects the answer to all his conceivable needs.

This does *not* mean that God does not exist! The very fact that we know we are surrounded by a *multiplicity* of objects, motions, energies makes it necessary for us, or at least for some human beings, to conceive or to feel the existence of an opposite factor, *unity*. The metaphysician may understand this fact, and its inevitable consequences, in terms of mental concepts, and he may formulate a cosmology or theology. The devotee and the mystic, in probably two different ways, feel it, and experience it as a consciousness-transforming intuition so realistic that it takes shape as some kind of Presence. But the word, unity, and the embodied Presence are nevertheless symbols. The whole universe, *as we perceive it,* is a symbol of our human and individual stage of evolution. This is why the Hindu philosopher called it *maya,* a word usually but not adequately translated as "illusion." Symbols are not illusions! They are projections of what we are, generically, collectively, and individually. But we need them in order to operate as human beings. They are the expressions of *the quality of human togetherness* at any particular time and place.

What we call "the law" is also such a symbolic expression. The laws of a society reveal the basic character of the togetherness of its members—and often the ideal rather than the actual quality of a particular way of life. Social reality often gives the lie to the ideals

embodied in laws. Yet from the point of view of a business opera-
tion, or even of a conjugal relationship, these laws must be "known"
—the ninth house is a third house starting from the Descendant,
principle of relationship—even if they are to be circumvented. The
ninth house represents the environment of the relationship, just as
the third house represents the environment of the self. Knowledge
of conditions in any environment enables one to function as suc-
cessfully as possible.

In this sense knowledge is power, or rather knowledge is the
way to achieve power. And while power at the personal level is
represented by the fourth house, at the social level it is a tenth
house matter.

The danger one faces in terms of ninth house experiences is
overexpansion caused by ambition and greed for power or the sym-
bol of social power, money. Ambition is the negative aspect of
understanding, for it implies a compulsive egocentric approach to
human relationships. The ambitious egocentric person *uses relation-
ships* to increase his power and/or prestige; he makes a relationship
his servant, and those to whom he relates slaves to his purpose.
Thus the relationship is perverted and eventually becomes at least
potentially destructive of the harmonious and wholesome life of
the greater whole—the society or the planet itself.

I stated above that selfhood and relatedness are the two prin-
ciples basic to all existence; harmonious and sound living demand
their interplay. One waxes in strength at certain times while the
other wanes, and vice versa. But each should retain its true nature.
When one of them succeeds in adulterating the character or the
essential purpose of the other, human life takes on a discordant,
tense and inherently destructive quality. The disharmonic process
begins in most cases in terms of third house experiences, that is,
because of destructive environmental pressures or shocks to the
sensibility, the nervous system, or the personal mind. It may be
focused further in the fourth and fifth houses, as the personality of
the growing individual becomes frozen in fear, distrust, or resent-
ment and he experiences repeated frustration in his efforts toward
self-expression. Then, he learns through sixth house experiences
that the basic choice left to him is between being a master or being
a slave. As a result, he can no longer experience love, sharing, trust;
so he begins to act within groups and with his partners in terms of
greed; he seeks to hoard the power generated by society and by

group relationship. This may mean amassing a large amount of capital as a means to reach the top level in society, and it implies twisting the laws—natural as well as political—so they become tools for his rise.

In such cases there is no question of harmonic understanding, only of the kind of knowledge which serves ego ambition. It is knowledge that can be used *against* the harmonious fulfillment of relationship, against love. It is the knowledge of a perverted mind, or it may even be the knowledge gained by researchers who seek knowledge merely for its own sake and in the process add to their personal fame. It is knowledge in which wisdom is absent, knowledge which does not consider the end results of what is known and formulated for general and nondiscriminating social-political use. Indeed, it is the kind of knowledge that our society holds in high esteem because ours is a society imbued with the competitive and ambitious spirit, worshipping success and power with no concern for the means used or for what these means have done to the quality of the relationships which made possible the rise to power of the ego-centered individual.

In such a society the mind all too readily becomes an instrument which tells how to use the energy released by group relationship and cooperation—often compulsive cooperation—to achieve success. This is the mind of the politician, and of the black magician as well, for magic was the original way in which human energies could be used for a group purpose. The purpose may be one of healing or of providing the group with whatever is vital to its existence or spiritual growth. In such a case one speaks of "white magic." When, however, the motivation for the use of group power comes from group ambition or from the greed of the leader, when it is based on hate, or rooted in fear, then it is "black magic."

The eighth house field of experience witnesses the release of collective group power, whether physical or psychic—occult. In the ninth house one learns the laws and the techniques which make such a release truly effective. In the tenth house the power itself is experienced in a focused state; it has become a social force, for better or for worse.

The Tenth House

IN THE FOURTH HOUSE, HAVING ACQUIRED AN AT LEAST
instinctive realization of what life and his ancestry have made availa-
ble for him to use—second house—as well as a knowledge of what his
environment allows and gives him opportunities to do—third
house—the individual learns to stabilize and organize his energies
in terms of what he experiences to be basic factors in his personality.
He finds out where he belongs in the narrow field of his family, and
what stand, instinctively or consciously, he has to take as a person.
His character takes on definite form; out of the depth of his being,
and as a result of the interplay of all his organic functions, he experi-
ences power, or—if he has been conditioned by weaknesses or a
frightening or chaotic environment—powerlessness.

In the tenth house the individual meets experiences which re-
sult from the fact he has succeeded, or failed, in gaining a social
position—that is, a place in the complex ritual of social, public, or
professional activities. He is integrated, or fails to become integrated,
into the greater whole in which he has learned, or failed to learn,
to participate cooperatively. He has a place, a definite function, a
public status in his community. Because of this status he has some
degree of social power, which in our society primarily implies money
but in other societies might mean other factors also related to social
or communal power and prestige. In the broadest sense the term

office implies a function or role which an individual performs together with other individuals. He is an "officiant" in a vast collective ritual. It is this "office" which defines his stand in the community as well as what he has been able to achieve as an individual.

The tenth house is the house of achievement. A series of gradual developments, in which seventh house relationships are particularly important, comes to a head ("head" is in Latin *caput*, from which the word, achievement, is derived). These developments were potentialities within the original impulse, or *logos*—"word"—which the Ascendant symbolizes. First house potential theoretically becomes actualized fully in the tenth house, if all has gone well during the process of actualization which is full of pitfalls, obstacles, and possibilities of losing one's way.

The individual and the social position he comes to fill are, in a sense, polar opposites, as are the fourth and tenth houses. They should complement each other, as all opposites are meant to do. The combination of the right person with the office most meaningful to him constitutes the consummation of human existence, at all levels of activity. Such a consummation is rather rarely attained in our present-day anarchic society, which may explain the often visible contrast between the qualitative value of the person and the character of the office he fills. A man may find what he calls his "vocation"—a tenth house realization—but this does not guarantee that he will have passed satisfactorily through the testing process which allows him, and others involved in the process, to see whether or not he is actually ready for an effectual discharge of the duties of the office to which such a vocation points. In the tenth house an individual is judged by the only test that is existentially significant: the proof of works.

Can the individual, who believes he has a vocation, *perform?* To per-form is to act through and in terms of a definite form. A pianist performs a composition according to what the musical score demands, not only in terms of muscular virtuosity but of psychological maturity and understanding—ninth house characteristics. Is the would-be officiant truly able to fill significantly the office to which his vocation has drawn him? Can he be *trusted* with the power inherent in the office?

Any social office—any job or professional activity which has an organic and integral function in a community—provides the officiant with social power. The tragedy inherent in our individualistic and

supposedly democratic social system is that the performance of a social function releases its power largely, and often exclusively, in the form of money, and money is an abstract form of social power which can be hidden, manipulated, used for any purpose, and thus *inorganically* used. Sexual and emotional power which builds up in the fourth house may also be used inorganically and for abstract and unrealistic ego purposes, but this egocentric and nerve-stimulating or glamorous use usually leads to satiety and boredom, or illness. The use of money has practically no limits, because it comes to mean the use of power—most of all power *over* people. And the thirst for power can very rarely be slaked. This is the curse of money and the meaning it has acquired in capitalist society.

A man in charge of a social office, especially if this office is indispensable to the welfare of the community, may be confronted with crucial experiences. Especially if he assumed this function without having been truly tested, not only for his intellectual and technical skill, *but for the quality of his psychological responses to the type of decision he will have to make,* the individual may lack the love and cooperative will—seventh house—the sense of responsibility—eighth house—and the understanding—ninth house—necessary to the performance of his tasks. The results of such a situation are often tragically demonstrated by the behavior of policemen and Army men as well as of many congressmen, senators, and presidents.

In a truly "organic" democracy, the misuse of the power given to a person by virtue of his office should be considered *more* criminal than the misuse of purely personal energies, especially under emotional stress or physical deprivation, for instance, hunger. Thus if a policeman lacking self-control brutalizes people in a public demonstration, or takes advantage of his position—and of the fact his testimony will hardly be challenged in a law court—to blackmail someone whose favors he desires, or to extract money for "protection," such a behavior should lead, not to mere dismissal, but to criminal prosecution. This is a *social* crime, and as such it is more destructive of communal health and harmony than a *personal* crime such as stealing, or injuring some other person for purely personal reasons. In the same way, a general who sends his troops off to a useless death or who shows a clear incapacity for handling a military situation should not only be demoted, but criminally prosecuted. There can be no excuse for repeated inefficiency and emotional or stupid inefficiency in the performance of a public function, even if in many

cases it is the whole social system and its procedures for promotion which are largely to be blamed.

No social position should ever be held permanently by any individual, regardless of his character, or the value and efficiency of his performance; the security this involves, the protection from dismissal or even prosecution for irresponsible use of power or authority, is what causes bureaucracies to become cancerous growths in the body politic. Any public performer would very soon lose his or her popularity if his or her performance suddenly revealed deterioration, save possibly in the case of an aging public idol who has become a kind of historical figure that people long to see before he or she disappears. Yet a bad artistic performance does not necessarily hurt the community; the conduct of a war or the overforceful police reaction to a peaceful public protest does.

The glorification of the individual as an independent and unique fact of existence obviously has a valid purpose, especially during certain historical periods. But no person actually stands alone or can achieve the full actualization of his powers without the cooperation of society. Individual success is a myth. What succeeds is the society—and ultimately mankind—*through* an individual who has developed powers of mind or skills which are actually the result of the endeavors and struggles of countless preceding generations. In many instances, of course, a man reaches power and success only by crushing or despoiling many other human beings.

An individual who has reached a certain degree of efficiency in his social or official performance very often may experience frustration and enmity because the system—the *Establishment*—refuses to be transformed in spite of glaring inefficiencies and obsolescence. Social structures and institutions have a tremendous amount of inertia, that is, of resistance to change, and conflicts inevitably arise between them and individuals who have come to feel, love, think, and understand in terms of a new and more adequate level of relationship. These conflicts then lead to eleventh house type of experiences.

When in the above paragraphs I have spoken of a society and social values, I was not referring to any *particular social system, institution, or cultural standards*. It is not "the system" *in itself* or any particular kind of performance which was discussed, but the relationship between an individual or a small group and society as a whole. The particular kind of social system in which a man lives

may be dehumanizing or archaic, or a perversion of a beautiful original ideal; then the individual person may seek with valid reasons to transform or overthrow it. No individual, however, can significantly improve, reform, or transform what he is not personally and effectively involved in. In the tenth house field of activities he becomes involved, and he experiences the results of his involvement. And he has to be involved, whether or not he consciously accepts the reality of it. Even the yogi meditating in a mountain cave is involved, often very consciously and powerfully, but sometimes in a negative way. Northern Buddhism scorned the *Pratyeka Buddhas* who sought to reach Nirvana alone, with no concern whatever for the fate of the rest of mankind. What can be reached in this way is only an illusory Nirvana; in a new cycle the deserter will be forced to meet the karma of his "spiritual selfishness." There can be no realistic achievement that is not achievement within humanity, and essentially in terms of human evolution as a whole.

The cusps of the tenth house—the Mid-heaven—is one of the four angles of the birth chart. As we saw in Part One of this book, Mid-heaven of the usual astrological chart is *not* the real Zenith; that is a point in the Sky just above the head of a man standing erect on the surface of our globe. It is rather the point at which the meridian—a great circle which passes through the actual Zenith and Nadir—cuts the ecliptic, that is, the plane of the apparent annual motion of the Sun in the Sky from one vernal equinox to the next. The Mid-heaven is therefore a "solar" factor. It refers to vitalistic processes. It represents the consummation of organic and communal functions. It is significant mostly where a society operates in terms of biological values and of strictly natural rhythms, typically an agricultural society.

When a man reaches a state of true individualization and is able to operate as an autonomous and authentic self, his consciousness should be able not only to function or participate in a life-oriented community and in biospheric activities, but to contact a transcendent field of experience and a superphysical type of energies. According to the new level of astrological symbolism, this field is that of the stars—that is, of galactic space. As a man stands erect, his spinal column becomes a section of a line which *through him* links the center of the Earth and *one particular star* exactly above his head.

This star is potentially a great symbol; it represents that man's spiritual identity, his "place" in the vast galaxy.

Today in astronomical practice it is not possible to identify such a star, and perhaps it is best that this should be the case, considering man's present stage of evolution. Moreover, should we be able to determine this star we would not know what symbolic meaning or character to give to it. Yet potentially the star exists. If we see the galaxy as "the Womb of Souls," as the ancients did, then there is in this vast cosmic matrix one star that represents our unrealized and unembodied "Soul." Its "ray" passes through us when we stand in the tallness of our innermost selfhood. It is the symbol of our cosmic office, and that of the Mastery which each individual someday may come to realize and to allow to incarnate in his transformed total person.

The Mastery seeks the one who will embody its qualities and its power in consciousness and in transpersonal deeds. The great office seeks the officiant who would both fulfill his natal potentialities in the required performance, and at the same time become a totally self-consecrated agent and servant of its purpose. Two movements are present in the true consummation of an individualized person: the man aspires to, works toward, dedicates himself consciously and irrevocably to the purpose of a social—and eventually a planetary and cosmic—function. At the same time a complementary and synchronous "descent" of the archetype—or divine Idea—which this function expresses takes place to meet the individual person's "ascent." The Mastery meets the Master-to-be, and in this meeting Heaven unites with Earth, God with a man who thereby becomes an immortal aspect of Man.

This is the Transfiguration process, on the Mount where the Son of God and the Son of Man become one. The star above blends its rays with the tone of the self within the human heart.

The Eleventh House

JUST AS THE FIFTH HOUSE REFERS TO THE RELEASE OF powers which were tapped in the fourth house, so the eleventh house deals with the forms which the powers manifesting in the tenth house phase may take as they are released. The energies and faculties concentrated in the fourth house find their expression through mechanisms developed in the fifth house: procreative or creative activities, emotional outpourings of self, risk-taking and all kinds of daring, dramatic gestures in which the individual functions in solitary splendor or as a master of men and conditions. The fifth house is the house of the cosmic autocrat, the Sun, who pours himself into space in effulgent glory, and rigidly controls the motions of his planets.

In the eleventh house the power of society, of the collectivity or the group, is released through the individual. More exactly, this power is released through the activities the individual performs within the social unit—nation, class, church, club, professional group —to which he belongs. As he succeeds in establishing himself as a participant in society, the individual is able subsequently to operate creatively or pleasurably in the social environment his work or his prestige opens up to him. The experience he has gained in the tenth house makes it possible for him to set new social objectives or new professional goals for himself, or to relax in the company of

his fellow workers and friends. If this tenth house experience is vital and he meets it with real power and in real openness to the needs of the situation which confronts him, he develops a new vision, new ideals, and concrete plans for social or professional improvement. If his participation in the life of society has been superficial, passive, or based purely on the enjoyment of privilege, he is likely to seek one type or another of social escape, from tea parties to night-club follies, in the company of like-minded friends.

We saw in preceding chapters that the meridian can be considered the axis of power, while the horizon represents the axis of consciousness. In the fourth house, power is drawn by the individual unconsciously, or in purely subjective consciousness, out of the matrix of race, family, tradition, or environment. It is thereafter worked upon and personalized by the individual. It is power that wells up from the roots, from the soil, and ultimately from the center of our globe, which is the sustaining foundation of all humanity. Tenth house power results from the shared participation which has taken form in the seventh house, become productive in the eighth, and reached in the ninth the preliminary depth of understanding required to insure a valid framework for the building of civilization.

Tenth house activities provide this framework or blueprint. In the tenth house, the Indian caste system, the economic and mercantile patterns of the Roman Empire, the guilds of the Free Cities of the late Middle Ages, the "planned society" of many a tomorrow, are established on the foundations of the laws discovered in the ninth house. But a pattern or framework must be filled with substance and vitality. The power of the human personality, alone or in groups must be released in and through these plans. Law and ritual alone do not make a civilization. The interaction of many individuals keeps the workshop of civilization running. But just as a home without progeny—be it biological or spiritual—is but a structure, a society without the creative vision and the means to release the power of creative individuals is a spiritless structure which must in time disintegrate.

But what is the substance of that creative vision, and how does it grow in the minds and souls of individuals?

In discussing the meaning of the meridian, and of the Zenith, I said that the meridian is also to be considered as the line formed by a man's spine when he is standing straight. This erect spine is the

"I" made concrete and operative. It is the signature of man's ego power and his individual strength and responsibility. One of the poles of the meridian is the center of the globe—and beyond it lie all the unconscious forces of the inner life. The other is the star which shines at the Zenith of the individual's life. Rooted in center, a star on his forehead, the individualized and conscious human being becomes an agent for the release of the creative power of the vertical axis of all life, root and seed.

In the fifth house, root forces are active. In the eleventh house the new seed is being formed. And this new seed, in the human kingdom, is more than a mere duplicate of the seed of yesteryear. It is a new seed because man has the power to add constantly to his vision and to his creation. All yesteryears can be combined by creative man into a *new* tomorrow which need not repeat today.

In the words of Count Korzybski, the human kingdom has developed the power to *bind time*. Man can add to himself constantly because he can remember. Remembering, he can record his experiences and his deductions; recording, he can transfer what he has gained to new generations, which in their turn will do the same. Thus there is a constant process of accumulation and synthesis at work in humanity, and this is what is meant by civilization. There may be periodic Dark Ages, but even in these relatively "dark" eras civilization is retained *in seed*. Records are kept—in caves, in monasteries, through word of mouth. The flame of civilization does not die. No generation need start from nothing. Revolutions destroy the upper crust of society, but here and there a few remember and pass on their knowledge to avidly seeking minds. And lo! Russia, whose aristocracy and intelligentsia had been wiped out, arose in less than two decades to astonish the world with its initiatives in war and in peace.

What does this mean? It means symbolically that the stars at the Zenith continue to shine and to invest in creative individuals, who have learned in the seventh house the secret of "shared participation," the power of the celestial Company of the Seed. Humanity is an organic Whole. Humanity lives in its total essence as a firmament, as a galaxy. The "dead" as much as the "living"—and in a sense perhaps also the "unborn"—constitute a creative Host. Man is that Host. It operates through and fecundates with vision those individuals who are clear and strong enough, dedicated and powerful enough, to carry the burning torch of civilization.

In the eleventh house *every* individual's star of destiny, which shines at the Zenith of his living, becomes a vibrant source of power in actual operation. The realizations that fill the tenth house phase of experience are largely conditioned by what occurred during the seventh, eighth, and ninth house phases. When the Zenith is reached, however, some new power fecundates the sum total of these last mentioned phases. This new power is the power of the greater collectivity, of human society, of the nation, of the universal Whole. It is the power of the stars, symbolically speaking. And that power descends from above and crowns the individual who is fulfilling to the best of his ability his function in the work of the world. It is the "tongue of fire" which descended upon every apostle at Pentecost. It is the Holy Ghost. It is celestial power—the power of the community, the power of the Church, the power of God, when God is conceived as the soul and wholeness of the universal Whole.

This power that descends from above operates in the eleventh house as creative vision. Here, the substance of every creative tomorrow is gathered and vivified by the power of the constellation at the Zenith. Here, creative destiny is fashioned by brave hands and farseeing minds. Here at work is the *élan vital* which forever generates universes, the powerful and unpredictable surge of creative evolution which spots forth tomorrows in spiritual and creative freedom.

Astrologers have often identified all creative processes with the fifth house. But in the fifth house it is the individual who creates, strictly as an individual or as the head of a home, and his creation is essentially based on biological factors. In the eleventh house it is the Whole that creates through the individual, fulfilling its function in the economy of the Whole. It is creation, not *of* the individual, but *through* the individual. Christ—the universal Spirit—acts then through the transfigured humanity of Jesus. This action, then, releases the power of the Christ, the power of the Whole—the power which, if there is not to be stagnation and crystallization, must periodically renew the substance and form of the organism. It is action without personal concern for the fruits of this action. It is the only truly creative and free kind of action. The individual becomes a *clear lens* focusing Light and projecting upon all virgin soils the image of the Sun, or the celestial harmony of the Brotherhood of the stars.

Traditional astrology speaks feebly of the eleventh house as

the house of "hopes and wishes." How weak a conception for one of the most vibrant of all the houses! It is a Medieval concept for in a society completely ruled by biological and feudal patterns what else could the submerged individual, the "sinner," do but "hope and wish" for a better future? The only way open for a more creative action was to become a member of a Brotherhood, and thus to participate in secret in the creative impulses of humanity. It meant banding together with friends, with companions fired by a similar yearning for vision and creative social or religious change.

It still means today the communion of the few who together constitute the seed of a new day. In this communion there is power, and this power alone is a guarantee of immortality, or the ability to become always different while remaining the same. In the twelfth house the seed will perform the ultimate sacrifice in order to make possible a new world. In the eleventh house it gathers power around itself. It brings to a focus within its walls the universal and creative power of life. Life always wins in the end. Yet many are the seeds that perish and become manure for the future. To dream and to fashion ideals is not enough. The eleventh house is a house of activated and concretized power.

If now we look at eleventh house matters from a more psychological point of view we find that the type of experiences normally to be met in terms of this house have much to do with an individual's attitude toward achievement and social success, or the lack of them. Let us say that a man has struggled eagerly and persistently to achieve something, and he has obtained his goal. He has fulfilled his ambition and is rewarded for his efforts by a social position, and perhaps prestige or even fame. What will he do with his success? Or if he has failed to reach the desired goal, what will he be able to make out of his failure?

The eleventh house is a succeedent house and, as we saw, the keynote of these houses is the word *use*. Failure can be used creatively as well as success, and often more easily. Success as well as failure must be used wisely, significantly, and creatively. It is the use a person makes of either achievement or failure which establishes his worth. If a person proves in the tenth house that he can fulfill satisfactorily a public function, in the eleventh house he has to show—to himself as well as to his friends—what this success has brought to his total being, to the way he lives, feels, and acts in his social circle.

Or he must be able to show whether he has the courage and stamina to learn from and rise above his failure.

Success or failure can be used imaginatively and creatively only if one has not become entirely identified with the struggle for achievement. The average "man of action" unfortunately identifies closely with his activity. If he succeeds, he becomes a prisoner of the social pattern that defines what is expected of him; his efforts to reach the top usually have conditioned him to identify with the established character of his social or professional role and with the interests and way of life of all those who belong to his class or group. He has obtained what he *wished*; he has found *friends* in terms of his social-professional achievements. Perhaps he has joined a certain club, has learned to enjoy certain types of cultural activities, belongs to a political party or fraternal organization which is open to him because of his success, but he must always be on his toes, for this party or organization must be courted in order to achieve more, to produce more, to grow bigger and bigger.

If, on the other hand, a man has been frustrated in his endeavors or defeated by a system which he comes to despise or loathe, he finds friends among men and women who share his attitude of discontent and resentment. He then becomes a rebel, perhaps an activist and revolutionary. Or he may simply be a man fired with a zeal for reform, the kind of liberal reform he hopes to accomplish within the framework of his profession, or of the legal possibilities provided by some sort of implicit if not explicit "Constitution."

The type of ideals for which an individual works as a reformer or a revolutionary may have been built through various kinds of experiences—in his early environment, at home, with his loved ones, in a national military service, with partners and co-workers, through contacts with alien cultures or inspired religious men, and while performing his social-professional duties. Indeed, every area of activity—every house of his birth chart—can be involved. But the eleventh house type of experiences deal specifically with the exteriorization of a man's ideals in relation to people who share these ideals. These people become his companions; they are "friends" operating within a social-professional setup, or fighting against it. This is, strictly speaking, what friends are, for friendship—in this eleventh house sense at least—is not based as much on purely personal attachments—fifth or seventh house types of relationship

—as it is on a shared and effectively used orientation which means either the enjoyment of collective patterns or a revolt against them.

A rebellious attitude or a deep discontent with the status quo results from a basic problem inherent in all tenth house conditions. Essentially this is the difficulty of reconciling or satisfactorily adjusting two opposite factors in any social situation which has become stabilized or even crystallized, giving rise to formalism, bureaucratic routine, and privileges. On the one hand there is the value of individual freedom and personal initiative or imagination and on the other the established requirements of the office itself and the drive to perfection in any public performance. The problem may be solved in a negative manner when society seeks to enslave the individual to his office—making of him a depersonalized cog in a machine—or when the individual comes to consider the power and authority of his office as his own, to be used as he wishes. The results of these negative solutions to tenth house problems condition eleventh house experiences. They may produce rebelliousness or abuses of power and wealth which in turn lead to the revolt of the less favored and resentful underdogs.

As I have said, all social institutions develop a powerful resistance to change. Yet change they must, when their negative products have become unbearable. These products may be physically, psychologically, or spiritually unbearable. In any case, a universal process— the change of any overly dominant trend into its opposite—cannot be arrested. Men and women arise who embody such a process of radical repolarization of social values and, in most cases, of destruction of institutions and privileged groups or classes. These men and women are the Promethean spirits who incarnate the Uranian power of relentless metamorphosis—a power assisted by Neptunian compassion and the devastation of Plutonian catharses which leave nothing untouched, no idol left standing. They are the iconoclasts, but they are also the great dreamers of often premature transformations. They are usually persecuted; they may experience martyrdom, and perhaps rebirth.

The eleventh house is followed by the twelfth, and once more by a new beginning in a first house experience of creation. The absolutely full must be emptied before there can be room for new growth, new contents. Yet the eternal question remains: How much can be saved of the old? What was the now crystallized and rigid pattern worth when it was fresh and vital? How can one save the

seed, the spiritual harvest of experiences of the past? To answer this question, a sharp, penetrating, intense, yet objective inquiry into the fundamental value of much that a society has so long taken for granted is necessary. The historian endowed with a holistic vision and a sense of structural developments has to cooperate with the emotional and passionate muckraker. Both operate in terms of eleventh house activity, but in different ways. Both are needed at the close of a cycle.

There are men and women whose task it is to dramatize discontent and protest; some of them no doubt enjoy tragedy and seek revolution as a way of life; poets and novelists find fame in baring the sordid and decadent, even within themselves. This way too is necessary, for the inertia of the average person is truly appalling and somehow has to be "earthquaked." But the deeper process is always, symbolically speaking, that of transforming a circle into a spiral—that is, of making it impossible for history to repeat itself. A point moving in a circular way will return exactly to its initial position, but if it follows a spiral pattern the return takes place at a higher level or in terms of a broader—and hopefully more harmonious—inclusiveness. Greater inclusiveness is a disturbing challenge to privilege and exclusive possession; thus the struggle goes on. And the great key to victory and progress is the conquest of fear. The greatest fear may be that of losing one's precious identity as an individual ego. In all "succeedent" houses the negative aspect of life as a relatively isolated being has to be surrendered.

The "pure breath" of potential individuality, related to the Ascendant, clings to its isolated status and to its proud craving for originality. It must surrender at least some of its claim when it has to use materials which a long line of ancestors have built or refined —second house—materials which, as a spiritual factor, it felt to be inferior and merely to be used as it wished. In the fifth house, the experience of emotional desire or passion and of caring for a progeny can mean a surrender of ego pride, the giving up of security, home, rootedness—fourth house matters. In the eighth house type of experience the bliss of the honeymoon—seventh house—fades out, as its exclusivism and glamor are rudely challenged by cooperative requirements and the pressures of the marketplace.

Finally in the eleventh house, the show of success, the special power and privilege of position—tenth house—when they feed pride and pomp, must be surrendered if the individual is to face reality

and to accept the possibility of rebirth. He can maintain his position for a long or a short time, but everything based on exclusive possession, pride, and self-glorification through the selfish use of social power faces inevitable decay and death—a death which, when the time comes, will direct a heavy karmic host toward the new birth. The moment of choice is known through experiences which belong to the eleventh house, but that choice has been conditioned by crucial experiences related to the second, the fifth, and the eighth houses. The cadent houses, then, witness the outcome of these choices. In the twelfth house we find the final result, the seed of all future karma.

The Twelfth House

THE TWELFTH HOUSE CLOSES THE CYCLE OF HUMAN
experience. It is the last stage in a process which may be repeated
during the lifetime of an individual, or terminated by what we call
death. In the twelfth house the individual either consolidates his
successes into the seed of a new cycle of growth, or he meets the
accumulated results of his failures. Indeed, there is practically no
man who has not achieved some kind of success and experienced
personal or social defeats. In the last house of the cycle, man is
unavoidably confronted by his successes and failures. His memories
of the past, conscious or unconscious, crowd over the threshold in
front of the new cycle. They are Angels of Light beckoning to the
beyond, or they are dark Guardians of the Threshold, whose features
are shaped by his frustrations, his denials of life, his fears, his sins
of omission as well as commission. The individual must face this com-
pound entity which he himself has created. He must go *through*
it, whatever the cost—if there is to be for him a new cycle.

Nevertheless, there must always be a new cycle, even if it is one
that follows the loss of the physical body. Thus there is no real
escape from the confrontation. Still, the conscious ego that is bent
upon beginning, or is fated to begin a new cycle of life in the same
body, usually comes to believe that he can escape the ghostly shapes
crowding at the gates of rebirth. He struggles frantically in the dark,

unable to accept or to bless, to redeem or to overcome. Tormented with pain at the memory of his failures, or oppressed by fears of what the new cycle will bring, he cries for help and light. And help does come—but often unnoticed, for he may be blinded by the darkness and haunted by the ticking of the clock of time, which seems always to run too slow or too fast.

Yet this darkness can be borne if man realizes that only by letting go of the lesser is it possible to be born into the greater. There is light, too, at the core of the seed which waits for the promise of renewal inherent in spring, but this light is a strange and disconcerting glow which makes all things take unexpected shapes and all events become mysteriously symbolic. It is such a strange light because it seeps through the fog of the accumulated past from a faraway reality. The Universal flashes its signals to the particular man; the Whole bathes the part in a sea of new life-giving blood. Under this light our limited concepts shine with an all-inclusive vision of life, like dark rocks transfigured by ultraviolet rays into fantasies of color.

The twelfth house should be understood, above all, as the last phase of the semicycle which began in the seventh house. In the twelfth house the realm of the Sky ends. It is in this above-the-horizon realm that man's experiences find themselves centered around the feeling of participation in society, or in a universe of all-encompassing Spirit. Participation in the social or universal Whole has become definitely and concretely established in the tenth house, at the Zenith. The energy produced by such a participation has been released in the eleventh house. The power of the group has flowed through the individual, as this individual performed his social or professional work. If the tenth house experiences have been vital and squarely met, the individual may enjoy the pleasures of culture and friendship, or he may seek to picture new social ideals, new hopes for a better future. He may enjoy his present, and he may create new tomorrows for himself and for all men. The source of such a creative act is the vision that was born in his communion with the Star shining at the Zenith of his being, a communion which had to be made real and concrete through constant work.

While discussing the meaning of the eleventh house I said that in it the Whole works through the individual so he can fulfill his function in the economy of this Whole; it is creation, not *of* the individual—as in the fifth house—but *through* him. What, then, of

the results of this creation? They may appear strange to our minds, which are so strongly hypnotized by our separative idea of what individual selfhood means.

If in the eleventh house we have acted as creative agencies through which the power of society—or of our particular social group—could be released in the traditional manner as determined by collective ideals, culture, and religion, then it is only natural that we should have been influenced, or molded, by the character of these ideals. If we live in a materialistic, decadent society, and if we have let it act through us without questioning its validity, can we hope to escape the inevitable fate of such a society? If we sing and dance in irresponsible pleasure while the world goes to its doom, must we not feel within our subconscious, if not consciously, the impact of this doom?

To the individual, the impact of collective destiny is *fate*. What he must remember, however, is that in the twelfth house he must face the ultimate, logical effects of tenth house causes—and, more distantly, of causal factors going all the way back to the preceding angular houses—first, fourth, and seventh. In the tenth house we met the needs of society; that is, we chose, or we were led to a profession, or a social position of some sort. We met these social needs under the distant—in rare cases the close—guidance of our Star at the Zenith. We establish our place in the larger pattern of things. From here on, the power of this larger social or universal pattern has to be the dominant influence in our lives. It is dominant *whether we accept it passively, or rebel against it; whether we play the game with our fellow citizens, or act as reformers, revolutionaries, or criminals.*

In the twelfth house we meet the results of our passive conformism, or our spiritual rebellion. We face the karma of society in a subconscious and blind manner, or we face our karma as individuals who fought society, for the sake of our own selfish interests or for the sake of a better world. Either we go to sleep spiritually, accepting traditions and precedents with comfort, or we bear the burden and the consequences of our ideals and our efforts to incorporate our vision among men. In many lives, both these possibilities are encountered simultaneously in varying proportions.

Just as the fourth, fifth, and sixth houses can be said to represent three different types of ego expression, the tenth, eleventh, and twelfth houses represent several types of *collective expression*. And

just as the sixth house denotes a crisis in experience and a transition between the below-the-horizon and above-the-horizon realms, so the twelfth house also denotes a critical state between two worlds. The individual who has been dominated by social and collective needs is struggling to emerge from the *set of conditions* which have bound him to a social or spiritual pattern, and to be reborn as a new individual. This, too, means repolarization and reorientation, but not in the same way as in the sixth house, where the individual has to work through personal conditions and the need for self-discipline. In the twelfth house, what is to be met has its source in collective issues, in national or social fate, in the pressures of society upon the individual, and of the collective unconscious upon the conscious ego. In both houses much pain may be experienced, but the pain that comes from the metamorphosis experienced in the twelfth house has a poignancy and a quality of inevitability which may make it harder to bear. One has no recourse against the universe, save to be reborn out of the universe.

The twelfth house contains the seed of that rebirth. This is shown symbolically in the fact that the horizon—which is the line of demarkation between the twelfth house and the first house—is curved. However slight it may be, there is significance in this curvature which bends the cusp of the first house downward, from the point of view of the twelfth house. We might say symbolically that the whole weight of the Sky presses upon the horizon. The Sky imprints upon the soil the seed pattern of the new destiny and the seed of the future cycle is released from the past. According to the ancient tradition of Indian philosophy, the last thought held in death determines the pattern of the future incarnation.

We may think of this merely as a symbolic statement, but its basic truth can hardly be challenged. Every birth is a new Act of God; but the soil into which the seed is sown and the very substance of that seed are products of the past. What is new is neither soil nor seed substance, but the God-bestowed power in the new entity *to shape to new ends these conditions inherited from the past*. It is this power which the Ascendant represents, and which the symbol of the rising degree of the zodiac helps us to interpret. This power is the real Identity of the individual, if he succeeds in reaching the state of truly individualized selfhood. It is the mystic Name of the newborn.

This individual Identity may operate or it may not. The collective power of the memories accumulated in the twelfth house—

what is called karma—may be so great that it stifles the individual Identity of the newborn, or drowns out the Tone of the new cycle of the man facing the possibility of rebirth. If this is the case, then the new cycle tends to become no more than repetition of the old, under only slightly changed conditions, and the power of the Collective will constantly challenge and perhaps entirely overwhelm the individual spirit struggling for identity. But if the confrontations experienced in the twelfth house have been met successfully and the individual has absorbed and assimilated the darkness represented by the "Guardian of the Threshold"—the memories and complexes of the personal and collective Unconscious—then, the Tone of the new cycle can ring out clearly. The individual, conscious of his true Identity, is able to use for his purpose of destiny whatever conditions have been inherited from his past and the past of his race, from his parents and from humanity.

The past must be used if an individual is to tread the path of creative accomplishment. The creative life is a constant synthesis of past and future in a radiant present—a synthesis of memories and of goals through a creative act. It is a life of plenitude and consecration. Individual Identity, Personality, Love, and Participation in the organic life of the Whole—these are the cornerstones of the temple of fulfilled manhood and womanhood. They are the four angles of the birth chart, the glorious cross of human living.

One of the stranger characteristics of our western civilization has been its refusal to think and feel in terms of cyclic processes. Such a refusal can be traced to a decision of the Council of Constantinople in the fifth century A.D., which prohibited belief in reincarnation and in all similar cyclic processes; but it is probably inherent in the particular emphasis which singles out western society and its essential function in the historical development of mankind, that is, an emphasis upon a definite break from all traditions of the then ending "vitalistic Ages." Our civilization has always emphasized, often with tragic results, man's capacity for transcending his natural biopsychic state—the state which dominates all instinctual and tribal forms of social organization, especially those related to agricultural and cattle-raising occupations—and to effect such a transcending through the use of intellectual analyses and mental abstractions. This requires separation of the mind and its organizer, the ego, from natural instincts and, in a sense, from all natural processes. It impels the ego mind to glorify itself in opposition to biological

demands and to imagine itself supreme ruler of life functions and their cyclic rhythms. But the mind alone can barely resist these natural drives and biological compulsions, often glamorized as "the great passion" or under other mythical images; so the Christian religion had to become its ally in the effort to transcend those life functions dominated by natural rhythms. This alliance gave rise to an implicit belief in the availability of *only one* life in which to achieve the goal of spiritual transcendence.

Only one short life available for such an achievement! This means that every moment in life should be strained toward the difficult goal; no time could be "lost," no effort spared. In order to succeed, one has to relentlessly control the energies of one's inner nature as well as of nature in general. All this inevitably led to considering death as *the* great tragedy against which there was no recourse. Dying and living are both parts of the natural cyclic process, but if man's mind and ambitions or desperate will could to a large extent control living processes, he seemed helpless to overcome the last and insurmountable enemy, death. Death had to be postponed at all cost—even at the cost of other people dying. Here we have the ultimate purpose of "black magic," and also of the kind of wars we wage now, not only against men of other nations or races, but against nature and its ecological balance, which, in preserving itself, takes no account of what must die and is not particularly concerned with *natural* dying.

In India and Tibet some men also have been driven by the will to transcend nature. But the natural forces they undertook to control and transcend were instincts and desires *within individual persons*. The kind of mind that was being used in this process of transcendence and in all ascetic practices was not analytical or intellectual, but mainly a holistic, imaginative, and integrating power *within the single individual*. It did not involve social functions and the organization of the communal life, but the at least relative and mostly inner isolation of the individual from society; in this isolation he found happiness and peace in being attuned to the cyclic rhythms of nature. As a result death was not feared, because it was seen to be no more than a phase of the all-inclusive process of existence. The yogi sought consciously to experience death in such a manner that dying would lead, either at once or after a phase of spiritual assimilation, to rebirth—as it does in nature. This gave rise to the general belief in "reincarnation" which was *personalized* for popular con-

sumption but whose universalistic and personality-transcending meaning was retained by the wise.

If death is not feared and the belief in the availability of "many lives" for the gradually evolving "soul" or monad is accepted, then a definite process of *conscious preparation for death* could be devised. This process was to be entered into quietly during the last phase of a person's life. Living and dying were polar opposites, very much like *yang* and *yin*, and when the life polarity had waned to a certain degree, the death polarity would gain the upper hand. This was the time to prepare for a significant, peaceful, and noble death.

This, in astrology, is the most positive and beautiful meaning of the twelfth house. It *can* refer to experiences which consciously and peacefully are related to the task of bringing a process of activity to a significant and not unduly—and especially not unnaturally—prolonged end. This can be, and indeed is, a difficult task, not only when related to dying, but whenever a person tries to bring to a meaningful and convincing conclusion whatever activity he has undertaken.

Any person who has had to improvise a speech after a dinner party knows how difficult it is to bring his talk to a convincing and significant end. When coming to the close of their speech many speakers fumble, repeat themselves, go from climax to anticlimax, and perhaps at long last let their words die out wearily and inconclusively. Their listeners by that time have become tired and their minds promptly dismiss or forget whatever might have impressed them at some point of the speech. The composer of music, the dramatist, and the novelist often find the same difficulty when confronted by the obvious necessity of bringing their works to a conclusion. It is relatively easy to start something; the natural impulse of life within the individual, the emotional eagerness to express himself can do the starting—and the people's attention is not yet well focused or critical at the beginning. They are warmed up only gradually and will forget how the thing began.

But nature in man will not produce a significant conclusion, worthy of remembrance. The natural end of everything is exhaustion —one gets exhausted and so do the people around you. The speech, or the individual himself, dies rather meaninglessly of old age. Unless the self, the spiritual being, takes control and, binding up all the loose strings of the great lifelong effort, gathers the most essential elements into an impressive and revealing conclusion, there

is danger that the great moment will become obscured by the setting dust of the struggle.

Everything that came before may be largely forgotten, but such a significant end will be unforgettable. It impresses itself upon the mind and soul of the people who are witnesses to it. Like a seed, it is the last produce, the consummation of the annual plant's life. The plant dies and the seed falls to the ground, but it contains within it the power of ever-renewed life. "Except a corn of wheat fall into the ground and die, it abideth alone; but if it die, it bringeth forth much fruit" (John 12:24).

Symbolically speaking, every great and significant conclusion to a prolonged human effort can be a "seed." Every cycle of experience, as well as every human life, can end with the release of such a seed. If it does not, then what remains is only a fleeting memory. The beauty of the flower of the cycle may be remembered, the leaves may have given shelter and food to some living creatures who lived more happily because of them; but if there is no seed, the essence and substance of the cycle of experience, of the speech, of the life are lost.

The body dies, but the value of the life may remain. It remains in a social form, in the memory of friends or foes, if the individual has been able to make a valuable contribution to his community. The value of an Edison shines forth in every electrical lamp; it has its undertones in any phonograph recording. But this element of value is not only a social factor. It is a personal and spiritual factor as well. By living, man adds value to his soul, for the soul is the granary in which the harvest of all cycles of experience is stored; this harvest is the very substance of man's eventual immortality in a spiritual body. When the granary is full, then man reaches individual immortality. He has overcome death, not by denying it—a futile gesture—but by learning how to die significantly: to die the death of the plant which is rich with fertile, life-renewing seed. The only tragic death is the one that comes in complete meaninglessness and utter weariness or boredom—that is, in spiritual defeat.

The art of bringing every experience to a creative end is the greatest of all arts—and perhaps the least practiced in our western world. What this art demands first of all is the courage to repudiate the "ghosts" of the past. It is this repudiation that is also called *severance*. There can be no real freedom in rebirth without conscious severance from the past, without either the ability to bring

the whole past to a significant and harmonious conclusion, or the courage to say "finished," and to dismiss the memory of what one must leave unfinished, unassimilated, unsolved if one is to enter the new life, the new cycle of experience.

Ghosts linger on, alas, with subtle tenacity in the unconscious—ghosts of things undone, of words unsaid, of small or big gestures which the heart and hands could not be made to perform. The speaker who sees from the clock on the wall that his time is over, that he must bring his speech to an end, may suddenly remember everything he had meant to say but did not. Will he try to crowd it all into a jumble of last-minute statements which would leave his hearers completely confused? Speakers often try this, and defeat themselves. One must have the courage to dismiss the things unsaid, the gestures unlived, the love unexperienced, and to make a compelling end on the basis of what *has* been done. This takes skill, of course, but even more it takes courage. It is a peculiar kind of courage, a psychological kind, but it is courage of the purest type and often far more difficult to summon than the strength to die well in the excitement of battle. The nature of this courage is usually neither recognized nor well understood. It is not an emotional or physical kind of courage. It is partly mental, but mostly it is an act of spiritual will. One takes one's loss and one goes on anew, knowing full well that some day, in some place, the ghosts dismissed will be met again. But if, in the meantime, one has grown enough and established oneself at a higher level of consciousness and power, one will know better how to deal with the unfinished business.

Astrological textbooks repeat that the twelfth house is the house of karma and of bondage. But it is also potentially the field of fulfillment and the symbol of the perfect end which is the prelude for a more glorious future. What the natal twelfth house indicates is how one can reach perfect fulfillment, if one can reach it at all. It does not say whether or not one will reach it. It does not say whether or not one will leave many waste products and much unfinished business at the close of one's life cycle or of any smaller cycles. It does not say whether or not one will be able to dismiss one's ghosts—dismiss them with a blessing and courageously renew one's mind and one's life. But it tells something concerning the nature and insistency of the ghosts one has to deal with; and it gives a general picture of the subconscious—the realm of ghosts and of the remains of problems unsolved or experiences unlived. It suggests

the best way to deal with one's ghosts and with the disintegrating products of the subconscious.

The twelfth house gives as positive indications as any other house. There are indeed no bad houses. But there are fields of experience in which crises do occur, and *must* occur for the sake of a greater future. In the sixth house, one meets crises that involve preparation for the life of relationships—the field of the seventh house. One must meet these crises successfully if one is to experience true partnership and the deep, vibrant sense of sharing steady companionship. In the twelfth house, crises result from the way one has worked out one's relationships to the community, or to the culture and its values. In the twelfth house a man meets the results of his social and professional failures or frustrations, but also those of his successes and his gains. Above all, he meets the less obvious results of the methods he has used in order to reach fame and power, or of the laziness and inertia which have brought him inner or outer defeat. Many achievements indeed produce a shadow as dark as the attainments were spectacular. Success often engenders resentment or enmity, or might inflict misery or even death upon others. One should be aware of these negative results and also of the fears, the sense of guilt, the remorse, the nightmares repeating past tragic scenes one cannot stop—the shadows which our own actions have produced, directly or indirectly, willingly or unwillingly.

The only way to deal with a shadow is to illuminate it by use of lights focused upon it from different directions. One must not become frightened or frozen up. Ghosts and shadows will vanish when subjected to the light of understanding and compassion.

Astrological tradition assigns to the fourth house the meaning of "the end of things," so the reader may wonder how this fits in with what has been stated in the foregoing paragraphs about the twelfth house. This apparent contradiction can be resolved if one realizes that the end of which the old astrologers spoke was a total end, an end that did not imply a new beginning. In the twelfth house, the individual faces an end which can and does become a beginning—a transition between two cycles. He stands on the threshold between two conditions.

But let us suppose that he stumbles over that threshold and collapses; that as he meets his ghosts, they overcome him. Then the new cycle is not a rebirth, but a descent into the abyss of final and total disintegration. He has missed the crucial moment of transforma-

tion, and he descends progressively through the first, second, and third houses to reach bottom, the ultimate end, in the fourth house.

In everyday life, many things do die without any conceivable return, at least insofar as our personal consciousness will ever be able to know. In horary astrology, when a person inquires about a particular concrete matter, the fourth house of the horary chart refers indeed to the *end* of the matter. Yet what seems very dead may leave ghosts; in this case, the remains of the matter one thought ended will come back to obsess the individual in the subconscious.

Nothing should be allowed to die a final death; everything should be transformed and transfigured—transformed in the eleventh house and transfigured in the twelfth. Every cycle of activity, as it comes to its eleventh and twelfth house stages, should theoretically become transfigured into a new beginning of activity at a higher level. Nothing comes to a dead end unless at some crucial time of crisis and opportunity it has failed to become transfigured or translated into something new and greater. The symbolic place where it can become so translated is the twelfth house. It is only when this translation has failed that the ultimate fourth house end comes inevitably by progressive stages—in the first, second, and third houses considered in a purely negative sense as phases of disintegration. The twelfth house is, therefore, a most profoundly important field of experience, with a meaning that extends far beyond the superficial one attributed to it by classical astrology. It is indeed a house of mystery, for all transitional stages are filled with mysterious and unknowable or irrational elements. These too must be met, in whatever form they may take. They should be met armed with a clear understanding of the entire sequence of past experiences, with courage and with faith, as well as with compassion. Such meetings are promises of immortality.

The Three-level Cycle of Individual Experiences

IN THIS BOOK I HAVE DEFINED THE NATAL HOUSES AS SECtions of the *space* surrounding the new human organism as it takes its first breath, thus establishing its primary and basic relationship with an open environment, the universe. As I went on interpreting the meaning of houses as fields of experiences, however, it should have become clear that what was pictured is actually a cyclic series of twelve phases in a process of individual unfolding; and any process, of course, implies the factor of *time*. Thus there is some degree of ambiguity in my approach. This ambiguity nevertheless simply refers to the most basic fact of existence—the fact that it takes time to become conscious of all the implications of existence in surrounding space.

We may put it differently by saying that time is the measure of an individual consciousness' inability, at whatever level this consciousness operates, to experience at once *all* that it is possible to experience. An individual consciousness operates in terms of the capability of a structured mind and of its instrumentalities—the brain and the whole nervous system—to perceive, relate, integrate, and interpret stimuli of various types. This capability is limited;

the mind can absorb and process only so much at a time. It is the limits of this capability which determine the relation of space to time; the more limited the mental ability, the more time is necessary to scan and react to the whole of the surrounding space.

All possibilities of experiences open to us as human beings, born at a particular point in space, are correlated, and they interact. Thus, as I have said, an individual theoretically can respond to life at any moment in terms of all the houses. If he rushes out into a fifth house love affair or procreates a child, the seventh house quality of his relationship to another human being, his professional achievements, his friendships, and his dreams may be involved *in the background*; as, of course, are his self-image—first house—and his possessions—second house. Nevertheless, his focus of attention will be on the love affair; his ego-consciousness will be centered in this type of experience. It could not be centered in this manner if he were only three years old, simply because the glandular and brain functions required for such a focus of attention and the subsequent arousal of specialized body energies would not then be sufficiently *actualized*, even though they exist in a latent condition.

We are therefore dealing with a gradual process of self-actualization, that is, with a growing person. This growth takes place, or can take place, at three specific levels—though here again the distinction between these levels should not be made too sharply. A "higher" level may be already partially reflected upon and illumining a lower one.

In my book *The Astrology of Personality* (first edition, 1936, page 229 and following)* I described in some detail "the Unfolding of the Individual Self," and the reader is referred to what is said there. The matter was also discussed from a somewhat different point of view in *New Mansions for New Men* (1938, Part One: Prelude, pages 3 to 11). What was stated in these works can be summed up in a few paragraphs as follows:

The experiences of a person having achieved a consistent state of individualization can take place at three basic levels, and the natural process of growth in personality—in the broadest sense of the term—is cyclic; as I already said, each cycle theoretically lasts 28 years. The number 28 can be shown to be "the measure of Man,"

* A paperback edition by Doubleday & Company was published in 1970 and the reference is to page 212 and following.

especially of Man in an individually conscious and self-actualizing condition of existence—man as we ideally imagine him today, "archetypal" man.

During each 28-year cycle a human being normally focuses his attention successively upon, and symbolically passes through, each of the twelve fields of experience represented by his natal house. Step by step he takes as full cognizance as is possible of the possibilities of experience inherent in each house-field from the first house to the twelfth. Then the process is repeated at a "higher" level from age 28 to age 56 and, potentially at least, at a still more inclusive and spiritual level from 56 to 84. The 84-year cycle is that of Uranus, and in astrological symbolism the power of self-transformation is characteristic of the Uranus function. A truly individualized person with a relatively well-developed mind has in him the possibility to transform his state of awareness so that he can move from one level of consciousness to another, and thus keep repolarizing his inner being. Man at a more primitive and tribal state of evolution was not able to individualize or transform his consciousness in this way—though in special cases another type of process was presumably at work, but the results were basically different.

One can therefore speak of three "births" which represent a sort of dialectical sequence—that is, thesis, antithesis, and synthesis. Astrologically speaking, a man is born in the physical *biosphere* of this planet at his first breath—thesis. He is reborn in the psycho-mental *noosphere* at age 28. And, potentially, he can be born again in the spiritual realm—*pneumosphere*—at age 56, provided his consciousness has been truly developed in terms of individual values during his mature period, 28 to 56. If there has been no such development, or this development has ceased, then the period lasting through the sixties until death can hardly mark anything but a slow disintegration or atrophy of the personality.

The first birth in matter is also birth in the field of a particular racial, cultural, and social type of consciousness. There the roots of the personality are established according to a collective tradition as well as a genetic pattern. These are the foundations of the temple of the individual, foundations in the dark, collective unconscious. The young person brings the past to a state of fulfillment in the present, theoretically as he graduates from studies which have enabled him to assimilate the past of his culture and,

deeper still, of mankind; but he may also rebel against what he considers to be obsolete, binding, and perverting.

The second birth is "birth in individuality." The still young person, around the age of 28, can realize what or who he is as an individual. He may realize this in terms of a definite vocation within an accepted social system to which he may bring new elements, or he may "find himself" through a long struggle against his tradition. But, before that age, what the adolescent and/or student may believe to be his own is most likely only a form of protest motivated by his dissatisfaction with old patterns. Protest binds as effectively as subservience; one is bound by hate as much as by love. The true birth-in-individuality comes only when *through, yet beyond* the discontent and the protest the maturing person becomes aware of the tone of his or her true self and destiny. Negative revolt should then give way to positive self-assertion.

The third "birth," if it occurs at all and not merely takes the form of an imprecise feeling or yearning for spiritual values, should transcend both the collective past of the society and the achievements of the individual. But in this very process of transcending, *both* the collective and the individual factors find fulfillment. The individual comes clearly to realize his function in his community, or in human evolution as a whole; and his society comes to realize the value of his contribution. Even if his contribution is a catharsis-inducing and revolutionary one, during this last 28-year period of the person's life there should be some experience of recognition and acceptance by at least a "seed group" composed of future-oriented individuals. The contribution tends then to take the form of "symbols" which, being transferable to other men, insure at least for a brief period the relative immortality of the individual who through them actualized the spiritual harvest of his experiences. Symbols in this case can be specific deeds which remain in the memory of those who witnessed them, as well as works of art, books, or teachings.

Astrologically, and in terms of astronomical facts as well, when one thinks of a process of self-actualizing through twelve basic fields of characteristic experiences, one visualizes a cyclic motion of the point representing the essential individuality of a person, namely, the Ascendant. It should be clear that actually the horizon —of which the Ascendant is the eastern end in a two-dimensional

birth chart—*does* move after physical birth. This motion is due to the rotation of the Earth in a counterclockwise direction around its axis—that is, from the first house to the second, third, etc. Yet, as I have already stated, while what is seen in the sky at the horizon may change, the fact that a person experiences a horizon does not change. Everywhere the individual carries with him a horizon and a meridian; they constitute the structuring factors of his individuality and his consciousness. If he were to float in interstellar space, he would not have an experience of horizon.

Most astrologers still think of the series of houses as an expression of the daily rotation of our globe around its axis. From a planetary point of view this is indeed the case, and when I wrote *The Astrology of Personality* I followed mainly this approach, though I already felt dissatisfied with some of its applications. In subsequent years I came to realize that if one thought of a birth chart as the chart of an individual and not as that of the whole planet at a particular moment, it was necessary to assign an essential place to the space factor. In any so-called person-centered approach to astrology, it must be accepted as a basic fact that man lives at the surface of the globe, not at its center. What the birth chart represents is the individual's relation to the universe at the moment of birth; it is *his orientation in space.* The individual person *is* his spatial relationship to the universe and to all that there is in it at that moment. This is the *permanent* pattern of his individual selfhood—or, one might say, the blueprint of the temple of his selfhood; and blueprints are space factors.

Yet this blueprint constitutes only an archetype, an ideal and potential structure. The ideal must become the real, the blueprint must become an actual building, and this implies a process of gradual actualization. This is what the astrologer means when he speaks of progressions and transits. But these deal primarily, if not always exclusively, with the movements of the planets. Astrologers have also used the motion of the natal meridian—thus the speed of the globe's rotation—as a basis for time measurements and predictions, for instance in the so-called primary directions.

These, however, refer to the actual motions of the celestial bodies and to their influence on the Earth; thus to *changes in the environment of the individual.* When I refer to the 28-year periods, I mean subjective changes in a person's conscious self-image—that is, the attitude a person has toward himself as he meets the

challenge of everyday experiences. This self-image evolves as changes occur in the rhythm and intensity of the body's energies. To a large extent the change follows the age factor. The self-image normally has a very different character in a child, a 40-year-old person or a retired man. These are generic changes, but they are deeply modified by personal characteristics and events.

These changes can be symbolized to a large extent if one uses the following approach. Imagine that the Ascendant, or point of Self, moves around the whole chart counterclockwise every 28 years; every seven years it touches one of the angles of the natal chart. Thus at the 7th birthday the natal Nadir point will be reached; at 14, the Descendant; at 21, the Zenith or Mid-heaven; a new cycle begins at 28, and again at 56.

This is a picture of the well-known 7-year cycle so often mentioned in esoteric writings, and I have dealt with the meaning of these ages—7, 14, 21, 28, 35, 42, 49, 56, etc.—in *The Astrology of Personality* and in various articles. This cycle, I repeat, affects every human being more or less deeply, and brings more or less characteristic and crucial events or changes in consciousness to him. But the *individual character* of what occurs in terms of this cycle can also be *suggested*—I shall not say *ascertained*—by the contacts that the Point of Self makes with the natal planets as it sweeps around the life-clock which the house-circle represents. These contacts in a great many instances seem to catalyze changes in the consciousness of the individual, but often not in an obvious way. These changes may depend upon or refer to external events, but they need not always do so.

A problem arises concerning the best way to measure the progress of the Point of Self around the chart. One can divide the number of degrees of the zodiac between the horizon and the meridian by seven, and thus calculate how many degrees the Point covers in one year. But as the East-North and the North-West quadrants of a birth chart in most cases do not contain the same numbers of degrees—and the same applies to the West-South and the South-East quadrants—this means that the Point of Self moves at varying speeds. But, according to the concept formulated in this book, what is essential is the *spatial character* of the houses—which fits the Campanus system of house division—and *not the time factor*, that is, the time it takes for a zodiacal degree and for the planets to rise from the horizon to the meridian—Placidus system. Therefore

it seems to me logical to divide the *space* surrounding the new-born at the surface of the globe into equal sections. Each house represents 30 degrees of person-centered space and the Point of Self moves through that space at an even speed from house cusp to house cusp, at the rate of 28 months per house—that is, 28 years divided by 12.

This means that in order to ascertain when the Point of Self exactly crosses a planet, one has to calculate its position in terms of house space. This is a more complex calculation, but exactness is not too significant in such a technique, for we are more con-cerned with subjective changes in consciousness and psychological attitude than with events located precisely in time. The Point of Self reaches the second house cusp of a birth chart 28 months— —two years and four months—after birth, the third house cusp 56 months—four years and 8 months—after birth, and the fourth house cusp or Nadir 84 months, that is, 7 years after birth. If a planet is located at the exact midpoint between the cusp of the third and the fourth houses then the Point of Self will first cross this planet at age 5 years and 10 months, and in its second circuit 33 years and 10 months after birth. If we divide the number of zodiacal degrees within a house by 28, the result will determine in terms of zodiacal degrees the space which the Point of Self travels in one month while in that house.

For instance, in my own birth chart the Moon is on the 25th degree of Aquarius in the second house which extends from Aquarius 1° to Pisces 16°—Campanus house system. The house therefore contains 45 degrees. The number 45 divided by 28 gives 1.6, a little over one and a half months per degree of the zodiac. The Moon is 23 degrees ahead of the zodiacal longitude of the second house cusp, which means that it is just past the mid-point of the second house. The cusp of the second house corresponds to age 30 plus 4 months and therefore the Point of Self crossed my natal Moon when I was 30 years and 4 months plus one year and a little over two months, or at the age of 31 and a half. During that month I experienced one of the very rare orchestral performances of a symphonic work of mine, *The Surge of Fire*, and it was a notable success. The Point of Self touched my natal Mercury at 4½ Pisces when I was 33 years and about 9 months, and at the time my book *The Rebirth of Hindu Music* was published in India and a book of poems in Carmel, California. But

more important still, during that period I had begun to lecture a great deal and to define my philosophy more strictly.

Exactly at the age of 35—the Point of Self entering the fourth house—the decision was taken which led, two months later, to my first marriage. The Point of Self had passed over my natal Sun— third degree of Aries—when a death and subsequent events set the stage for this marriage. It led indirectly to devoting most of my attention to astrology, and to a great deal of writing.

At the time when the Point of Self had passed a triple conjunction of Pluto, Mars, and Neptune at the end of my sixth house, I had been gravely ill—age 13 to 14—and twenty-eight years later a much less serious yet difficult situation developed involving a kind of psychological crisis. Significant contacts and changes in my sense of relationship occurred when the Point of Self crossed Jupiter in my seventh house for the first and second time. When it crossed it for the third time in 1966 I experienced a wide spread of public interest in my works and my approach to life. The third crossing of my natal sixth house was manifested as a vast increase in work, in consequence of which I had to struggle against constant fatigue and to give medical attention to the aging processes of the body.

Such an example does not mean much in itself. There are cases which reveal very significant correlations between the planetary contacts of the moving Point of Self and changes in consciousness; in others these correlations are not clear. Obviously much depends on how a person responds to the possibility of inner transformation. One can say nevertheless that, in general, the contacts between the Point of Self and the planets tend to indicate the times in a person's life when the functions represented by these planets tend to affect in an especially noticeable way the self-image of the growing person, and they should draw his attention. Contacts of the Point of Self with the positions of planets "progressed" according to the secondary progression technique may also be significant. In some cases they have been found to correspond more closely to the actual events which catalyzed the change in consciousness. The puzzling thing is that one often does not find any correspondence for changes or crises which one considers very basic. It may be that these crises are actually the inevitable outcome of previous turning points and individual decisions which at the time did not appear important. Here we face the most serious of all astrological problems, the determination of when anything *really* begins.

part three

The Four Angles and
Their Zodiacal Polarities

IN THE PRECEDING CHAPTERS I DISCUSSED THE GENERAL
meanings of the twelve houses as related and sequential fields of
experiences. The individual must pass through and absorb the con-
tents of these twelve basic types of experiences in order to actualize,
in concrete terms and under the conditions prevailing in the Earth
environment in which he lives, the potentialities inherent in his
moment of birth. Defining the seventh house as the field referring
to experiences of partnership tells nothing about the character of
these experiences in the life of a particular person, nor does it tell
us how he will tend to approach and respond to his closest associates.
The astrologer tries to understand these factors, and the nature of
the individual's actions and reactions, by considering (1) the zodi-
acal sign and degree at the cusp of the house; also the number of
degrees in the house and whether or not it includes an "intercepted
sign," (2) the planetary ruler of the sign on the cusp, and (3)
whether a planet or several planets are located in the natal house.
 Astrological textbooks usually tell, often with a very unfortunate
kind of definiteness, what can be *inferred* from the presence of
every sign of the zodiac at the cusp of every house. I stress the word

"inferred" because this is merely an inference, a possibility, at best an expectable trend. "Textbooks" present quite inevitably an analytical picture of what everything *may* mean; and often the meanings listed under each heading in the textbook refer to very different matters which at first glance can hardly be related to one another. If the descriptions and listing are sound there is nevertheless a basic relationship between the traits of character or the type of events listed. Yet a house, for instance, on whose cusp we find the "expansive" sign, Sagittarius, ruled by Jupiter may also contain Saturn, a planet whose nature is limiting, constrictive, and often frustrating. The basic problem one has to meet in interpreting an entire birth chart is how to synthesize these opposite meanings. Another problem is what is best to tell the person whose chart one is interpreting, considering his age, his or her present circumstances, and the probable ability he or she may have to respond constructively to what is being said. But these are matters which cannot be discussed here, and the reader is referred in particular to my series of booklets on Humanistic astrology.

In these booklets I have explained the difference between a holistic and a strictly analytical approach to astrology, between "person-centered" and "event-oriented" types of interpretation. If I mention these matters here it is because in this chapter and the next I shall attempt to clarify some points which refer to the usual textbook type of analytical interpretation. To do this seemed necessary in order to bring a degree of definiteness and practicality to the general principles formulated in the preceding chapters.

Even if the astrologer has to focus his attention analytically on one single factor in a chart, there are nevertheless certain basic facts he should always hold in mind. The most important of these are that everything in a chart has its polar opposite, and that any factor can have a negative as well as a positive significance, regardless of whether it is usually classified as good or bad, fortunate or unfortunate. This *principle of polarity* is the cornerstone of any sound astrological interpretation, and it is particularly in evidence when we deal with *axes* in a chart. The horizon and meridian are axes; the Ascendant and Descendant, the Zenith and Nadir are the theoretical ends of these axes as they cross the ecliptic. Likewise the North and South Nodes of the Moon, and of all planets, are the two ends of axes. To define the meaning of one end *without including in the definition the meaning of the other end* simply does

not make any sense, at least if one wants to present a complete picture of a situation or a personality. Yet this is what is commonly done.

What I mean, for instance, is that if one wishes to describe the characteristic qualities of a Leo Ascendant—that is, how the person's self-image has a Leo character—one should take into consideration the inevitable fact that his approach to partnership—Descendant—will have an Aquarius character; and vice versa. One cannot separate the way one sees oneself—which means also the best way to experience one's essential individuality and unique destiny—from the manner in which one meets people and enters into various types of partnership. These two factors in the personality—selfhood and relationship—are constantly interacting because they are two interdependent aspects of one fundamental drive, the drive to full individualized consciousness. You cannot be conscious alone, in a vacuum; the types of relationship implied in the seventh house must involve some degree of conscious awareness of the self and of the other person or persons.

Thus if an astrology text lists the characteristics to be attributed to Aries at the Ascendant the list should include traits which can also be referred to Libra as the sign at the Descendant. This is often done, but without making clear how the characteristics come to be included in the description of the Ascendant, and this can be confusing. In most cases, however, the astrologer does not think at all of the Libra Descendant when he is telling a client about his Aries Ascendant, and in such a case the interpretation must necessarily remain essentially incomplete. I shall therefore indicate sketchily how one can approach a bipolar interpretation of the natal horizon as a whole, which includes both the Ascendant and the Descendant. Such an interpretation will be in terms of the zodiacal signs found at *both* the eastern and the western ends of the horizontal line in our present-day two-dimensional charts. Then I shall do the same with the vertical meridian axis, which links Zenith and Nadir—or, in terms of the zodiac, Mid-heaven and *Imum Coeli*.

I shall now simply restate that the horizon refers essentially to consciousness; the meridian, to power. The Ascendant—eastern section of the horizon—represents the inherent and intuitive awareness of self, or of individuality. Here a human being discovers his uniqueness, his spiritual identity, which also means the keynote of his destiny. Here also a person realizes his difference from other

persons. On the other hand,· the Descendant—western section of the horizon—symbolizes the individual's special way of approaching the problems and opportunities derived from interpersonal relationships, and in general from all relationships in which he is willing to enter on a basis of equality and mutuality. Here the individual's difference has to become adjusted to other people's differences; this becomes possible through cooperation and in a spirit of love and sharing—or, negatively, of enmity and conflict.

The meridian refers to the power that comes from the integration of many elements within an organized and structured existential whole. In the fourth house what is involved is the integration of the personality and the stability of its operations and basic approach to life, whether this approach is determined by family or national traditions, or by the person's own rhythm of being. The tenth house indicates the most natural and best way in which the individual can become integrated in a collective organism, that is, a community, a profession, a national state.

Keeping these principles in mind we can then proceed with a brief characterization of the different types of natal horizons and meridians.*

THE ARIES-LIBRA COUPLING

These two signs are equinoctial signs of the zodiac. Throughout the annual solar cycle two forces interact which I have called the Day-force and the Night-force, and which correspond to the Chinese polarities *Yang* and *Yin*. At the spring equinox the Day-force and the Night-force are of equal strength; that is, days and nights are of the same length. But the Day-force is in ascendancy, filled with dynamic intensity as it overcomes the Night-force. At the fall equinox the two forces are again equal in strength, but now the Day-force is waning, retreating, and the Night-force is eagerly increasing its power and its control of the situation.

Aries represents a straightforward movement of life toward a concrete, tangible, and personalized state of existence, because it is the nature of the Day-force to seek manifestation through differentiation and personalization at *any* level. Thus, if Aries is the

* For a detailed psychological study of the twelve signs of the zodiac, the reader is referred to *The Pulse of Life* (new edition by Shambala Publications, Berkeley, California).

sign rising at the eastern horizon when the first act of at least relative independence is performed—the first breath—the child's latent consciousness is stamped with a rather impulsive and impetuous eagerness to assert his uniqueness of destiny—his *dharma* —and to attempt to define more clearly who he is by taking a lead in life situations.

Aries is a sign closely linked with the spirit of adolescence. At this time the Day-force is just beginning to display its strength; it is still insecure. But being insecure, it compensates by appearing aggressive. The person with an Aries Ascendant may tend to romanticize his selfhood. He may be full of yearnings and desires for anything that mirrors to himself his essential and unique self. The objects of his desires and the mirrors of his true self will tend to have Libra characteristics, for Libra will be the sign at his western horizon, the Descendant, thus the symbol of the way he will—or should— approach interpersonal relationships.

Libra represents movement toward the development of a social-cultural consciousness, the eagerness for an "I" to interact with a "Thou," so that through this interplay a greater life may be experienced. Because the Aries Ascendant stimulates the typical adolescent yearning for self-expression and the assertion of uniqueness, it requires as a balancing force a sense of social values. One has to have *something* to assert oneself in or for, but at the Aries level this should not be too much of a challenge; it is better that it should take the form of a group, a collective set of values, a noble ideal, or perhaps faith in something that would allow the Aries drive for self-actualization to take form in the release of impersonal or transcendent spiritual energies.

When the reverse situation presents itself, that is, when Libra rises and Aries sets at birth, the individual tends to be a field of operation for collective urges and group ideals, for it is in terms of group activity, or at least in terms of a strong and idealized partnership, that the individual will learn what and who he is. This does not at all mean that the person will be "balanced"—the Libran symbol of "the Balance" is not really understood by astrologers*—but rather that he will be much concerned by his social or cultural role, by the

* What matters is not the way scales traditionally look, but *what they are used for.* They serve to weigh an individual's contribution to society or to a group relationship in terms of some *collectively accepted standard of value.* In Libra the collectivity sets standards which determine the worth of the individual participation in any group process.

value of his acts of self-expression. It will not be easy for him to find himself in aloneness, and he may experience insecurity and inner confusion until he has found his place in some kind of group or society which he intuitively feels to be where he really belongs.

This person will need an individualistic, self-actualizing, emotional partner to help him find himself *through* their relationship. This may mean at times forcing one's way into a partnership in a rather adolescent manner, or rushing into a devotional commitment to a person—or a personalized cause—in relationship to whom the individual with the Libra Ascendant can display his capacity for group organization and social, cultural, or religious enjoyment. Any group experience requires the catalytic presence of an individualized vision or release of energy.

The meaning to be attributed to the presence of Aries and Libra at the two ends of the chart's vertical line follows the principles stated above, except that now we are dealing with the capacity for organization and integration at both the private-personal—fourth house—and the public-professional—tenth house—levels. We should be thinking therefore of the best kind of *power* to be sought and experienced in this process of personal and social integration.

Aries at the cusp of the fourth house stresses the need for sharply focused activity and enthusiasm, or faith, in the search for personal foundations and inner security. Security is not too likely to be found in passive subservience to a tradition or family pattern. As an English philosopher wrote during the early nineteen thirties: "The only security is no-security"; or, one might say: The best defense is to take the offensive. The problem is: Where does one want to go?

The zodiacal sign at the Mid-heaven should provide the answer to this question, and this sign is invariably Libra. Thus the goal should be to participate in a definite social activity and perhaps in the establishment of new social values. This sense of participation in a communal enterprise can be so overwhelming as to imply the sacrifice of the values attached to a strictly personal life—especially in a case where Sagittarius is at the Ascendant. Such a total devotion to a social-cultural process, perhaps a deeply transforming or even revolutionary process, may hide a deep sense of personal insecurity, which in turn may mean a quasi-adolescent and unstabilized approach to home situations, perhaps a revolt against the mother and

all binding forms of possessive love. A solution for personal problems of integration should be sought in those tradition-transcending values which participation in a large, future-oriented or spiritual-religious community might—hopefully!—reveal to the soul operating at a critical state between two psychological and mental stages of human evolution.

There should be some discussion here of an important factor so far merely hinted at in my analysis of the Aries-Libra coupling—that is, the position of the planets that rule the zodiacal signs, Aries and Libra, and the Aspects these planets make to the other planets. It is impossible, however, within the confines of this book to discuss this factor and all the problems to which it gives rise. Today the concept of "planetary rulership" is rather ambiguous. It made very much sense in the old geocentric Ptolemaic system, as it was formulated in terms of the Sun-Moon polarity and the five levels of planetary activity, each ruled by a planet. But since planets beyond Saturn are now being used, the symmetrical picture presented under the old system is destroyed, and rulership should probably be understood in a different way according to our modern concept of the solar system.

Still, even in this awkward and transitional situation, a study of the planets which traditionally rule the four angles of the birth chart can be very significant, especially in terms of the house in which the rulers of the zodiacal signs at the four angles are located. For instance, if Mars—ruler of Aries in the old system—is placed in a person's seventh house, the Martian function he should most effectively use in discovering his identity and his destiny is definitely involved in marriage or partnership. The key to the discovery of the self lies in the type of relationships the individual will assume. If Mars were in the fifth house, the individual would most likely come to discover *who* he is in the mirror his creations or his children—or any dynamic attempts at projecting outward *what* is active within him—will present to his intuitive perceptions. In the sixth house, the planet ruling the Ascendant would suggest that the key to self-discovery lies in devoted work, service, or discipleship.

The same type of reasoning could be used with regard to the other angles of the natal chart, and possibly—but far less effectively —it could apply to the planets ruling the zodiacal signs on the cusps of the succeedent and cadent houses. A person with the ruler of the

sign on the Descendant located in the second house may see his intimate relationships closely involved in financial matters and requiring a close management of his innate resources and abilities; in the eighth house, it might refer to the need for regeneration through experiences of ego surrender if the marriage is to actualize its transforming potentialities, or to a careful consideration of the financial outcome of a partnership if the latter is to prove significant and valuable.

The possibilities offered by such a technique are numerous; they may be used particularly in vocational guidance with respect to the tenth house and the planetary ruler of the sign culminating at the Mid-heaven. If this ruler is in the fifth house, self-expression is necessary for success in communal activities, or in one's profession. If Libra were then at the Mid-heaven—Venus being then the ruler of this tenth house—the possibility of success in some creative occupation, or of giving birth to a gifted child, would be evident. But if that planet is in disharmonious and tense relationships to other planets, the realization of these possibilities would require great effort and determination. An opposition between Venus and Saturn would tend to delay success, or to require a great depth of inquiry and perhaps a struggle against set patterns of social operation or conventional friends, who nevertheless in the end could be won over.

From all of this it should be clear how important it is that the house pattern of a birth chart be exactly established and that the angles be calculated for the precise moment of the first breath. It is also clear how incomplete any system of "equal houses" must be which does not take into consideration the two axes determined by the time and place of birth—or any system which fails to consider the houses.

THE TAURUS-SCORPIO COUPLING

These two signs represent the reaction which follows actions begun during the equinoctial periods. They refer to a process of coalescence and stabilization dominated by a definite organic purpose. In Taurus the process operates mainly at the biological and instinctual level; in Scorpio what is implied is identification with forces which aim at the interpenetration of individual units for the purpose of building a larger social or "occult" organism—an interpenetration which, in order to be effective, must reach the very

roots of the being (thus the connection of Scorpio with sex). Yet it is Taurus which symbolizes the operations of the natural and biologically compulsive sexual function, while in Scorpio sexual activity has a personalized character. In Scorpio, it meets *human* needs and answers *individual* yearnings. Its compulsions are psychological, rather than glandular and instinctual; thus it is possessive in a personal sense and subject to all kinds of perversions, but also to transmutation. In Taurus, on the other hand, it is simply a procreative instinct aiming at producing a progeny, or a strictly natural release of biopsychic energies.

With Taurus at the Ascendant a person normally discovers his true nature through productivity, at one level or another. He or she produces and tends to cling to the products. There may be a thorough identification with both the process of production and the person or group whose needs this process will satisfy. There may be not only a fixity of purpose, but pride in accomplishments, biological or social, and as a result a good deal of self-centeredness and a somewhat narrow horizon. Still, within the particular field of production in which it is the dharma of the individual to operate, great results can be obtained. Spiritually or even psychologically speaking the problem is not to become too personally attached to the results of one's activity, and to allow nature or life to act *through* one's person.

A Taurus Ascendant implies inevitably a Scorpio Descendant. The individual will have to surrender at least partially his ego attachment to his own products by relating to persons who have a more social vision or who need to experience the spontaneous and natural release of organic energies. Such relationships strengthen the part of his nature that seeks broader horizons and in many cases a more conscious and controlled approach to productivity—also a more responsible approach in terms of group purpose. The individual may seek partners through whom he may become more fully aware of larger social, moral, or political issues.

In the reverse situation the person with a Scorpio Ascendant will often seek to fulfill his role in society by drawing power from persons very close to him. Numerous political leaders have been born with Scorpio as their rising sign—Disraeli, Gandhi, Lenin, Stalin, Mussolini. These people enjoy the use of social power and identification with the need of their people to achieve some sort of organic integration at the national level; but, as they relate to their partners,

they draw vital forces from them and they demand concrete results along fixed lines of activity.

The fixity of purpose and natural organic productivity of the sign Taurus when related to the fourth house stresses the importance to the individual of deep roots in a particular land and tradition, and of a solid home foundation. But, as in every other case, the character of this foundation depends a great deal on what zodiacal sign is on the Ascendant, for the Ascendant is at the source of all that characterizes the essential function of the individual *as an individual*, that is, his identity as a unique person. In temperate regions of the northern hemisphere if Taurus is at the Nadir point of the chart one can expect Capricorn, Aquarius, or even Sagittarius at the Ascendant. The "Earth" character of Taurus would be strengthened by a Capricorn Ascendant, and the Cancer Descendant would add to the concentration on productivity within the radius of the home or of a well-defined field of activity. I need hardly repeat here that any astrological indication must be related to many others —indeed to the whole chart—before one can grasp its meaning in terms of a person's character and destiny. The individual personality is a chord of dynamic factors, and no one factor can be understood if taken out of the context of the whole chart—which is why such analytical characterization as suggested here can be tentative and only partially valid; they deal only with general principles.

Taurus symbolizes in the cycle of the year the evolutionary ascent of life toward the Sun, the ascent of the sap which nourishes the plant and culminates in the blossom. The Scorpio Mid-heaven, which polarizes this ascent if Taurus is at the cusp of the fourth house, represents the flowering of the life energy in the at least relatively full-grown organism of personality—thus the glamor of youthful bodies enamored with one another and, through sexual embraces, seeking to reach the experience of power which expresses itself through the union of life polarities. A cycle of experience later, around age fifty, this fulfillment of vital energies may be replaced by the exaltation of social-professional achievements. These also imply a union with a superpersonal reality—a group, a nation, mankind—which releases social power. This may result in the assumption of political leadership, especially if the sign Leo is rising —as was the case in Bismarck's chart, and in that of J. P. Morgan

the Elder, the international banker who had much to do in bringing the United States into World War I.

Here again we see polarity at work in the opposed ends of the natal meridian, Nadir and Zenith. In the fourth house the product of Taurean fertility is *oneself as a person*; in the tenth house, the product of Scorpio's urge to commune in depth with other persons should result in *a significant and productive "office."* The officeholder and the office depend upon each other. Results are generated by their interaction.

THE GEMINI-SAGITTARIUS COUPLING

The sign Gemini is characterized by a vivid eagerness to extend the scope of one's personal experiences through many kinds of human contacts, and the absorption of a variety of information which is found to be readily available. Gemini is the most typical symbol of intellectual curiosity and of the mind which neatly and analytically classifies knowledge for practical and personal use. The opposite sign, Sagittarius, refers to a more abstract and mature type of knowledge, concerned with the integration of distantly related factors, with philosophy, religion, and any form which the quest for basic values and understanding or wisdom may take. Gemini deals with easily accessible encounters and the concrete mind; Sagittarius with all that expands the horizon, takes one away from routine existence, and incites one to dream great dreams. Gemini represents the type of mental faculty which is concerned with control of the environment for greater personal convenience and the feeding of the ego; Sagittarius is haunted by ever larger horizons, by the thirst for great adventures beyond the familiar.

A Gemini Ascendant often indicates an avidity for knowledge and the deep-rooted expectation that it is through knowledge and a multiplicity of sensations and contacts that one will discover one's own individual identity. Indeed, the use of thought processes will be very important, but the danger is that one may be caught in a web of small concerns, logical statements, experiments, and lost in a maze of information which, while well ordered, may be empty of larger meaning and unconcerned with social consequences. The Sagittarius Descendant suggests that relationships should be based on a larger scheme of values. Sagittarius provides Gemini with its abstract frames of reference, its logical concepts, its dissatisfaction with the

near-at-hand and the temporarily fashionable. It makes possible an expansion of consciousness through relationship. The personally assimilated information, even the mental awareness of one's essential nature, should be put to use in terms of human fellowship and a sharing of values with greater minds.

When Sagittarius is the rising sign, the individual may be fond of outdoor life and travel—or so says the tradition!—but far more significantly he is a person who will come to realize what and who he is through involvement in a great cause, a social or religious belief, a search for truth. This sought-after Truth may be so capitalized that the individual seeks to promote or propagandize it with an often fanatic zeal, or at least with great dedication. He may find his own truth and dharma through teaching others what has fired his enthusiasm; but he needs the polarizing influence of the more precise, more empirical and analytical Gemini mind. He should, theoretically at least, seek partners who will cooperate with him along practical lines, perhaps along several lines of endeavor so that his generalizations and his expansionism may be fed with a variety of relevant data and multilevel relationships.

Gemini at the cusp of the fourth house tends to provide changing situations while the process of personality integration takes place. The tree of personality may be like a palm tree or a sequoia with a very wide and extensive network of roots not far below the surface, instead of a deep-reaching taproot. Concentration on very basic feelings may be somewhat difficult. The individual may have antennae feeling for multiple impacts and stimuli for growth, rather than a solid and secure realization of what he actually is and stands for as a person. The danger is for a strong and clever ego to develop as the efficient and perhaps proud organizer of complex life experiences.

Much depends in such a case on the sign at the Ascendant. In most instances it will be either Aquarius or Pisces; only in the far north could it be Capricorn, a steadying influence. An Aquarius Ascendant may stress idealism and/or social discontent; a Pisces Ascendant would tend to give a touch of transcendence and perhaps psychic instability to the Gemini foundation of the personality. And the positions of planets in the fourth house could considerably modify and polarize the typical Gemini characteristics, either adding restlessness or stabilizing the intellectual structures upon which the person depends for inner security.

When the situation is reversed and Sagittarius is at the cusp of the fourth house, philosophical, religious, or ancestral concepts should be sought as roots for the stabilization and strengthening of the personality. A personal ambition to leave a strong imprint upon society may be a significant factor. The early home may be open to many influences and visitors. The mother may have intense religious convictions and impress them upon the growing child and adolescent. There may be early travels in childhood. Later on, in times of crisis, the individual will tend to renew his inner strength by strong acts of faith in his destiny, and by seeking philosophical or moral justification for his feelings and perhaps his social ambition.

With Gemini at the Mid-heaven, intellectual capabilities should be used to the utmost. The assistance of intellectuals, specialists, researchers will be important in the pursuit of a social or professional goal. A quick mind can be most valuable in adjusting to the demands of whatever public situation one has to deal with. This power of social adaptation and the ability to handle information should balance the determination and perhaps self-righteousness and proselytism of Sagittarius at the chart's Nadir. Franklin D. Roosevelt's chart is an example of such a situation, but planets in his tenth house and a massive group in the sign Taurus were even more important in determining his personality and destiny.

THE CANCER-CAPRICORN COUPLING

These two signs have their origin in the solstices, the moments at which the two polarities of the solar life power are found in a condition of maximum disequilibrium. In Cancer the Day-force is at the acme of its power, even though the Night-force is by no means annihilated, and from then on it will slowly wax in strength. In Capricorn the Night-force is as dominant as it ever can be. Thus the characteristic features of one of these two forces are exaggerated and overemphasized in these zodiacal signs. This emphasis serves a basic purpose in the over-all pattern of the zodiacal cycle: one of the two polarities is revealed in all its implications and limitations.

In Cancer the Sun which had been moving northward *in declination*—that is, the sunsets had occurred for three months to the north of exact West—"stands still," which is what the word sol-stice etymologically means, *sol* being the Latin for Sun. This symbolizes an abrupt reversal of the process which had been going on for half

a year. The Gemini eagerness for conquering more life space and increasing knowledge through all kinds of experiments stops. Symbolically speaking, the young man who had been scattering his energies experimenting with a multitude of things gets a job, marries and settles down to become the head of a family. In this sense, Cancer represents the stabilizing power of a home. Life energies are being *focused*; and a home can be a narrow and exclusivistic focus of attention, setting a well-defined stage for the birth and education of the child.

This focusing of energy can operate at several levels. Albert Einstein had a Cancer Ascendant. His ideas led to the concept of a finite spheroidal universe and he was concerned with the formulation of one basic principle encompassing all known manifestations of energy. Because the Cancer type strives for the concrete realization of Unity at the root of all modes of experience, it may be led to mystical realizations of a sort. The sign Cancer is often associated with psychic gifts, but the validity of this belief depends a great deal on what one means by psychic. Clairvoyance is usually a holistic process in which the essence and meaning of a situation *as a whole* is seen by the clairvoyant as a symbol or a scene. Characteristic here is the *whole-making* activity. Building a home—and not merely a physical house—is a whole-making activity. The bipolar couple, man-woman, is ideally a reconstituted whole, potentially procreative because stabilized as one single biological and social unit.

Capricorn also refers to the achievement of integration, but while Cancer refers to the narrow biopsychic unity of a *personal* situation, Capricorn deals with the large-scale political or managerial institutions of a complex national state. Modern nations in most cases are not at first composed of people of the same race or culture; indeed, the purpose of a national state—at least spiritually speaking—is to integrate different races and cultures. The problems which all western nations have faced, and are still facing, arise from the fact that several distinct ethnic groups are made to interact and to cooperate in the establishment and above all the maintenance of a perfect union. France is a typical instance, but so is Great Britain, and of course in a special sense the United States.

A Cancer Ascendant will tend to make a person concerned with very definite, perhaps intellectually formulatable or experientially workable goals. The issues are sharply definable and involve

individual personalities. A Capricorn Ascendant leads one to discover one's own essential identity and destiny in activities that involve the integration of distant factors or of basic antagonisms which can be integrated only by means of strictly logical systems or legal instrumentalities requiring some type of police force to enforce patterns of order.

What is perhaps even more important is that the Cancer Ascendant person will trust more in the use of personal power and of the dynamic power of love, while the Capricorn Ascendant will resort to large impersonal or superpersonal concepts or techniques of organization. Carl Jung had a Capricorn Ascendant and his system of depth psychology stresses the idea that the power of archetypes of the collective unconscious is ultimately more important than that of strictly personal feelings or intellectual concepts. On the other hand, Adler, another psychologist who also left the Freudian school, had a Cancer Ascendant, and he emphasized the importance of purely personal reaction to some kind of handicap and the will-to-power which compensates for feelings of inferiority by expressing aggressivity.

The person with Cancer as rising sign will also use this process of personal compensation but primarily as he establishes associations with other people. He is afraid to meet them in a person-to-person interaction. He may hide under broad concepts and Capricornian social generalizations. He has to build a social *persona*, to play a role in which he can appear superior to other people; and clairvoyance may turn out to be quite a remarkable way of impressing the persons with whom one comes into relationship with one's superior faculty of perception, while at the same time one is inwardly painfully aware of one's own individual insecurity.

On the other hand, the person with a Capricorn Ascendant has need of people with whom he can relate person to person, for without such concretizing meetings and close interpersonal empathy he might feel personally overinvolved in ambitious schemes and large-scale social planning, or in mystical and cosmic realizations. Capricorn can refer to experiences and faculties that many people would call "mystical," but the reference is rather to the type of consciousness that is able or desires intensely to operate in terms of a transcendent type of order, of a cosmic and—in the real sense of this much abused term—occult use of power. He may tend to overwhelm other people with such power, seeking potential

subjects in order to fulfill what he considers his destiny. It could be a catabolic kind of destiny.

A fourth house with Cancer at its cusp indicates a human being in whom the archetypal characteristics associated with the number 4 in numerical symbolism—perhaps the most universal of all symbolic systems—are quite strong. This is because Cancer is also the fourth sign of the zodiac. Indeed, the often stressed identity of meaning attributed by astrologers to Cancer and the fourth house can only be justified on such a numerological basis. The number 4 is the symbol of concrete embodiment and of the most basic feelings associated with the operation of life energies and their psychic overtones—the basic drives studied by psychologists. This number defines the process of integration as it operates *at the biopsychic level* within human consciousness. It refers to the type of intelligence which works as the obedient servant of the life force in order to provide a secure foundation for the growth of personality—an intelligence whose operations are controlled by expediency, empiricism, and adaptation to concrete organic needs. This intelligence is related to the Moon in astrological symbolism, and the Moon is said to rule the sign Cancer. It refers to the mother only because it is the mother who cares for the baby incapable of meeting his own needs—the need for food, clothing, shelter, cleaning, and also for security and love.

A Cancerian fourth house refers therefore to the particularly strong and probably lifelong need of the individual to focus much of his attention upon his ability to adapt to changing conditions in his private life. This stresses the importance not only of the home life, but of all that refers to the process of personality integration. However, such a concentration upon the near at hand, the organic, the feelings, and upon some sort of Mother-image, could be overwhelming if not integrated with what the Capricorn tenth house implies: that is, an equally strong concern for establishing oneself securely in a social position. The latter provides the social power, the money, necessary to run a secure, satisfying home.

When the situation is reversed, and Capricorn is found at the Nadir point of the chart, public concerns may well dominate a person's private life—that is, if no special planetary "influence" is at work in the fourth and the tenth houses. Professional or social activities, however, will tend to be determined by expediency.

Indeed, the public or professional life should be managed with a keen sense of adjustment to the rapidly changing moods of the community. If the individual identifies his own fourth house personality with a broad, social, or cosmic purpose—Capricorn—he will indeed need flexibility of response, a sense of timing, and a "psychic" feeling of what is vital and acceptable to his public in order to succeed. With such a position one most often finds a Libra Ascendant. This of course emphasizes the concern with social issues and values, and the ability to deal with groups—and in so dealing to discover one's own identity.

THE LEO-AQUARIUS COUPLING

The four cardinal signs of the zodiac refer to four most characteristic types of solar activity insofar as nature in the Earth's biosphere is concerned—equinoctial and solstitial types. These modes of activity become "fixed" in Taurus, Leo, Scorpio, and Aquarius. They are fixed within four specific types of human organisms; they are condensed, concentrated, and given characteristic forms which are filled with specific types of substances—and we know that substance or matter is simply a condensed state of energy. When a creative person composes a symphony, or paints, or when a performing artist incarnates on a theatrical stage the personage of a play, he projects his personal vision by bringing together the esthetic materials his culture has made available to him or he has selected from his natural environment. He "fixes" these material elements in a form which expresses his personal character, or during some collectivistic periods—the character of his culture, religion, or communal way of life.

In Taurus the equinoctial impulsiveness of the Day-force becomes substantiated and incorporated through the use of materials available in the biosphere. In Leo the personalizing characteristics of the summer solstice are given an individual form in which a life species and a consciously developed human person see themselves embodied or reflected. In the opposite section of the zodiac Aquarius gives form to a stabilized social whole—an ethnic group or a nation—producing what we call a culture. A culture is expressed in a wide variety of art forms, social forms, clubs, salons for the discussion of new or old ideas, etc. A culture can only develop where the social will has established its domination over the heter-

ogeneous desires and opinions of the separate members of the community; where a definite "way of life" has emerged.

The individual with a Leo Ascendant seeks to discover who he is by creating mirrors upon which he can project and reveal to his consciousness what his original birth-potential—or Soul potentialities and *dharma*—is. He seeks to find his self in his creations, at whatever level these creations find their embodiment; thus the creation may be a child, a work of art, a specific kind of social performance, etc. If one understands well this process, two factors will stand out clearly. First, the Leo rising individual has to impose his desire for self-projection upon whatever materials are necessary; he has to see that they are available and responsive to his projected *imagination* and will force—in Sanskrit, *Kriyashakti* and *Ichchashakti*. When these necessary "materials" are other human beings, the Leo person becomes the man who *has to* lead and even to rule over people or social projects. But the second factor, which should not be forgotten, is that this intense desire for self-projection is rooted in and conditioned by the fact that the individual is *not sure* of what he essentially is. He tends to be socially insecure because he is uncertain of his *dharma*. He has to prove himself to himself, to discover who he is in the mirror of his creations. His grand gestures may indeed be compensations for this inner lack. At all cost he must find out how people react to him, and perhaps discover his strength in their subservience. In order to be able to express his unclearly known self, he has to be able to handle cultural products and thus Aquarian symbols, words, concepts. He meets his partners in terms of vast concepts —social, cultural, occult. These are needed to provide *basic forms* for his will to expression. Thus the Leo Ascendant must interact with the Aquarius Descendant.

When the situation is reversed and the sign Aquarius is rising at birth, the individual tends to identify himself, spontaneously and intuitively, with his culture and all the enjoyments it provides; or with great dreams of reform, challenging old structures, pioneering for a New Age. Then, because these cultural forms can be empty of real vital meaning unless personalized, the individual will seek partners who will cooperate with him—either partners in cultural play or in reform and perhaps revolutionary activities. These partnerships may have a very emotional character, because the

individual will demand wholehearted cooperation and often exclusivity.

When the sign Leo is at the cusp of the fourth house, a person's home life and the development of his personality may be conditioned by a feeling of pride and the desire to live in an at least relatively sumptuous residence which will become a stage set for self-expression, or at least in tune with the need for the exteriorization of what the person senses to belong to him by right of destiny. Richard Wagner was an excellent example of such a situation. The fourth house process for personality integration may take on dramatic overtones, perhaps verging at times on theatricalism. The person with Leo at the Nadir of his birth chart may have a somewhat regal but possessive mother. Wherever he is, he wants to be "lord of the manor"—and it may have to be a well-fortified manor with ego-walls.

The Aquarius Zenith usually indicates reliance of the creative person upon professional and social patterns as fields for the projection and stabilization of his personal power. He often seeks some relatively large, and perhaps idealistic, field for public action; he wants a broad stage on which to play his role, a role in which he can shine individually. His whole community should be such a stage, or it might be a professional field which deals with new inventions or offers the opportunity to become a leader or a prophet.

When Aquarius is at the cusp of the natal fourth house, the search for personal integration should be deeply affected by social issues and home life may be inspired or even invaded by idealistic or revolutionary dreams. Then the Leo Mid-heaven will manifest itself as the tendency to pour energies emotionally and dramatically into whatever makes possible the fulfillment of the Aquarian ideals. In such a situation we often find a Scorpio or Libra Ascendant, and this stresses even more the feeling of identification with social or occult groups.

THE VIRGO-PISCES COUPLING

The Virgo type is characterized by his analytical and critical temperament, and by the urge to reorient or repolarize the essential energies of his emotional-personal nature. Virgo is a symbol of

psychological crisis, and may also refer to ill health, or to a deep feeling that something is to be done with regard to health. Virgo follows Leo, as trouble usually follows the too personal manifestation of our urge to self-expression at any cost. But it can also mean progression to a higher realm of consciousness and personal metamorphosis.

The Virgo-rising person will seek to single himself out by his progressive transformations, his spiritual overcomings, his bodily rejuvenations. In some cases he may achieve much through a sense of humility and a will to serve others; in others, there will be much criticism or insistence upon technical achievements. There may be a deep yearning for purity and even sanctity, which may lead to self-deception and unsound devotional attitudes.

The Virgo-Ascendant type of person meets his closest associates in a Piscean manner; and where he is critical as an individual, he may easily be much too open as a lover or a partner. He is longing for the loss of himself in a collectivity or a cause, just because he is seeking to achieve his individual status as one who has experienced a personal metamorphosis. He has to be devoted to whomever or whatever seems to embody the state of being which is the goal of this metamorphosis.

Pisces symbolizes a state of social, collective crisis. At the stage of life represented by this last of the zodiacal signs, man finds himself swept by social storms against which he is powerless. He is controlled by the fateful consequences of the "sins" of his fathers, and of his past cycles as an individual. He has to give up all solid things, all comfort or security, and lose all reliance upon social, cultural, or religious structures, if he is to be reborn in Aries as a true individual, a source of new life. In Virgo man has to give up personal limitations which bind. In Pisces, he must give up his allegiance to old gods and ancient laws and face the new God whose countenance is as yet unrevealed.

The Pisces-Ascendant type may be wide open to the collective unconscious—perhaps a medium, perhaps a true seer. But he may also be a crusader, a leader of armies or of groups dedicated to a greater future for their nations or for humanity. This very openness to the unknown will call for partnerships of a critical Virgo type. The Pisces-rising person will demand of his loved ones that they should pass through ceaseless metamorphoses. He may demand rigorous discipline and a spotless conduct from his associates. Having

his vision absorbed by vast changes, he will often meet daily trivialities with impatience and meticulous care. For himself he will rely upon intuition, but will seek to find intellect and accuracy of technique in his partners, or will display such Virgo characteristics in his dealings with others.

Because Virgo and Pisces are signs of the zodiac which refer to critical states in the evolution of consciousness and of the ability to use power constructively, it can be expected that when these signs are found at the natal meridian the individual will tend to achieve power and to fulfill his destiny in the midst of personal and social transformation. He may discover where he belongs in the effort to meet issues in personal or social situations which challenge his impulse to serve, or to play a role in revolutionary upheavals.

Virgo at the cusp of the fourth house should normally bring a great deal of self-analysis and self-criticism in the process of personality integration. The value of ancestral, usually taken-for-granted traditions may be questioned; there may be much preoccupation with the improvement of the home situation. The mother's influence could lead to concern about diet and health; the child may feel confused and upset by a critical mother. If Cancer is the rising sign, the possibility of a mother complex against which the adolescent may rebel more or less successfully, may be fairly strong. If Gemini is rising, a greater stress on intellectual processes and analytical procedures is likely.

Virgo at the Nadir point implies Pisces at the Zenith. The public and/or professional life should be concerned with large social issues, especially in terms of a transformation of the *status quo.* Albert Einstein—with Cancer Ascendant—is a good example of this, for his work involved him directly in changes of awesome magnitude in the conduct of international affairs. He stressed the use of intuition even in scientific discoveries, and his ancestral roots had tragic overtones. Pisces at the Mid-heaven often favors a musical profession, as in the case of Richard Strauss, but a Piscean approach to one's participation in society may take many forms. Much depends as always on whether or not planets are located in the tenth house, and what these planets are. The great humorist Will Rogers had a Piscean Mid-heaven. Humor, in a sense, is related to situations of crisis, because it challenges assumed values

and appearances, particularly regarding public figures and institutions. On the other hand, Pope Pius XII, with a Piscean Mid-heaven and a Sagittarian Ascendant, led a religious organization in a time of crisis.

If the situation is reversed and Virgo is at the Mid-heaven— and Pisces, therefore, at the fourth house cusp—one may find a person who identifies with large social trends at a time when it may be his personal destiny to focus forces of radical change. This in turn forces him to take a critical Virgo approach to social institutions or set professional patterns. We see this strongly emphasized in the birth chart of the great iconoclast Nietzsche and of Benito Mussolini, promoter of Fascism and of the managerial state. (Mussolini even used castor oil as an instrument of political power, his gangs forcing his political opponents to absorb a vast quantity of it on the night preceding crucial political speeches, and votes—with the expected intestinal results for the victims!) Lenin was another example, with a Scorpio Ascendant suggesting passionate identification with collectivizing forces; his Pisces Nadir befitting a homeland in a crisis of total transformation.

In closing this chapter I should stress again that what has been said indicates trends that can be deeply modified by the presence of planets in the angular houses, and by their relationships to other planets. In addition, the importance of the *degrees* of the zodiac at the four angles of a chart can hardly be overestimated. But this refers to another field of study which is full of ambiguity and of confusing claims, yet most significant. I can only state here that degree symbols can add a new dismension to the interpretation of the internal character of the angles and of all planets. They indicate, at least tentatively, the inner quality of the basic situation and the activity represented by the angles and the planets located on these degrees; the whole set of 360 degrees theoretically can be likened to the set of the 64 hexagrams of the I Ching. But in order to do this, the cyclic series of degree symbols has to prove its validity by its internal consistency and by the structural interrelationships between the symbols, when they are related in several ways.

The only set which I feel meets these requirements are the Sabian Symbols, which were recorded during the nineteen twenties by Marc Edmund Jones and Elsie Wheeler, and which I reproduced

with Marc Jones's permission in *The Astrology of Personality*. However, when this book was written—1934-36—I had not yet made sufficient use of these symbols to realize that their formulation, and especially their interpretation, needed a great deal of revision. Marc Jones tried to do this in a later book, *Sabian Symbols*, but I personally am not satisfied with the results. A series of articles I wrote in *American Astrology* in 1945-46, *The Wheel of Significance*, also leaves much more work to be done. Yet even in the form in which they are available, these symbols can be a significant tool in the hands of an intuitive interpreter who does not force a philosophical or social point of view upon them but allows every detail of the symbolic image or scene to speak for itself.

The Planets in the Twelve Houses

THE RELATIONSHIP BETWEEN A PLANET AND A HOUSE CAN be interpreted in two ways. On the one hand, the planet in a house indicates that the basic type of experiences to which the house refers can be handled to the best advantage by the physiological and especially the psychological function symbolized by the planet. On the other hand, the fact that a planet is located in a particular house suggests that the character of the experiences represented by that house will affect the manner in which the planetary function normally operates. To illustrate this last point we might say that if a man lives in an arctic region, his liver and his drive toward physical achievements will operate in a manner which is distinctly different from that which can be expected in the tropics.

The houses have often been linked with the various types of life *circumstances*, and this interpretation is correct up to a point. In a strictly person-centered and humanistic astrology what is essential is the individual's *experience* under these types of circumstances (circum-stances literally means what surrounds the experiencer); in other words, the subjective aspect of the houses is emphasized rather than the objective situation inducing the experience. This seems far more important because the same external circumstances can produce different experiences in different individuals, or even at different periods in the life of the same individual.

What matters psychologically and holistically is the attitude of the individual to what occurs.

A planet in a house indicates what type of functional activity will *naturally condition* this attitude. It is "natural" for a cat to want to eat birds, but the cat may be trained not to chase them. In terms of nature's ecological balance, however, it is "best" for any living organism to act according to its instinct, death being merely a phase of the vast rhythmic process of nature. In the Bhagavad-Gita the divine Manifestation, Krishna, enjoins his pupil, Arjuna, to follow his *dharma*, what in man is the *conscious* equivalent of compulsive and unconscious instinct in animals and plants. Arjuna, a leader of the Warrior caste, is told to strike his enemies not under the impulse of *personal* hatred, but as a consecrated agent of the divine Will, leaving this Will to account for the results of the struggle.

If therefore Mars is in a person's first house, that person will find it "natural" to go forth as an individual with Martian impulsiveness; by so doing he or she will "best" come to the realization of his or her essential "truth of being" or spiritual identity. On the other hand, the Mars function in that person will tend to be rather strongly individualized, because its basic purpose will be to reveal to the individual what he or she really is. The Mars function will be most effective—it will most truly fulfill its purpose —when used in terms of first house issues, and not, for instance, in terms of fifth house love affairs and children, or of second and eighth house management of personal or conjugal business, etc.

This obviously is not meant to convey the idea that the Mars function cannot operate in all the life circumstances in which it is needed; but *the typical character* of that operation in the above-mentioned case should carry the stamp of a highly individualized purpose and, in a sense at least, it should be related constantly to the central problem of self-discovery if it is to be of maximum value to the person with Mars in the first house.

I believe that it is only as this basic approach to the planets and their positions in natal houses is clearly understood that the student of astrology can use this particular astrological tool to full advantage. The difficulty in giving specific examples is that the house position of a planet is only one of many factors which constantly interact. It should be clear, however, that a planet in any house, or in any zodiacal sign, always retains its basic func-

tional character. The traditional concept that a planet is strong or weak, exalted or in detriment in certain house and sign positions is open to question; in any case, strength or weakness does not change the functional character of the planet. At most it can only indicate whether circumstances and genetic patterning are more or less favorable for the operation of the function. A relatively weak function can dominate the consciousness of the organism and perhaps find substitutes for action when such action is essential to survival or to the individual's basic purpose; moreover, we should realize that so-called discordant aspects can also release great strength. Nevertheless, the position of a planet very close to one of the angles of the chart makes its function a prominent feature in the person's basic approach to life.

What follows is to be considered only a series of general statements or guidelines for interpretation. I repeat that many factors can modify what is said, and no astrologer can ascertain at what level the function of the planet will operate in the life of the individual whose chart is being studied, unless this individual's state of consciousness and evolutionary level are known or deeply and intuitively felt. Even then no absolute certainty is possible because the individual in most cases is truly free to choose the kind of response he will give to any basic challenge.

THE SUN. In each house the Sun indicates that the kind of experience to which the house refers will tend to call for a spontaneous and at least relatively forceful release of vital energy.

In the *first house* this energy should illumine and sustain the search for identity and the intuitive perception of who one really is, or of one's self-image. The person with the Sun about to rise may experience an inner enthusiasm, a freshness of viewpoint, or simply a robust health that will enable him to radiate what he is in a distinct and compelling manner. It is in such a search for identity and in all deeds requiring personal self-assertion and emotional intensity that the Sun function will be called upon to operate most successfully. The negative aspect of this position may be pride and "in-solence."

In the *second house* the Sun tends to stimulate the production of inner or outer wealth, that is, the outpouring of collective,

ancestral, or social energies into the personality; the result may be that these collective energies—which may manifest as money—will overpower the person's individuality, that they will use him instead of being used by him. Vitality can become possessiveness, "having" may overcome "being." On the other hand, the person may become an eminently successful manager of wealth and fulfill his individual destiny in this way.

In the *third house* solar vitality should stress the faculty of adaptation to the environment, which in its characteristically human sense is intelligence. Intellectual pursuits will draw an abundant flow of energy. Illuminating experiences can be reached through the power of the mind—a mind that is both analytical and clear. The Sun in the third house does not necessarily make a person an intellectual in the usual sense of the word. It can, however, make him a powerful force vitalizing all that surrounds him, like Abdul Baha, the son of the great Persian Prophet, who, during forty years of confinement in Akka, brought light and love to all his companions.

In the *fourth house*, the Sun stresses the vivifying power of inner experiences of personal integration, and in many cases suggests a vital contact with one's ancestry, home, and tradition. The roots of the personality are strong and experiencing their power may lead naturally and spontaneously to some kind of illumination. But concern with the home and the land may demand a great outpouring of energy. Self-reliance and a deep belief in one's "source" can be characteristic of such a solar position, but it may also mean that security has to be sought and fought for.

In the *fifth house* the Sun may, yet need not, reveal artistic creativity and radiant spontaneity in self-expression. The vital forces tend to express themselves in adventurous and perhaps speculative actions which are usually rich in emotional content but often egocentric and may represent merely a way out of inner pressures which seem intolerable. The love motive may be dominant—as in the case of the Duke of Windsor. There can also be a strong urge for the use of power and perhaps leadership, particularly in situations which call for intense vitality. One could cite the examples of Franklin D. Roosevelt and Lenin.

In the *sixth house* the Sun may indicate the value in following the path of service, devotion, and discipleship, for a masterful individual may illumine that path. Hard work or concentration will

draw energy from sources of strength deep within the individual. Crises and transforming events will be met with great stamina and faith. It should be evident to the person that such challenging events have to, and can successfully be met. A sense of dedication to a highly stimulating task is expected, but the Sun in the house which also refers to health and illness can signify the need to use one's will power for self-healing. It does *not* mean low vitality, but the focusing of vital energies for the purpose of overcoming some weakness, karma, or the result of misdeeds.

With the Sun in the *seventh house*, the vital forces tend to be stimulated mainly in the play of interpersonal relationships. The individual will normally reach the clearest realization of his basic life purpose by associating with others in partnership and in view of establishing a foundation on which a feeling of joint participation in a social purpose can be based. The individual may be a light to his partners, or he may discover his true vocation in dealing with matters of interpersonal relationship—as the psychologist Carl Jung did. In a negative sense he may be an autocrat who uses his partners to serve his goal of mastery. In any case, interpersonal relationships will demand and receive much attention; they will draw out the best in the individual, according to the character of his self and his destiny.

In the *eighth house* the Sun may bless the fruits of any relationship and all that increase and illumine the feeling of close union with and integration into a group process, a social or occult ritual. It may stimulate the capacity for business management, or for identification with any power or entity which seems able to help one pierce through the barrier of the known, the familiar, and the egocentric. It will spotlight the use one makes of the power born of relationship, and of what the recent past of one's race or society has made usable; thus the reference to legacies in this house.

In the *ninth house* the Sun illumines the understanding but also may indicate an all-consuming ambition. It vitalizes all attempts at self or group expansion. The lure of the foreign and the exotic may be great, and so also that of the mystical. Religions and philosophical pursuits are stressed because the vital drive is toward discovering the basis on which all social and cosmic relationships operate; thus the meaning of life and all events. "Great dreams" should be watched and studied. The danger is to become overpowered by bigness, or by megalomania, to lose contact with everyday facts.

As the *tenth house* is the field of achievement and of public or professional operations, the Sun in this house can mean outer success, leadership, social power and prestige. It may refer to having an illustrious father, or living in an authoritarian society. It can also mean that the basic energy of one's nature will be called upon more or less constantly to handle difficult, even negative situations. When a planet is in a house, problems may also arise with regard to the kind of power the planet represents. With this solar position, prominence is often gained through self-exertion, but in other instances there may be a natural, spontaneous, and irrepressible radiance in the personality which produces the fascinator of men.

The Sun may be found in the *eleventh house* of the birth chart of men whose urge for social or cultural reform or revolution is glowing at white heat, men who can bring new vitality to the social or cultural groups to which they belong. The energy of these men will be oriented more toward the future than toward the expected fulfillment of traditional patterns. They may be crusaders for a cause—as were George Washington, Sun Yat-sen, or the writer Upton Sinclair. But they may also be excellent managers of social wealth and should treasure friendships and develop cultivated tastes.

The Sun in the *twelfth house* tends to throw light on the "unfinished business" of the past. The clearing up of karma may become a central life work, which may mean the cleansing of the subconscious and the repudiation of the ghosts of the unlived life—whether in terms of the concept of reincarnation or in relation to the first 28 or 56 years of this present life. The individual may need great solar energy to perform this task and his attention will be drawn to it again and again. Personal illumination may come while in jail or confined by physiological, social, or psychological crises. Power may come to the individual through identification with some great image of the collective unconscious, on the basis of which a new start may be made.

THE MOON in a house singles out the field of experience in which the ability to adjust to the challenges of everyday life is most likely to be required. The individual will have to feel his way cautiously, ready to make needed compromises and to take care

not to be swayed too much by personal moods, or by the demands of those who depend upon him or her for guidance and "mothering."

In the *first house* this Moon faculty for adaptation and instinctive evaluation of opportunities and danger operates within a more or less well-defined individualistic structure. The individual needs this faculty—which may also manifest itself as reliance upon a Mother figure—in order to realize his uniqueness and his destiny. Experiences of self-discovery, under certain Moon aspects, may be fleeting and irrational. In a woman's chart the experience of motherhood may be decisive and may structure the whole life.

With the Moon in the *second house* an individual has to use all his resources without rigidity, and remain open to what every day brings. If he is a public figure, an artist, or writer, public response will condition his financial situation. All money situations tend to be fluid. A person with the Moon in the second house may be very sensitive to the needs of the times and the demands of the collective unconscious.

A *third house* Moon should stimulate intellectual activity and the ability to find one's way in what may be a disturbed or chaotic environment. Relationships with siblings, and particularly with a female relative—or with women in general—may stir up the imagination and may guide the development of a keen intelligence. Objectivity is needed to complement feelings and dissipate moods.

In the *fourth house* the Moon refers largely to the mother's influence and the feeling one has toward one's home and tradition. The individual may often withdraw within his psychic foundations, perhaps for fear of meeting disturbing confrontations. A strong sensitivity to the feelings of people and to the psychic atmosphere of places in which one lives may be necessary for survival or peace of mind and soul; it also may cause problems, because of too subjective an approach to the hard realities of existence. An example of this is Helen Keller, who, though deaf and blind, with the help of a remarkable woman became a well-known person and a symbol of courageous adjustment.

The Moon in the *fifth house* can stress the poetic imagination, but also an unsteady emotional life, too open to impulses of passion. Yet the Moon function is needed there to act as the mother of

children, or as the mystic Muse which inspires the artist or musician. A mother should avoid keeping her children in psychic bondage, even though they may greatly need her guidance.

In the *sixth house* the Moon can bring extreme personal sensitivity to the need for change and personal reorientation. The individual needs this Moon function to deal with problems of adjustment to often strenuous working conditions, or to poor health. In time of trouble he may yearn to be mothered, but instead he should depend on his own ability to adapt and to effect constructive compromises, even if this may appear to be mere expediency.

In the *seventh house* the Moon should provide the sensitivity needed to adapt oneself to a partner's idiosyncrasies and demands. Flexibility in matters of interpersonal relationships, particularly in marriage, is very important. The relationship itself should be nurtured, and even more care should be given to it than to the other partner. A partner should be selected who could respond to one's psychic projection, especially if the seventh house in a man's chart is being considered.

In the *eighth house*, the Moon function can refer to the ability to foresee evolving trends in the field of business, and the need for taking a sensitive approach to popular moods. The Moon in this field of experience may be like a magic mirror reflecting unseen forces at work. But, if in strenuous aspects to some planets, this Moon can bring confusion, occult glamor, and a passivity to elemental forces. Guidance and an analytical practical mind should be most valuable.

The Moon in the *ninth house* indicates the potential ability to adapt to unfamiliar and perhaps exotic or transcendent conditions of existence, or to new concepts and symbols. This is a valuable lunar position for people engaged in large enterprises or in the search for metaphysical truths or abstract principles. It tends to enable the consciousness to reflect what the mind may not be able to analyze rationally. In some cases it can produce seership or a keen understanding of deep currents in politics, as well as the ability to formulate relevant plans of operation.

In the *tenth house* the Moon indicates a capacity for putting into operation large concepts or social plans when it is practical and above all expedient to do so. The needs of the moment and the mood of the public in regard to social or political affairs are

cleverly assessed and adequate action easily follows, unless of course
the Moon function is disturbed by other factors. President Franklin
D. Roosevelt is a good example of a tenth house Moon, but with a
strong Mars nearby challenging his public activity. Gandhi is an-
other example.

In the *eleventh house* the Moon may either reflect the achieve-
ments of a society and its way of life, bringing the individual charm-
ing friends and relaxed feelings, or it may make this individual
keenly aware of social injustices and failures, and focus a collective
feeling of public discontent and perhaps rebellion. In Joan of Arc's
traditional chart the Moon is conjunct Jupiter in this eleventh
house—quite an appropriate situation for one whose "Voices" led to
the resurgence of her invaded country and the birth of the French
nation.

In the *twelfth house* the Moon can indicate a psychic gift, or
the general ability to reflect in the mind the whole meaning of the
transition between an ending cycle and the birth of a new one. All
depends on what is done with this faculty. It can be overwhelming
and confusing. It can precipitate karma, leading to a sort of closing
of accounts. One must beware of a passive or defeatist attitude, and
of too great an openness to the collective unconscious, or to one's
personal complexes.

MERCURY in a house indicates the field of experience in which
the power to communicate information, to remember the results
and causes of past experiences, and to establish relationships be-
tween such experiences can operate with maximum effectiveness.
What is also shown is the type of circumstances which will require
the use of this Mercury power.

When this planet is in the *first house*, the person will tend to
use his mental faculties to discover the nature of his essential being
and destiny. He will see himself differentiated from other persons by
his intellectual approach to his own problems. Much will depend
upon whether the Sun is above or below the horizon. In the chart
of the Hindu mystic Ramakrishna, Mercury and Jupiter are in the
first house, but at his birth the Sun and Moon were conjunct in the
twelfth house, which therefore polarized his vital devotional energies.

In the *second house* there may be need to concentrate intellectually upon financial and managerial problems, or upon ways to make use of the foods for thought provided by one's culture, and perhaps to improve natural products or techniques of production or acquisition. Money may be made by means of intellectual efforts.

In the *third house* Mercury operates in a field of experience to which he is particularly well suited. Intellectual faculties, any learning process, and matters referring to the communication of information should be emphasized in evaluating and adjusting to one's environment. This is a fine position for experimentalists in science, like Louis Pasteur and Luther Burbank.

In the *fourth house* Mercury should be particularly effective as the power of intellectual concentration and also of discrimination in terms of what can best be used to provide a solid basis for personal security and strength of character. In some instances the mind in this house is dominated by national and religious traditions.

In the *fifth house* Mercury may bring literary abilities and the capacity to project one's emotional impulses in forms which can communicate them to other people. Creative impulse could nevertheless be too formalized and systematized, losing some of their spontaneity and directness. On the other hand, the mind may be swayed by emotions and ego drives.

In the *sixth house* Mercury tends to refer to the intellectual worker; or at least it shows the importance of using one's mind when at work, or when serving a cause or a great person to whom one is devoted. As the sixth house relates to situations of crisis and self-transformation, the mind should be flexible, critical, discriminating, and able to bring objectivity to the emotional life—of others as well as of oneself. Examples of Mercury in the sixth house are Carl Jung, Franklin D. Roosevelt, and V. I. Lenin.

Mercury in the *seventh house* favors contacts with intellectuals and all activities that formalize interpersonal relationships—contracts and intellectual agreements of all types. The mind will grow and mature through human relationships more than by the study of books. One should be objective in and try to bring clarity to any relationship.

In the *eighth house* Mercury is needed to work out the practical details of contracts at all levels. It should lend objectivity to feelings of sharing and the search for the beyond. In that house Mercury

may be transcendentalized and given greater depth, as was the case in the life of Ralph Waldo Emerson and Mary Baker Eddy, founder of the Christian Science movement.

In the *ninth house* Mercury is called upon to define as clearly as possible abstract concepts or religious intuitions, or to plan carefully distant journeys and large-scale attempts at expansion. It may help to remember dreams and to relate unfamiliar experiences to one's individuality and purpose.

In the *tenth house* Mercury is likely to bring an intellectual basis to one's vocation. It should define clearly one's conscious participation in the community or in society as a whole. The mind tends to be drawn to social or professional problems which are in need of being solved and which the individual feels he can solve.

In the *eleventh house* Mercury may bring many valuable social contacts with individuals of intellectual stature. The mind should be used to study and criticize the past, and to plan for a better future. Friends may expect mental stimulation from you as well as intellectual advice. One should try to formulate clearly one's hopes and wishes.

In the *twelfth house* Mercury points to a life turned inward, a life of meditation perhaps dedicated to transcendent purposes, or forced to withdraw perhaps by society or by illness from outer activity. Much attention should be paid to intuitions, hunches, or inner guidance. The mind may be focused on dealing with social crises or injustices, or with one's own personal karma and subconscious urges.

VENUS in a house indicates the field of experience in which the desire for interpersonal relationships and the sharing of values will tend spontaneously and most effectively to operate, and also how this type of experience can release its fullest meaning for the person.

With Venus in the *first house,* a person will probably seek to discover his unique character and individual purpose in an open and magnetically attractive manner, for he will feel that this discovery involves his relationship to other people. Yet he will tend to relate to himself whatever he realizes in association with others. He above all wants what love experiences and cultural values can

bring to him. He attracts others, but often in order to possess or integrate them with himself.

In the *second house* the possessive character of Venus is likely to be quite strong. The individual may find in himself the flowering of a significant trend arising from his cultural or ancestral past, bringing this past to a consummation. He should extract value and meaning from it; if it relates to wealth, he should let it operate in a harmonious and meaningful manner, not making love or meaning subservient to possessions.

With Venus in the *third house* a person may want to share value and love with people close to him, relatives and neighbors. Venus in that house brings a glow to the urge to make the best of one's environment. One should seek to beautify, harmonize, integrate this physical as well as psychological-social environment, and also to bring warmth to mere intellectual opportunism.

In the *fourth house* Venus tends to bring harmony to the home situation and to interpret one's sense of rootedness in a family, a land, a tradition in terms of one's responsibility to bring the values they contain to fruition. A certain degree of introversion may be valuable, for the individual has to impart meaning to his feelings.

Venus in the *fifth house* indicates that a person can best evaluate life and understand the significance of his own character when he goes forth in creative activity or reaches out to someone who will be a catalyst to the revelation of the archetypal truth of his being. The individual has to project himself outward in order to see his image reflected in someone else's eyes and love. This projection may be frustrated again and again, but the desire remains. It may mean self-projection in one's child; and if so, what must be avoided is overattachment and possessiveness.

In the *sixth house* Venus casts a glow of hope and faith upon the trials of periods of transition, because the critical state between two conditions can more easily be given meaning in terms of the whole process of existence. Service may be pervaded with love, the routine of work by mutual understanding between employee and employer. The disciple's emotional life can be concentrated upon and indeed surrendered to the Master, but this usually involves a difficult ego-transcending and emotional repolarization.

The *seventh house* theoretically is the field of experiences in which Venus can truly radiate, but Venus may also insist that all

intimate relationship reveal their deepest significance and value. The quality of the relationship may be more important than the partner as an individual, yet without relationship life would seem barren. Discordant aspects to Venus may nevertheless give a negative or even sadistic aspect to the need for relationship. Adolf Hitler presents an excellent example of a Venus operating along the path of destruction, for Venus was also the planetary ruler of his Libra Ascendant. Venus can devour as well as bless with love.

In the *eighth house* Venus can bring to fruition business deals and all contractual agreements. The sharing with partners is normally harmonious, but money may not be the only factor involved. Venus in this house should be used to cement with love the members of a productive group or a group of seekers after transcendent realities. It should help to keep the meaning and value of the group clear and convincing.

To the typical experiences of the *ninth house* Venus should bring the sense of individual value which an ambitious person, or a man seeking to escape into exotic or pseudo-mystical realms of consciousness, can easily lose. But Venus in that house can add glamor and excitement to any adventure or long journey. It can give to a creative artist an imagination inspired by religious, metaphysical, or cosmic vistas.

In the *tenth house* Venus may be an indication of an artistic vocation or, more generally, of the capacity to organize and integrate groups of people—or materials—and give them significant form. This is a good position for a charming and intelligent woman who wants to have a salon where important people meet. She can then play a significant role by bringing together the right people for the right purpose—as she sees it.

Venus in the *eleventh house* can be a powerful magnet, establishing fields of attraction in which human beings can enjoy and profit from the results of their public or professional activities, whether as real friends or as persons sharing a common ideal within a common culture. The love of beauty and the arts, or a deep feeling for people crushed by society can be experienced. Venus in this house is the great humanitarian as well as the refined man of culture. Collective values are likely to be more meaningful than personal values.

In the *twelfth house* Venus may represent either dependence

upon traditional values and profits from state institutions, or the individual's attempt to fathom the meaning of both his own past and his society's accomplishments, perhaps mainly in order to have a significant basis for making a new start. If ill-aspected, Venus in the twelfth house can refer to emotional complexes which need to be investigated and overcome, perhaps in a place of retreat or confinement.

MARS in a house reveals the field of experience, and thus the circumstances, in which physical strength, initiative in the pursuit of what one desires, and some degree of aggressiveness can most successfully be applied in terms of a person's individual destiny or *dharma*.

Mars energy in the *first house* can best be used to pierce beyond appearances and to force one's way to the center of one's innermost being. More generally the search for a self-image may be pursued most effectively through personalized forms of activity, by involving oneself wholly in what one attempts to do. A good example is President Theodore Roosevelt whose "big stick" policy gave strong impulse to American expansionism. Roosevelt was a weak child, and probably overcompensated by becoming a symbol of aggressiveness.

Mars in the *second house* does not mean lack of money, as some astrologers claim, but rather a constant outflow of money which may leave nothing in reserve. A person assumes risks in the management of his resources and may perhaps follow irrational impulses. Everything has to be used and the Mars function may thus become overpersonalized and involved in material values. A person with Mars in the second house may be a financial genius, or a mere spendthrift.

Mars in the *third house* indicates the need for initiative and courage in matters affecting the environment. Conversely, it may reveal the influence of an aggressive sibling, relative, or neighbor who challenges a person to use his or her capacity for intellectual agility and quick action. The mind should be sharp and analytical, perhaps caustic when its beliefs are attacked. Dante, Victor Hugo, Pasteur, and Harold Wilson had Mars in the third house.

In the *fourth house* Mars may refer to a home life in which the individual has to meet situations arousing his emotions and causing irritation; these may challenge him to be positive. The urge to fight against a perverted tradition may be evident, as in the case of Martin Luther. The individual may seek to go deeper and deeper in order to discover a solid foundation for his personal activities, regardless of obstacles or family pressures.

Mars in the *fifth house*, which refers to emotional outgoing and self-expression, tends to give unusual force and impetuosity to a person's desires. It may stress the use of the will and the value of wholehearted self-projection and risk-taking. It should stimulate the power of faith and the artistic imagination. The purpose to which the will and imagination are directed depends on the level at which the individual operates. Both Lenin and Pope Pius XII had such a Mars position.

Mars in the *sixth house* often indicates a natural drive to overcome personal handicaps—perhaps physical ones—and the will to transform oneself through work, retraining, service, and/or discipleship. If there is a concern with ill health, it is because illness is seen as a challenge to seek healing or a higher form of well-being. Mary Baker Eddy had her Mars in this house and founded the Church of Christ, Scientist based on faith, will, and the denial of evil.

A person with Mars in his *seventh house* may rush eagerly toward any form of close association. He should display initiative in interpersonal relationships and seek partners in whom he can arouse devotion to a cause which his imagination and faith may have envisioned. Difficulties with partners will be challenges to use his will for power, or survival.

In the *eighth house* Mars indicates the need to take an aggressive or at least forceful, attitude in business, and to arouse a group of associates to action. In this position Mars is the leader of social or occult rituals, often impulsive and reckless in driving others to a goal.

In the *ninth house* Mars evokes the need to push forward with indomitable strength and courage in all great quests, be it the search for gold, for power, or truth, or for a God experience. This position should favor prosecutors and lawyers, and politicians during a period of national expansion; it reveals the inner drive that made Disraeli a symbol of British expansionism.

Tenth house experiences can be energized by Mars, the power that drives the individual to public achievements and fame. There may be antagonisms to overcome, but a good fight is welcome. Success will be achieved mainly through initiative, courage, and faith. A person's energy will tend to be mobilized for public purposes. Examples, again, are President Franklin D. Roosevelt and the composer Richard Wagner.

In the *eleventh house* Mars should be used as will power in any struggle for the realization of one's ideals. One may have to be very positive in friendship, or in the promoting of cultural or spiritual goals. This may mean trouble and/or intellectual controversies which will become quite animated and emotional. This is a good position for reformers and critics of social injustice.

A person with Mars in the *twelfth house* may push to the limit his revolt against society or against what is found in his unconscious, or in some cases in the collective unconscious of mankind. Mars power can be used to pierce through old illusions or "karmic deposits"—witness the case of the great Indian political leader, yogi, and poet Sri Aurobindo—to redeem and transfigure the past, or simply to claim one's due from social institutions.

JUPITER in a house does not need to indicate "good fortune" in matters signified by this house. It reveals what is the field of experience in which the drive toward a greater, more expansive, fuller life can most significantly be focused. Jupiter essentially symbolizes human fellowship and the increase in well-being or power which result from togetherness and cooperation. SATURN is in most ways the polar opposite of Jupiter, for it represents the drive to self-limitation in order to ensure greater security and a more concentrated type of activity; yet because man is basically a social entity, the Saturn function finds its true field of operation as the result of the operation of the Jupiter function, that is, in the field of social relationship. Saturn makes a man secure in the fact that his society accepts him and guarantees his place in it, his name, his signature.

In the *first house,* Jupiter indicates that there will be self-discovery through the use of personal authority and managerial power.

The guru realizes his "divinity" as he expands his consciousness within the circle of his chelas or devotees; the manager needs social activities which demand to be managed. Thus there is a basic dependence on the use of traditional values which are valid for the group.

Saturn, on the other hand, when in this first house, reveals the need to define *for* oneself and *by* oneself what one is. There tends to be an attachment to form and to whatever brings concreteness to intuitions and inner promptings. But such an attachment shows that survival or sanity may depend on clear definition and focus. No position of Saturn is "bad"; Saturn does not bring negative results to the type of experiences that the house signifies. It simply tells what is best to be done with such experiences, and where the self-protective, self-focusing power of Saturn will operate most significantly.

In the *second house* Jupiter tends to bring to the experience of ownership a feeling of abundance, perhaps even at times of satiety. The Jupiter function is called upon to manage physical or psychic wealth in terms of its accepted social use. The owner should see himself as a trustee of this wealth for society, because the value of his possessions is social in nature. The selfish enjoyment of privileges represents the negative aspect of this Jupiter position.

When Saturn is in the second house this does not imply an absence of possessions, but a crystallization of the concept and feeling of ownership. The inertia of past social habits prevails because the individual feels insecure. His task is to concentrate his sense of ownership where he can feel secure, which may mean within himself. He should not seek expansion into ever vaster new fields, but he should attempt to focus traditional values and energies around his own center. The old miser is the caricature of such a goal.

In the *third house* Jupiter should bring expansiveness to the experiences related to this field. The intelligence should use broad social and moral or religious ideas in seeking a not only satisfactory but expansive adaptation to the demands of the environment. A person should meet all opportunities for experimenting, learning, or communicating information in a spirit of good fellowship and social participation; the mind should not only collect but integrate data in large classes, to serve as a basis for abstract generalities and principles of organization.

On the contrary, Saturn in this house is meant to teach the

individual how to concentrate on essentials and to develop caution, objectivity, and an economy of means in formulating or communicating knowledge. The immediate environment in which the individual destiny is to unfold may be dangerous, or the person oversensitive to its pressures. The youthful ego must be insulated or protected to allow wholesome growth.

In the *fourth house* Jupiter reveals the need to broaden the social basis of the personality and to socialize the home life. The experiences related to personality growth and the identification of the consciousness with some kind of tradition or land will acquire their highest significance if met with optimism and trust in the cooperation of all people involved. Negatively this may mean pride in one's ancestors or family estate, and the overacquisitiveness of a somewhat inflated ego; or if not pride and bombast, then a longing to gather people around oneself in a court of admirers.

Saturn in this fourth house tends to restrict home life, to draw a person's energies back to their central point of origin and to overstructure the consciousness, forcing upon it a strict moral code or set ego-pattern generated by insecurity or fear. But this can be valuable if required for living in terms of a secure and well-ordered sense of values. The individual should not venture beyond his own depth and should carefully feel the ground under his feet. Saturn in the fourth house may indicate a karmic condition at home and heavy pressure from parents, but Jupiter can bring even more trouble through an overoptimistic mind and a deep-rooted craving for "big things."

In the *fifth house* Jupiter evokes the possibility of a warm and generous love life involving persons of wealth or of expansive temperament. The individual should have faith in his eventual success even through hard times. Education and teaching may be fertile fields of activity for him. He may feel that he has a social mission to perform, whereas it may be only that such a belief actually serves to magnify his every attempt at ego expression. The Jupiter function focused in the fifth house may imply an urge for personal gratification, and self-indulgence through another person who is seen as only a means to that end.

Saturn, on the other hand, restrains the urge to self-expression and risk-taking in love and speculation or gambling, because there is an innate sense of danger and an insecurity that manifests itself

as shyness and social withdrawal. Yet Saturn in this place can also give much greater depth to creative activity, even if it restricts production to a small number of works or to very select or technical fields. The individual's handicaps, however, can become the very basis for his success or fame—witness the deaf-blind Helen Keller.

Jupiter in the *sixth house* can easily bring to the fore the relationship between employer and employee or guru and chela. It may produce warmth of understanding and sympathy without detracting from a sense of responsibility, or from the authority of the one who is discharging this responsibility. Interest or involvement in labor problems or in all forms of healing is to be expected. The individual in a state of transformation or crisis should have hope and faith; and the healer or guide should be totally dedicated to his work. A sense of self-importance and the exaction of some form of worship should be avoided, at least in our western society.

Saturn in the sixth house tends to stress feelings of deficiency in health, strength, or social abilities and thus indicates the need for training or retraining, self-discipline, and a pure or restricted way of life. It may be good to train and exercise the will, but this may make the character rigid and the ego more powerful. Avoid transforming discipline into a rigid dependence upon a fixed routine leaving no alternatives.

Jupiter in the *seventh house* reveals the value of an expansive approach to interpersonal relationships and a broad sense of human sympathy. The experience of partnership should be considered in the light of a social-cultural purpose, that is, as a foundation for a more effective participation in one's community or in society. If the individual's Ascendant should be Sagittarius, he will seek to discover his essential nature through relationship. He may want to relate either to people of many types, or to one person who can offer a wealth of possible avenues for the intimate sharing of ideas and energies—example: Carl Jung.

Saturn in that house refers to a restricted but perhaps most significantly focused feeling for interpersonal relationship. Security in relationship will require subservience to set patterns and traditional rituals. Some kind of innate fear or shyness has to be overcome through social mechanisms which protect the individual—or in some cases through a hard mask of aggressiveness. There may be a transference of the Father image to the husband or even to

authoritarian social figures whose ambition may exact rigid obedience but also provide a strong purpose in life.

Jupiter in the *eighth house* points to the need to manage effectively and in broad terms the fruits of any partnership a person enters into. Society may place responsibilities upon him as a trustee of wealth. As leader of a group he will need understanding, empathy, and a sense of proportion and fair play. His innate social sense will seek situations in which he can work with a group and play a controlling part in some ritual activity.

Saturn in this house can also bring a person in relation to a group, but mainly for the purpose of finding greater personal security in sharing his problems and perhaps his fears with others while pursuing some kind of social work or performance. He may seek to corner as much group-generated power as he can, but he may also refuse to participate in anything concerning which he feels insecure, or which overwhelms his imagination. If he does participate, he may feel lonely and overburdened.

The *ninth house* refers to a field of experience in which Jupiter can shine in all its glory, either in terms of what feeds a strong social ambition and will-to-power, or in terms of an eager search for the understanding of the processes of existence, whether at the social, legal, historical, religious, or cosmic level. The mind—and also perhaps the ego—reaches toward ever larger fields to understand things and reduce them to manageable proportions or formulas. The danger may be fanaticism, or loss of individuality in too-big projects.

Saturn may accept the idea of expansion, but every step of the process has to be firmly secured. The abstract idea or mystical experience has to be concretized and personalized. The "God experience" of the illumined soul becomes in the hands of his followers an institutionalized set of symbols. Ambition tends to be limited by the ego to whatever certifies rank and position along traditional lines.

Jupiter in the *tenth house* demands that the individual aim for big roles in which social, political, or religious power is openly demonstrated and acclaimed. He may be born to such a social position —Queen Victoria—or may reach power and fame through years of effort—Victor Hugo, George Gershwin. Even if public recognition is not obtained, the goal of significant participation in community or universal human issues should be held vividly in the individual's

consciousness as his essential destiny, though personal obstacles may have to be overcome.

Saturn in this house will also draw the individual's life toward some kind of social activity, but the results of this activity in many cases will serve primarily to bring to the ego an enduring sense of security and perhaps an unchallengeable position of strength. In some cases, nevertheless, this enthroned Saturn refers to the sharply focused use of social or political power for purposes which seem, at least at first, to be for the greatest good of a community or nation in a disturbed and disintegrating state. Hitler is a good example of this position of Saturn, as is perhaps Napoleon; also the English Prime Minister Benjamin Disraeli, and the founder of modern China, Sun Yat-sen. The traditional idea that a tenth house Saturn means political success ending in defeat certainly need not apply in all cases. Besides, what is important in humanistic astrology is not the event but the state of consciousness of the individual. Napoleon, Disraeli, and Hitler "succeeded" in becoming great symbols in the history of the western world; they presumably fulfilled their destined roles.

Jupiter in the *eleventh house* indicates that the individual should direct his abilities toward the implementation and exteriorization of his ideals and his vision within society. Henry Ford is a good example of success in this line, as is the Mormon leader Brigham Young. The ideal, however, may be to enjoy a good life with friends after retirement, professional achievements having been thought of mostly in terms of the financial results and comfort they would bring in old age.

Saturn in this house emphasizes the personal motive, the value of friends and cultural contacts in providing secure enjoyment. While Jupiter in the eleventh house may work for important social transformation—Ford assuredly changed, directly or indirectly, the lives of billions of human beings—Saturn tends to indicate a conservative and traditional viewpoint and, as in the case of Queen Victoria, a rigid attitude. Even in meeting friends a person may feel the need to rely upon formalism and moral taboos, though the Saturn function may simply be used to give form to dreams or to symbolize death and depression.

In the *twelfth house* Jupiter can have many meanings according to what is or has been the most basic relationship of an individual to his society and to the culture of his period. It can bring wealth,

honor, and comfort at the end of a cycle of experience that has witnessed a successful rise to a social position; it can lead compassionate and socially dedicated men and women to bring companionship and sympathy to people who have been battered by a ruthless society; it can make of some creative personalities symbols of the great achievements of a closing cultural period—as Dante did toward the end of the Medieval era. The subconscious life of a person may be reorganized and dreams significantly integrated, or an inward-directed life of meditation may open the consciousness to spiritual guidance—especially in times of social crises—and perhaps to the will to sacrifice.

Saturn in the twelfth house may lead a person to give a concrete, visual, or audible form to subconscious images or inner pressures. There may be a deep sense of psychic insecurity calling for anything that would bring order and stability to a confused inner life, particularly if the social environment is chaotic, or has forced on him some form of isolation or exile. The twelfth house has been called "the house of karma and bondage." It need not be, but Saturn does stress the value of dealing with the "unfinished business" of the past. This may be *interpreted* by some as "past lives," whatever exactly is meant by these ambiguous terms.

As the planets beyond Saturn's orbit stay for a number of years in one sign of the zodiac, the positions they occupy in the houses of a birth chart are particularly important. However, these are planets representing deep and radical processes of transformation, and the problem for the interpreter is to try to ascertain intuitively the way in which a person can respond to such processes and especially whether he or she is able to respond positively and constructively.

URANUS in a house indicates the type of experience which will allow the power of transformation and renewal within the individual's deepest being to operate most significantly. In some cases the possibilities of radical transformation are small and the person would not be able to withstand more radical crises; but a crisis which may seem superficial can at times be merely the indication of a more far-reaching and total metamorphosis occurring

below the conscious level. The transit of Uranus over a person's natal Sun is in nearly all instances with which I have ever dealt an indication of deep-seated change, but it is impossible to know exactly how the change will manifest itself. It may be mainly a change of consciousness and attitude, or it may take the form of an apparently external crisis-inducing shock when actually the shock occurs *because* the individual's pattern of unfoldment, that is, his destiny, calls for it. The same uncertainty prevails when one tries to interpret the meaning of Uranus' position in any house. The following are therefore only very brief indications.

In the *first house*, Uranus indicates that the individual will discover his essential truth or dharma mainly through crises challenging him to state, at least to himself, where he stands and what his goals are. The person may move from crisis to crisis, with each one perhaps bringing new illumination. Thus he or she may be a born reformer or leader in some cause challenging the status quo (Annie Besant, Mary Baker Eddy, Cromwell).

In the *second house* sudden events may alter a person's financial status, or genetic factors may induce physiological disturbances and crises. The individual may abandon his family fortune and insist on financial independence, repudiating his past.

In the *third house* Uranus may produce a restless mind and an often-changing environment which demands a capacity for quick readjustment. The individual may welcome such changing conditions—example: Mutsu Hito, the Japanese emperor who presided over his country's change from feudalism to modern industry.

In the *fourth house* Uranus points to the possibility of becoming constructively uprooted, of becoming an agent for basic and thorough revolutionizing forces. Clinging to static home patterns or to a yearning for ego stability would be futile. Much depends here on what Saturn and the Moon indicate in the birth chart, for Uranus is the great foe of Saturnian security and normal adaptation to a steady environment.

With Uranus in the *fifth house* a person may develop inventiveness or originality in creative activity. He should not depend on traditional patterns or modes of expression but instead develop a new way, successful or not, of releasing his energies and making an impact upon his society—examples: Thomas A. Edison, the Irish poet and occultist William Butler Yeats, Swami Vivekananda, founder of the modern Vedanta movement.

Uranus in the *sixth house* stresses the need to face crises with faith and determination. The will to transformation is called upon as the backwash of past failure or inefficiency is experienced. Illness should be seen as a test of growth. One should serve the future-in-the-making, not a present rooted in an obsolescent past. Example: Richard Wagner, apostle of the "Music of the Future," whose life was a long series of crises.

With Uranus in the *seventh house* an individual cannot be content with any entirely normal type of relationship, including marriage. He may deal as a psychologist with crises in interpersonal relationships—Carl Jung—or with the breaking down of collective patterns of association—George Washington, Sun Yat-sen. He should bring a new and free spirit to the principle of cooperative activity —Henry Ford and his assembly-line system of production.

Uranus in the *eighth house* demands a new way of managing business deals, an unfettered mind in approaching the search for the beyond and in working through groups. It stresses the need for radical changes in the operation of social processes—V. I. Lenin, Percy Bysshe Shelley.

In the *ninth house* Uranus is called upon to revolutionize a person's mind and his traditional approach to organized religion or law. It may send the individual upon paths of physical or spiritual discovery. Nothing is too big or secure to be challenged, and this by often unconventional methods—Gandhi, the Duke and Duchess of Windsor.

In the *tenth house* Uranus indicates a public life which must resolutely accept change or else be broken up—Stalin and Mussolini, the guillotined French queen, Marie-Antoinette. New concepts of social or professional organization should be implemented, and are needed for success. The tide of change may indeed be irresistible.

With Uranus in the *eleventh house* the individual is typically involved in social, political, or cultural ideals, in reform or revolution. He should make dynamic, stimulating friends who challenge him to transform his ideals—Victor Hugo, Disraeli.

In the *twelfth house* the Uranian drive may best be focused upon one's own subconscious motives and whatever complex may result from one's "unlived life." The stage should be cleared and set for rebirth, even if this has to be done in isolation or ap-

parent defeat. A new stream of energy may be allowed to flood
the inner life once it is fully opened to the future—Sri Aurobindo,
who also had Mars in this house. The individual becomes an agent
for collective transformation.

NEPTUNE in a natal house transforms by dissolving all that re-
mains of the past, but it holds within this dissolution and de-
personalization the subtle outlines of a wider and more inclusive
future—perhaps what often is called a utopia.

As experiences related to the *first house* are normally centered
upon what constitutes an individual's uniqueness and difference
from other individuals, Neptune in that house indicates that this
is not the way to reach one's highest truth of being. The at-
tention should rather be directed to the whole of which he is a
part; or his consciousness should give up all feeling of being
focused and, as it were, allow the universe to enter. Thus the
sense of self, at least theoretically, would become universalized.
Negatively, this may lead to mediumship and a blurred self-image,
and perhaps to a dependence upon psychedelic drugs. It may lead
to an immense compassion for the underprivileged and the op-
pressed—Victor Hugo, author of *Les Misérables*—or it may indicate
the presence of valuable psychic gifts.

Neptune in the *second house* tends to dissolve the normal
feeling of possessiveness. One may rely upon society or life in general
to supply what one needs. In other cases, the individual may de-
liberately make himself a channel through which collective forces
and movements can act without interference.

With Neptune in the *third house* a man should allow his con-
crete mind and his adjustments to his environment to be illumined
or transfigured by collective or mystical forces. He may become the
mouthpiece for revelations which could challenge the very quality of
his environment. For Carl Jung this meant a continued openness to
the collective unconscious throughout his life.

In the *fourth house* Neptune challenges a person to give up
reliance upon tradition and family patterns—the Duke of Windsor
—perhaps in the name of a glamorous ideal or personal fascination.
But it may also mean using collective needs to establish a broader
foundation of existence, or the incentive to spread oneself over a

large field of experience. Henry Ford did this, at least symbolically, and his popular car was instrumental in breaking down the limits of the home scene.

A person with Neptune in the *fifth house* may be attracted by glamorous adventures and unsound risks. He may strive to impress his community by giving it what it craves rather than to exteriorize his own individual truth of being. Neptune in the fifth house may indicate musical or theatrical gifts, or a facile approach to love experiences.

In the *sixth house* Neptune helps to dissolve ego pride and to make one experience, through personal crises, a deep sense of cathar-sis. One should seek to serve humanitarian causes, to develop com-passion, to heal or allow healing forces to make one whole. In Gandhi's chart it indicated the technique of nonviolence and the use of "Truth-force"—*Satyagraha.*

A person with Neptune in the *seventh house* may find it difficult to focus his attention upon one single partnership. He may want to neither possess nor be possessed by another. New ideals of interpersonal relationship should illumine the consciousness. Here hu-manitarianism is extolled and the search for a transcendent union can be all-absorbing—Richard Wagner.

In the *eighth house* Neptune can be used to universalize in-volvement in group rituals and mass productivity. It tends to fuse the consciousness of the participants in a mystical experience of superpersonal oneness. At the level of business it stresses the value of propaganda, and of "hidden persuaders." It may lead to illusory states of paradise.

In the *ninth house* Neptune is the lure of mysticism or psy-chedelic experiences and the urge to reach the "unitive state" of cosmic or theocentric consciousness. For a more down-to-earth in-dividual, it may lead to a healing profession, especially spiritual healing. It may drive a few persons to the sea and its vast horizons.

In the *tenth house* we see Neptune pervading the public life with a social consciousness that reaches for distant boundaries and seeks an ideal community. On the way, the individual may accept socialism as a means to an end. The glamor of the life of society may also be attractive.

With Neptune in the *eleventh house* a person tends to have broad and humanitarian ideals, and to dream of beautiful utopias. Experiences related to music and the arts which present more or less

abstract and transcendent ideals should be most valuable. One may be attracted to idealistic or highly social friends.

Neptune in the *twelfth house* may present the individual with the faculty of dissolving the ghosts and memories of the past, or it may give psychic gifts and the ability to tap vast but perhaps imprecise stores of knowledge. Subconscious images and prenatal drives may intrude upon the consciousness. Compassion for the afflicted and those who our society allows to drop out and languish may bring ennobling experiences.

PLUTO can remain in a zodiacal sign for many years and as a result it primarily represents the style of life of a period, or of a generation. In the birth chart of an individual the position of Pluto in a house tends to indicate in what field of experience the person will make his or her greatest contribution to his society, and ultimately to mankind. Nothing much more can be said of its house position because people may not react to what this symbol of the twentieth-century type of human being signifies. When effective, it usually implies experiences of a deep-reaching and irreducible or irrepressible type. It tends to *finalize* the process of transformation which Uranus began, but in so doing it opens the door to a new phase of the evolution of consciousness. What comes through that door may be blinding and awesome to the normal consciousness of ego-centered man.

Briefly stated, a person with Pluto in his *first house* will contribute most to his society by emphasizing the uniqueness of his individuality. He may focus collective or spiritual forces, and he should try to do this thoroughly, uncompromisingly. With Pluto in the *second house* a person should contribute the possessions and abilities latent in his total physical-psychic being. These abilities, inherited from the ancestral past, through him may be given a new value for mankind. With Pluto in the *third house* a person's capacity to deal significantly with his environment—his intelligence and ability to communicate information—may be the greatest thing he can pass on to those who know him.

With Pluto in the *fourth house* a person's most valuable contribution to society should be the capacity, which may be demonstrated by his personal life, to integrate diverse energies and drives in a wholesome and powerful personality. Integration here implies

either exemplifying in a new statement of being the traditional roots of a solid cultural attitude, or discovering and drawing inner strength and security from a strictly individual center. With Pluto in the *fifth house* a person could have a creative destiny to fulfill, if he lets no lesser goal distract his attention and lead him into emotional bypaths. His creations would then be his most significant contribution. With Pluto in the *sixth house* the capacity to work steadily and undistractedly, and the will to serve in utter dedication, would be his greatest contribution, even if the work itself may be unimportant in an absolute sense.

If Pluto is in the *seventh house* the ability a person has to relate closely to his partners—but in terms of principles and social purposes rather than on an emotional-personal basis—can be his greatest contribution. He may set a new tone to human contacts and thus to social processes. In the *eighth house* Pluto may deal with one kind of ritual or another. To prove that in their togetherness human beings can produce new values and release transcendent energies can be the greatest contribution a person born with such a Pluto position can make. With Pluto in the *ninth house* a person can contribute most valuably the experiences and intellectual or spiritual realizations he has reached in his search for ultimate values and meanings.

With Pluto in the *tenth house* a person's characteristic participation in the affairs of his community and in the "work of the world" should be his most meaningful contribution, for it is his way of integrating the two polarities of existence, the individual and the collective. Pluto in the *eleventh house* tends to give a definite and perhaps fateful character to a man's ideals and to his vision of better things to come for himself and his companions. If he can exemplify an unswerving and total concern for and concentration upon these ideals, that very fact can be a major contribution to the nobility of man. In the *twelfth house* Pluto places his stamp upon the terminal features of a cycle of experience. To accept this "judgment" and face its consequences courageously and undeviatingly is a most significant and creative contribution to the typical human capacity to learn from defeat, as well as from fulfillment, and on that basis to move forward from cycle to cycle.*

* For a study of the meaning given to the positions of the Moon's nodes in a birth chart, cf. *The Planetary and Lunar Nodes* (Humanistic Astrology Series No. 5).

Epilogue

AS A CONCLUSION TO THIS STUDY OF THE TWELVE AS-
trological houses I would like to restate a point that at this time
I consider very basic, not only in reference to astrological practice,
but for nearly every field of human endeavor.

I have stressed elsewhere the difference between an "atomistic"
and a "holistic" approach to astrology, and I have shown that the
conflict between them, and the possibility of integrating these two
approaches, is of crucial importance not only in modern science,
but in all disciplines of thought.* The issue that cannot be dismissed
is whether a man's consciousness interprets his experiences most
significantly in relation to a whole, on the parts of which these
experiences throw some light, or as separate facts about which only
close analysis can give us valid knowledge. Today, of course, it is the
kind of knowledge that provides us with *power over* definite things
that we consider "valid."

Astrologically speaking, can we really understand a birth chart
and the total person it is said in some manner to represent if we
assign definite meanings to each planet—or each zodiacal sign, each
house, each aspect—considered as a separate factor? Should we first
analyze, and then try to piece together the data, contradictory as it

* Cf. *Astrology for New Minds* and *Astrology of Self-Actualization* (Human-
istic Astrology Series Nos. 1 and 2).

might be, or should we approach the chart first as a whole having a definite "form" and consider it a complex "word" that can reveal "meaning" to us? A careful study of the many factors comprising this whole—the "letters" comprising the word—would still be necessary in order for us to grasp the details of the whole picture. This analytical study could alter considerably as well as give precision to our first "holistic" perception of the chart, but what we would learn analytically would still fit into the picture of the whole. The overall form of the chart would remain what it is.

Another way of stating these two possibilities is to say that one can look at anything we experience—whether it be a life situation or an astrological chart—either in terms of its being a sharply definable and persistent—that is, relatively permanent—*entity*, or in terms of its representing one phase of a *process*.

If we take the first approach we tend to personalize whatever appears to be the cause of our experience. This is the attitude of what we call primitive man. Everything he sees or feels is considered a "spirit." The cloud, the lightning, the season of the year, dawn, a disease, etc., are given names and considered separate entities or gods to whom one may pray or who can be propitiated or controlled by adequate ceremonies and specific acts. Mankind is still operating very much at this level, even in our supposedly highly advanced society. We give to the person we meet a name, and perhaps an immortal Soul. Even though he may alter his appearance, from that of a child to that of an old man, we still speak of him as the same individual. We speak of anger as if it were an entity absolutely distinct from compassion. We refer to the disease named arthritis, and the doctor prescribes remedies which apply only to the removal of the symptoms of that disease. We speak of atoms as separate entities having a permanent character, which can be altered by other specific entities acting upon them. We think of God, in most cases, as a Supreme Entity or an absolute Person.

There are exceptions to this, of course, and today these are fast multiplying. The scientist now presents us with a picture of the universe in which everything not only changes but cannot be defined too closely. The atom has become a field of energies and, to many psychologists, the individual is no longer an irreducible unity but a complex of ever-changing biopsychic factors. Moreover, the individual and the environment are seen in a state of constant transforming interaction. This does *not* mean, from this point of

view, that we cannot speak of atoms, of persons or of special diseases and particular seasons, electric storms or clouds. What it does mean is that all these entities can and should be seen as temporary and sequential manifestations of *processes* which, in the broadest sense of the term, are cyclic and include many different phases.

A process, when seen as a whole, can be called an entity; but it is an entity in the sense that it has a time structure, a beginning and an end. If I see a caterpillar I know that it will become a chrysalis and a butterfly or moth. The form of the caterpillar represents only one phase of a process which includes the other forms. Besides, if I want to *understand* the life process of which this caterpillar is a phase, I have to consider its relation to the plants in its environment, to the seasons, the condition of the air around it, etc.

The change from the concept of "permanent entity" to that of "process" was most likely sparked by the teachings of Gautama, the Buddha, over twenty-five centuries ago. The Buddha in particular sought to *dis-entitize* man's approach to the human person; he did this by denying that one could speak of a human being as a permanent and reincarnating *entity* retaining an absolute character. A person was, in his eyes, the integration of many constantly changing factors and the result of causes and effects within a most extensive process—a "wheel of existence"—having a cyclic pattern. The process was real; the person experienced at any one time was to be regarded as only a phase within a process, which nevertheless did not make it less "real" for whoever also was involved in the process.

In atomic physics it is said that the electron in certain conditions can be considered a particle, in others a wave—a "wave of possibilities." This has seemed a most ambiguous and unsatisfactory concept to many people, yet it is one which can and should be applied to all human experiences. It should be applied to astrology as well and to the study of the houses of a birth chart—as I have already pointed out.

A house—as I defined it—is a 30-degree section of the space surrounding the newborn, but not of the zodiac. It is thus one of twelve parts of his universe—that is, of the *total possibility of experience available to him.* One can divide this total possibility into twelve basic categories and, as the newborn is at the center of space, the twelve categories *are there* around him. But they are there *in space* and only as potentialities. The newborn himself is also there in space as a total organism, but this organism has to develop *in time* in order to unfold all its potentialities. As it does so, the

twelve basic categories of human experience will be opened one by
one to the growing consciousness.

In this sense therefore "space" refers only to what one might
call archetypal potentialities of existence. In fact, this is always what
space means, for by extending himself in space and—if he is able to
do so—moving through space, a human being has the possibility of
new experiences. Space "is there" now, but the experiences it offers
to us are *only potential*. Time is needed for us to reach them, as we
move through space, either by our own efforts or as the Earth brings
us at every moment to a new region of galactic space. This Earth
motion may well be the basic fact in all evolution, just as the
seasons are the basic fact in the yearly growth of plants, and the
day-and-night alternation of waking consciousness and sleep condi-
tions—probably much more than we think!—the development of
man's personality.

To return to the astrological houses: they exist in space as
twelve archetypal categories of individual experience, yet these ex-
periences require the passing of time to become fully actualized.
Likewise the classical concepts of "planetary ages" and "planetary
hours" also refer to the actualization of potentialities. All the planets
"are there" always, but at certain ages and at certain times of the
day we can experience *more focally* the functional types of activities
to which they refer in astrological symbolism. We can think of the
planets as entities sending us "rays" that somehow affect us on
Earth, but we can also think of them as focalizing phases of a
process that establishes the cyclic relationship of a person to the
entire solar system through the days and years of his existence as an
organic whole.

This implies a holistic approach to experience and indeed to
the fact of actual existence. No doubt we can also picture and
interpret the universe and ourselves in terms of "being," but this
inevitably means in terms of *potentiality of experience*. If we are
dealing with *actual* experiences and the problems that result from
man's personal development in an actual and specific environment
—and this is what psychologists and psychotherapists have to deal
with—then we have to translate the archetypal categories of "being"
into the facts of "existing." We have to deal with circumstances and
experiences—or the refusal to experience!—one after the other, as
sequential phases of a process. To this process we can attribute
meaning and a purpose, and by so doing we can totally change the
meaning and purpose of each experience.

It is this psychological or psychotherapeutic approach that I have taken in all my astrological and philosophical works. In this sense I could be called an "existentialist," but unfortunately this term has acquired a very special meaning of late and it refers to a very special attitude to life with which I entirely disagree, and which I consider very illogical as well as depressing. Let me state again that to speak of "process" does not imply that there is no "archetypal potentiality of being." We have to think of space as well as of time. At the birth of any organism space *is*, yet the particular space which surrounds this new birth has significance for the new-born only in terms of the time this organism will have in which to actualize the potentialities of experience and consciousness implied in that space factor. And with time we also have to consider the organism's speed of reaction, which presumably refers to the speed of transmission of sense data—that is, of "information"—along the nerves of the body.

Thus every living organism—or rather every *existential whole*, for this should include as well atoms and galaxies—has its own space and time, or *at least* the space and time of the species of life or the cosmic level of experience to which it belongs. It has a specific speed of reaction to external impact and to internal changes. It has been surmised that the speed of light may constitute the characteristic "speed of reaction" of the cosmos—a speed enormously faster than that involved in conveying information from any part of the human body to the brain and back to the organs of action, simply because the life-span of a man is enormously shorter than that of the galaxy.

At birth space *is*; and therefore it is perfectly valid to discuss the meaning of the signs of the zodiac and of the houses—the two basic frameworks in astrology—in terms of geometrical relationships and of polygons inscribed within a circle, as has been so far the most usual practice. But I have followed the sequential or rhythmic approach because to my mind it had never been fully explained or emphasized, and because today, at a crucial moment in human history which imposes crisis-producing experiences upon the development of individuals, the most important issue is how to deal constructively with these experiences. And I feel they can best be dealt with, given meaning and purpose, and utilized when they are approached as passing phases of the vast process of human existence.

C♦R♦C♦S BOOKS

THE ART OF CHART INTERPRETATION: A Step-by-Step Method of Analyzing, Synthesizing & Understanding the Birth Chart by Tracy Marks, $9.95. A guide to determining the most important features of a birth chart. A must for students!

THE ASTROLOGER'S HANDBOOK by Julia Parker (Author of the best-selling THE COMPLEAT ASTROLOGER), $12. Individualizes the astrological details of any person's chart, combining the Sun Sign with the Rising Sign, Moon Sign, and the planets. It also provides a wealth of quite specific advice and information regarding friendship, love, marriage, careers, and money — making it one of the most practical astrology titles ever published.

ASTROLOGY, A COSMIC SCIENCE by Isabel M. Hickey, $14.95. A perennial best-seller in hardcover, this classic of spiritual astrology is finally in paperback! This new revised and expanded edition includes seventy pages of new material that the author wrote about Pluto but which has not been readily available.

AN ASTROLOGICAL GUIDE TO SELF-AWARENESS by Donna Cunningham, M.S.W., $9.95. Written in a lively style by a social worker who uses astrology in counseling, this book includes chapters on transits, houses, interpreting aspects, etc.

THE ASTROLOGICAL HOUSES: The Spectrum of Individual Experience by Dane Rudhyar, $12.95. A recognized classic of modern astrology that has sold over 100,000 copies, this book is required reading for every student of astrology seeking to understand the deeper meanings of the houses, a subject treated only superficially in most introductory books. The most accessible and practical of Rudhyar's many books, it interprets each planet in each house.

ASTROLOGY: The Classic Guide to Understanding Your Horoscope by Ronald C. Davison, $9.95. This classic work is now back in print in a new edition, with an instructive new foreword that explains how the author's remarkable keyword system can be used even by the novice student of astrological methods.

ASTROLOGY IN MODERN LANGUAGE by Richard Vaughan, $13.95. An in-depth interpretation of the birth chart focusing on the houses and their ruling planets — including the Ascendant and its ruler. A unique, strikingly original work.

New Edition! ASTROLOGY, KARMA & TRANSFORMATION: The Inner Dimensions of the Birth Chart by Stephen Arroyo, $13.95. A revised and expanded edition, with added footnotes and a new Comprehensive Index. An insightful book on the use of astrology as a tool for spiritual and psychological growth, seen in the light of the theory of karma and the urge toward self-transformation. International best-seller.

THE ASTROLOGY OF SELF-DISCOVERY: An In-Depth Exploration of the Potentials Revealed in Your Birth Chart by Tracy Marks, $13.95. A guide for utilizing astrology to aid self-development, resolve inner conflicts, discover and fulfill one's life purpose, and realize one's potential. Emphasizes the Moon and its nodes, Neptune, Pluto, & the outer planet transits. An important and brilliantly original work!

ASTROLOGY, PSYCHOLOGY AND THE FOUR ELEMENTS: An Energy Approach to Astrology & Its Use in the Couseling Arts by Stephen Arroyo, $12. An international best-seller, this book deals with the relationship of astrology to psychology and using astrology as a practical method of understanding one's attunement to universal forces. Clearly shows how to approach astrology with a real understanding of the energies involved.

STEPHEN ARROYO'S CHART INTERPRETATION HANDBOOK: Guidelines for Understanding the Essentials of the Birth Chart by Stephen Arroyo, $10.95. Shows how to combine keywords, central concepts, and interpretive phrases in a way that illuminates the meanings of the planets, signs, houses, and aspects emphasized in any chart.

DYNAMICS OF ASPECT ANALYSIS: New Perceptions in Astrology by Bil Tierney, $13.95. The most in-depth treatment of aspects and aspect patterns available, inlcuding both major and minor configurations. Also includes retrogrades, unaspected planets & more!

EXPLORING JUPITER: The Astrological Key to Progress, Prosperity & Potential by Stephen Arroyo, $14.95. The first new book by Stephen Arroyo since his best-selling CHART INTERPRETATION HANDBOOK. This book's self-improvement theme makes it virtually a sequel to Arroyo's all-time best-seller ASTROLOGY, KARMA & TRANSFORMATION, which has sold over 100,00 copies.

NEW INSIGHTS IN MODERN ASTROLOGY by Stephen Arroyo & Liz Greene, $12.95. In this revised edition of one of the most acclaimed astrology books of recent years, the most articulate astrologer-psychologists discuss relationships, chart comparisons, myths, etc.

PICKING YOUR PERFECT PARTNER THROUGH ASTROLOGY: A Guide to Compatibility in Relationships by Mary Coleman, $12. A comprehensive, easy-to-understand, and dynamically intelligent blend of astrology and psychology that reveals what really makes — or breaks — relationships.

PLANETARY ASPECTS: FROM CONFLICT TO COOPERATION: How to Make Your Stressful Aspects Work for You by Tracy Marks, $13.95. Revised edition of HOW TO HANDLE YOUR T-SQUARE focuses on the undestanding and use of stressful aspects and on the T-Square configuration both in natal charts and as formed by transits & progressions.

PRACTICING THE COSMIC SCIENCE: Key Insights in Modern Astrology by Stephen Arroyo, $13.95. A revised edition of PRACTICE AND PROFESSION OF ASTROLOGY, presenting a challenging, wide-ranging treatment of such crucial subjects as astrology as a healing process, the purpose of astrology, and astrological counseling as a legitimate profession.

New Edition! RELATIONSHIPS & LIFE CYCLES: Modern Dimensions of Astrology by Stephen Arroyo, $12. A revised edition now with comprehensive Index. Includes natal chart indicators of one's capacity for relationship; techniques of chart comparison; using transits practically; and the use of the houses in chart comparison.

A SPIRITUAL APPROACH TO ASTROLOGY: A Complete Textbook of Astrology by Myrna Lofthus, $15.95. A complete astrology textbook from a karmic viewpoint, with an especially valuable 130 page section on karmic interpretation of all aspects, including the Ascendant and MC. A huge 444-page original work.

YOUR SECRET SELF: Illuminating the Mysteries of the Twelfth House by Tracy Marks, $15.95. Demonstrates in a unique and fascinating way how themes of a birth chart emerge in one's dreams and how to liberate oneself from patetrns that interfere with one's goals and wholeness.

For more complete information on our books, a complete catalog, or to order any of the above publications, WRITE TO:

CRCS Publications, P.O. Box 1460, Sebastopol, CA 95473, USA